ART OF AEGIS

PRAISE FOR

ART OF AEGIS

"Beautiful renditions! Just one step closer to seeing the Aegis Odyssey come to life on the silver screen."

*

"We finally get to put the faces with the names of our heroes and villains."

*

"Art of Aegis adds another layer to the phenomenon that is the Agis Odyssey."

*

"The Art of Aegis is like getting a peak inside the mind of the author, and seeing exactly what he sees."

*

"This is a great companion piece that I highly recommend to new readers of the Aegis odyssey. Definitely a must have."

*

BY STEPH PANTOJA

The Paladin: Blood Bank $TASH Dead Bang

The Elementaries Cycle of Operation Nerd Geek City

Omnibus: Swords, Shotguns, Science & Shadows

Escape from Planet Fubar

The Aegis Odyssey

Copper Aegis Bronze Aegis Silver Aegis

Gold Aegis Platinum Aegis Electrum Aegis

Amethyst Aegis Art of Aegis

www.pantojapress.com

ART OF AEGIS

STEPH PANTOJA

ART OF AEGIS

No part of this publication may be reproduced, stored in or introduced into a retrieval system, or transmitted, in any form, or by any means (electronic, mechanical, photocopying, recording, or otherwise), without the prior written permission of the author.

This is a work of fiction. Names, characters, places and incidents either are the product of the author's imagination or are used fictitiously, and any resemblance to actual persons, living or dead, events, or locales is entirely coincidental.

The publisher does not have any control over and does not assume any responsibility for author or third-party web sites or their content.

If you purchased this book without a cover you should be aware that this book is stolen property. It was reported ad "unsold and destroyed" to the publisher and neither the author nor the publisher has received any payment for this "stripped book".

The scanning, uploading and distribution of this book via the Internet or via any other means without the permission of the author is illegal and punishable by law. Please purchase only authorized electronic editions and do not participate in or encourage electronic piracy of copyrighted materials. Your support of the author's rights is appreciated.

Copyright 2024 by Pantoja Press

All rights reserved.

ISBN: 9781300849285

Dedicated to

My true family, friends and fans.

"I had the time of my life fighting perfection with you."

Special Thanks to

Damon Carpentier, Marcello Delgado, Eric Matias,

Rodney Pena, Randy Rosa, and Kevin Sonilal.

Very Special Thanks to

Our Parents, for letting nerds be nerds.

ART OF AEGIS

FOREWORD

This sketchbook is more than just a collection of images; it's a journey into the world of the Aegis Odyssey, a universe both familiar and strange, where heroes, monsters, and mystics move through deserts, arenas, and starry realms.

Each character within these pages has a story that I've tried to capture not only in appearance but in essence.

The sketches here aim to reflect the heart of this ensemble cast and their struggles, drawn from a place of admiration for their bravery, resilience, and deep connections to their lands and loved ones. In their expressions, poses, and attire, I wanted to illustrate not only their physical form but also the legends they carry and the worlds they inhabit. These are heroes born in battles against darkness, seeking freedom, purpose, and redemption in realms woven with magic and ancient lore.

My hope is that, as you turn each page, you'll feel drawn into the world of Tellus. Let these characters be your guides through their world, and may you discover stories that resonate beyond these pages and live on in your own imagination.

- **Steph Pantoja**
 The Chromatic Club, est. 1983

ART OF AEGIS

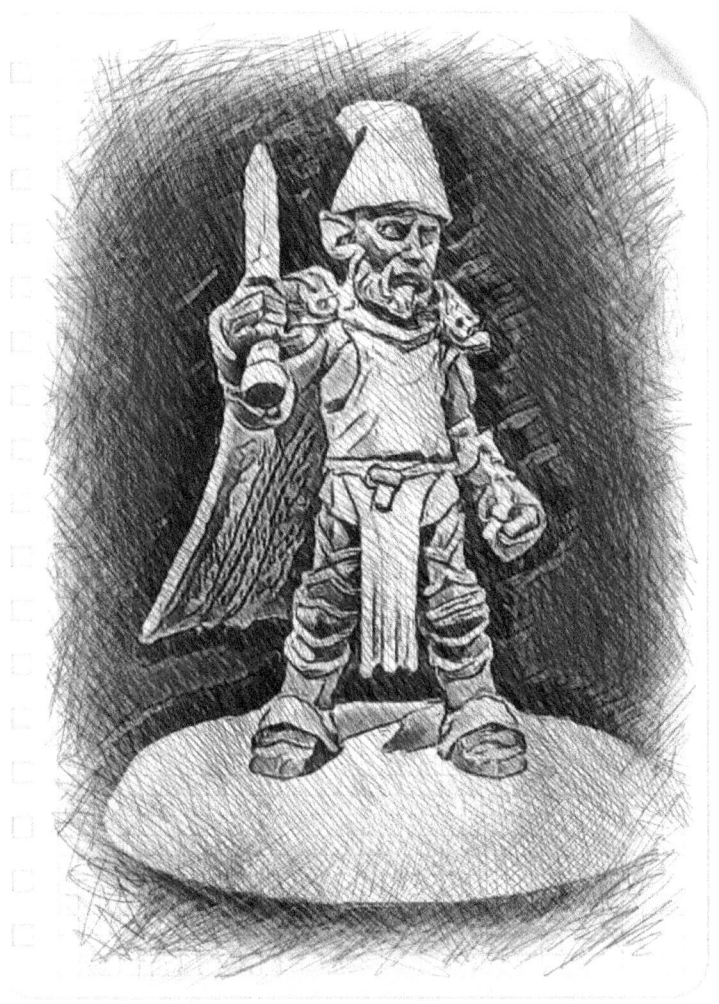

King Adamas Titanson from the gnome kingdom Tinkerhearth, and the leader of the Rabbit Riders.

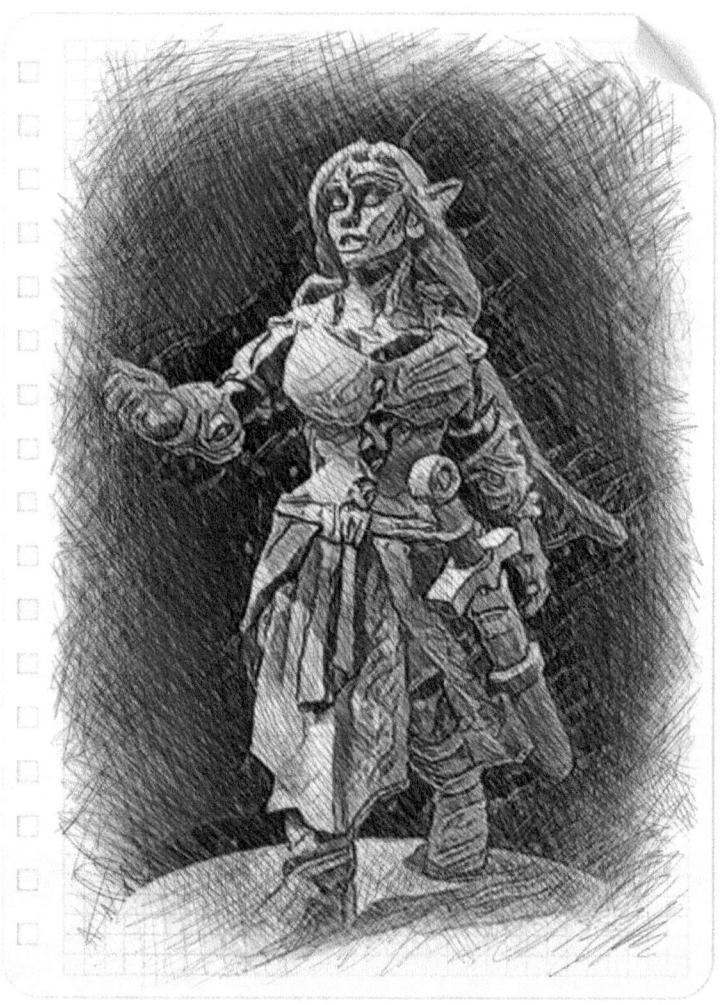

Princess Alaurel Hazelhawk from the light elf kingdom Sunkith, of the Sidhe Court. Former druid of Tir Greene.

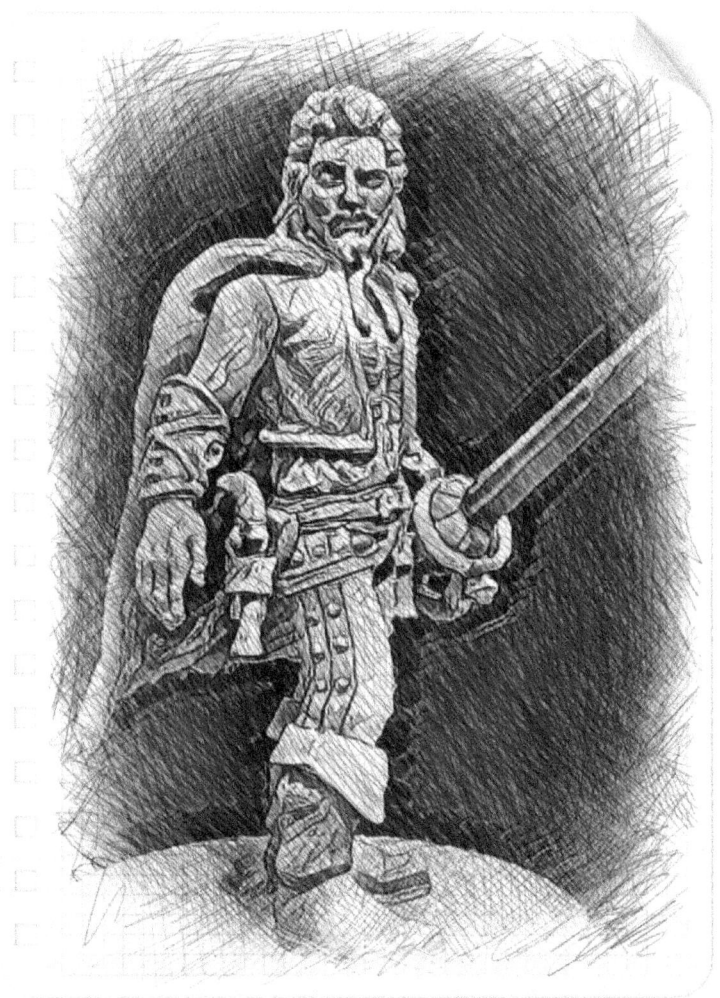

Alexandro Vincente LaSombra (Capistrano) from Thieves' Town and the Governor General of the Crossroads.

**a.k.a. Ultio of Los Rodeleros.*

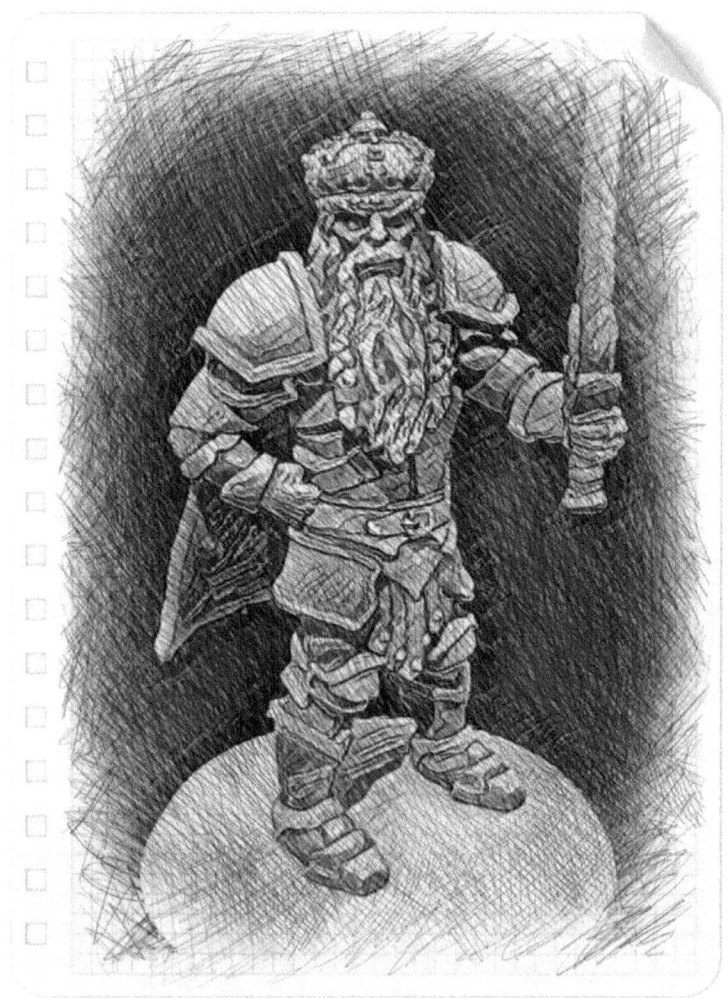

Overking Ambrosius Questir Pendrake XXIV from Caerleon, and the ruler of the Caerleon Empire.

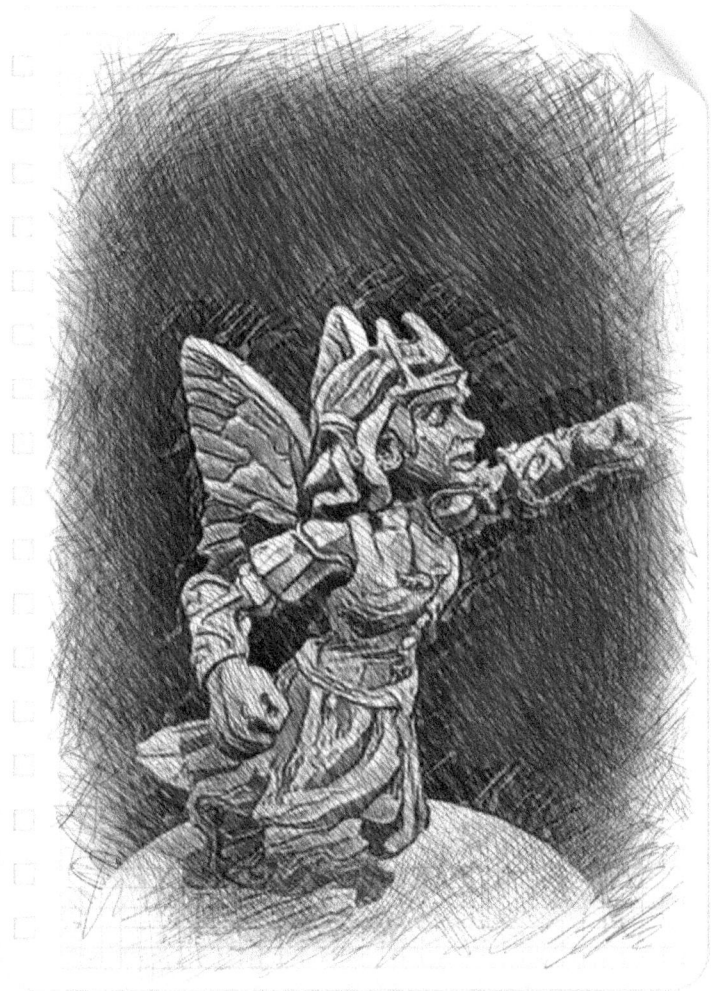

Princess Appleblossom from the sprite kingdom of Summer Eyrie, of Marutui the Realm of Air.

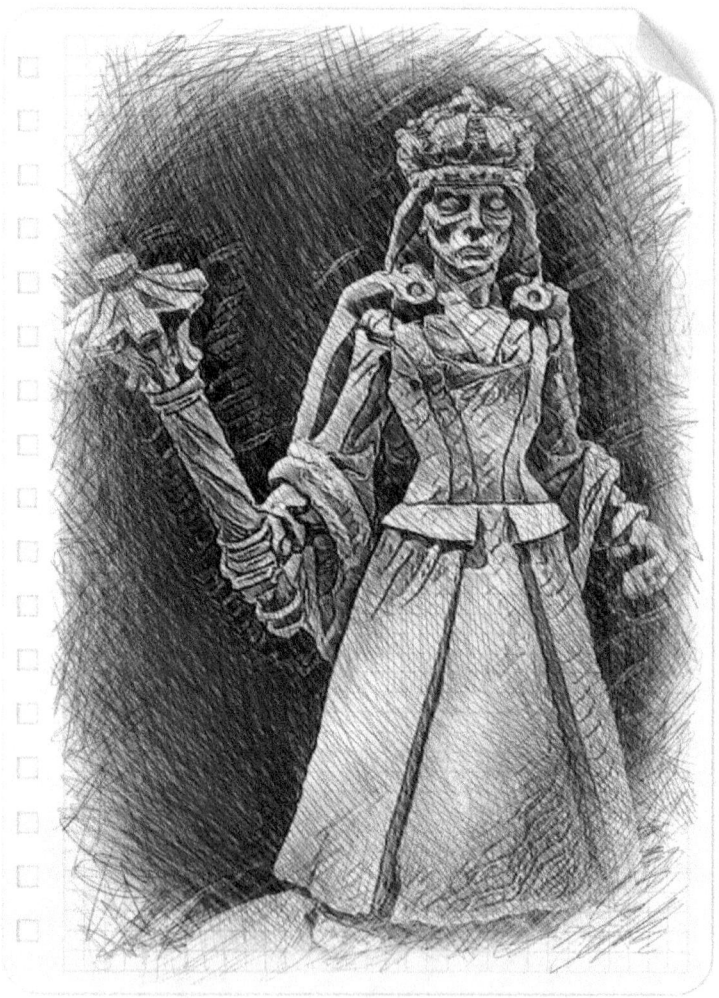

Emperatriz Aragona Joaquina Sepulveda Del Batista from Gran Caparra, and the ruler of the Hystrian Empire.

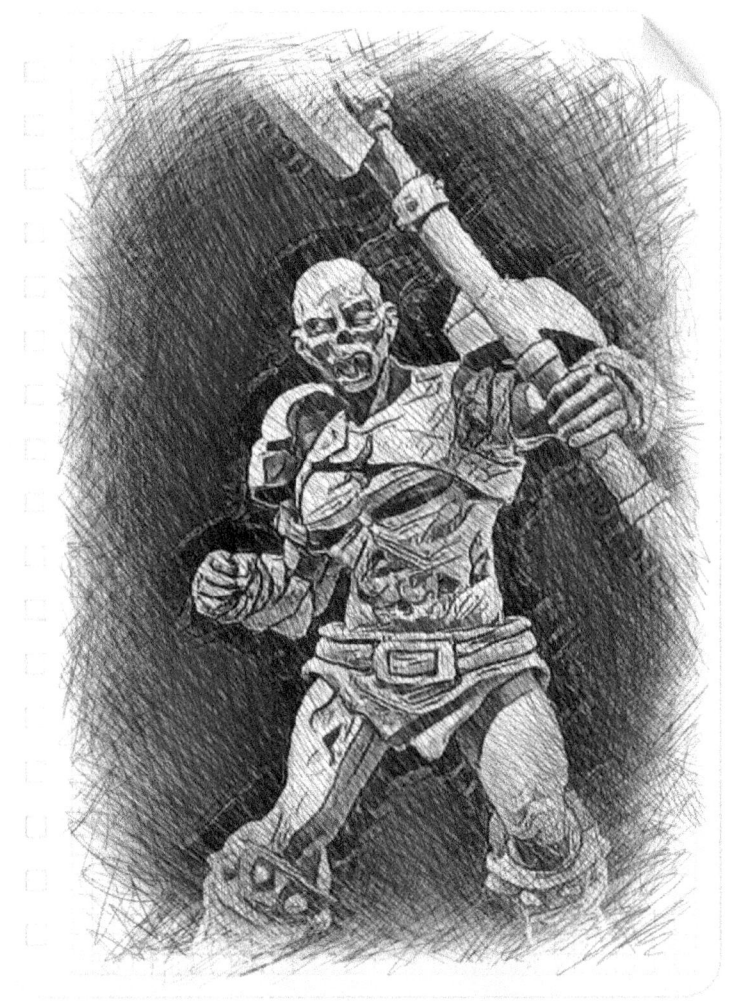

Armon, flesh-golem enforcer of the Hellmongers.

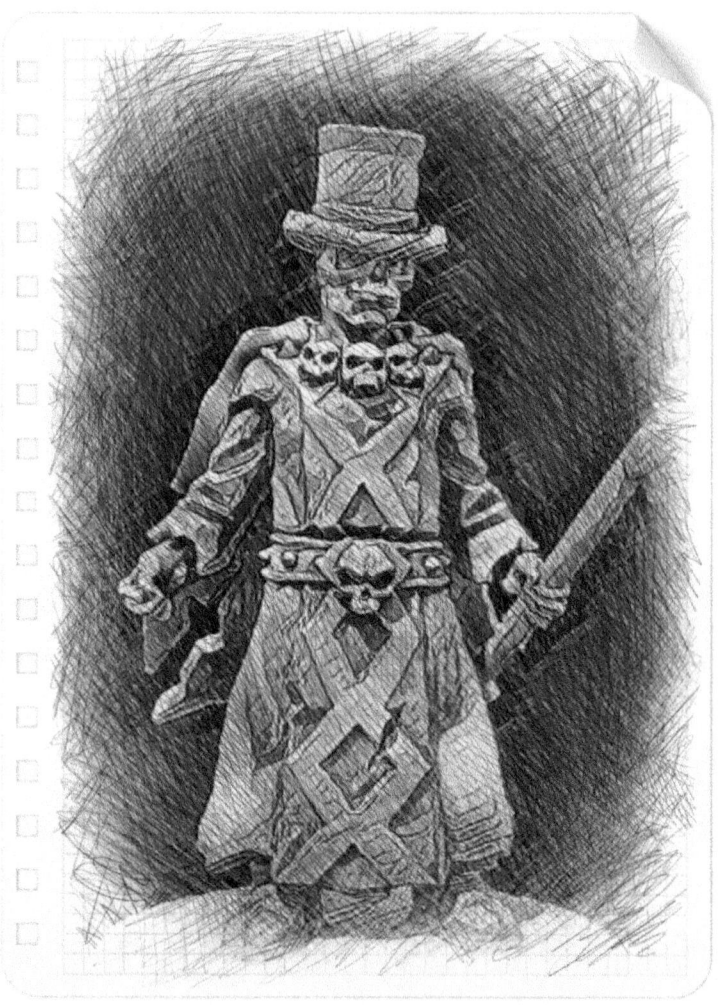

Baron Papa, Bandit King from Port-au-Samedi, and the leader of the Krew du Vodun.

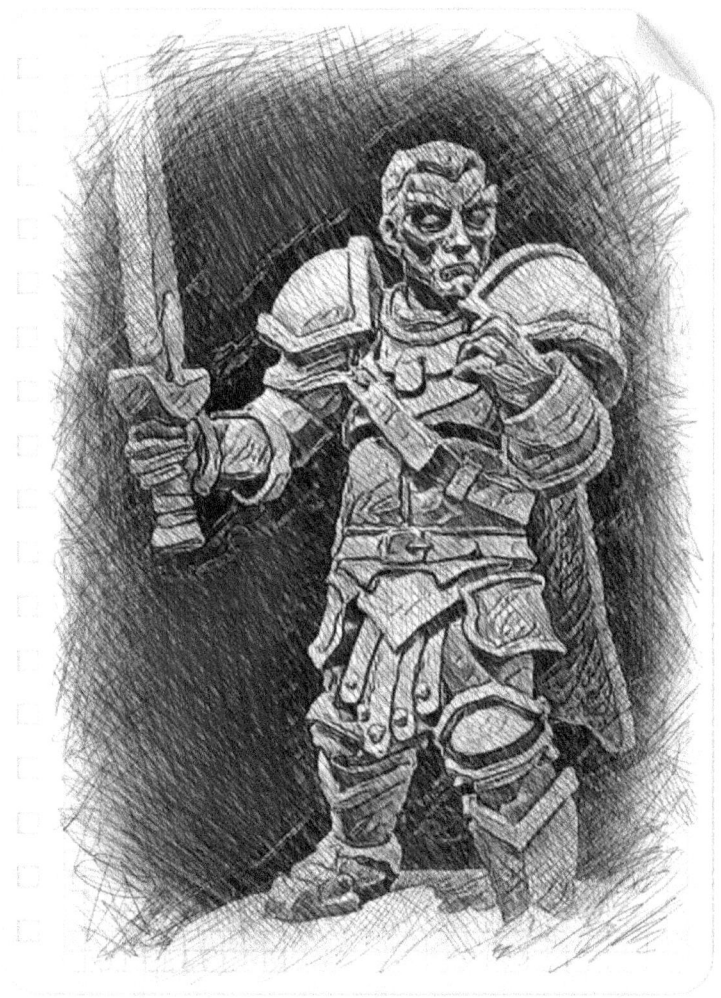

Mon Benoc D'Astolat from Gaulvale, and the Lord Commander of the Knights of Caerleon.

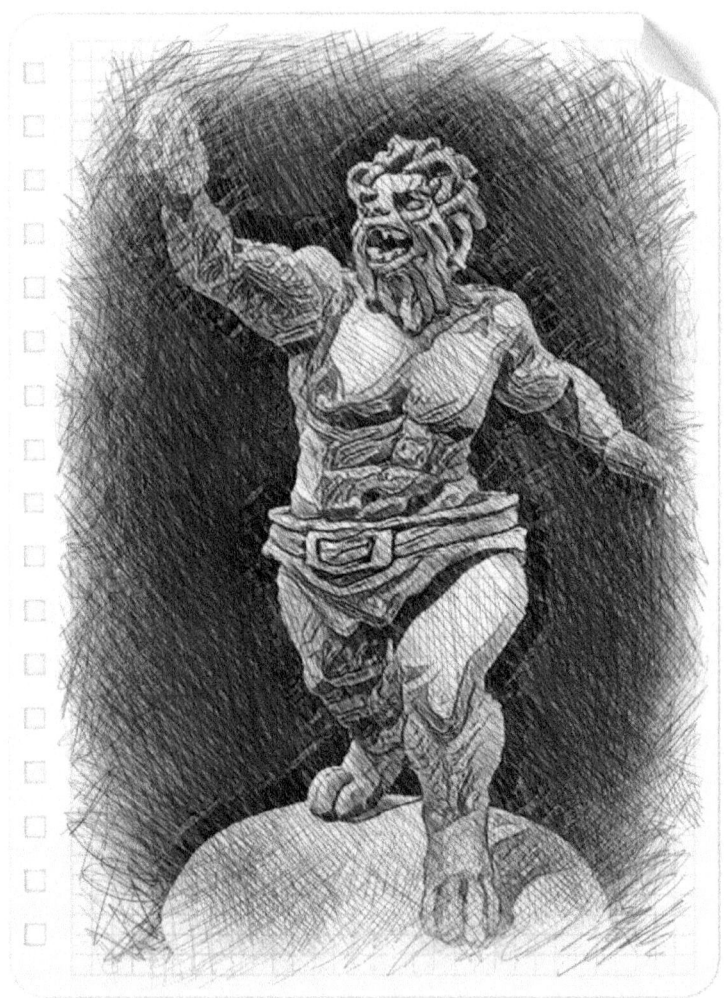

Bjornen from Caern Fjord, were-bear Beta of the Ghet of Shuck.

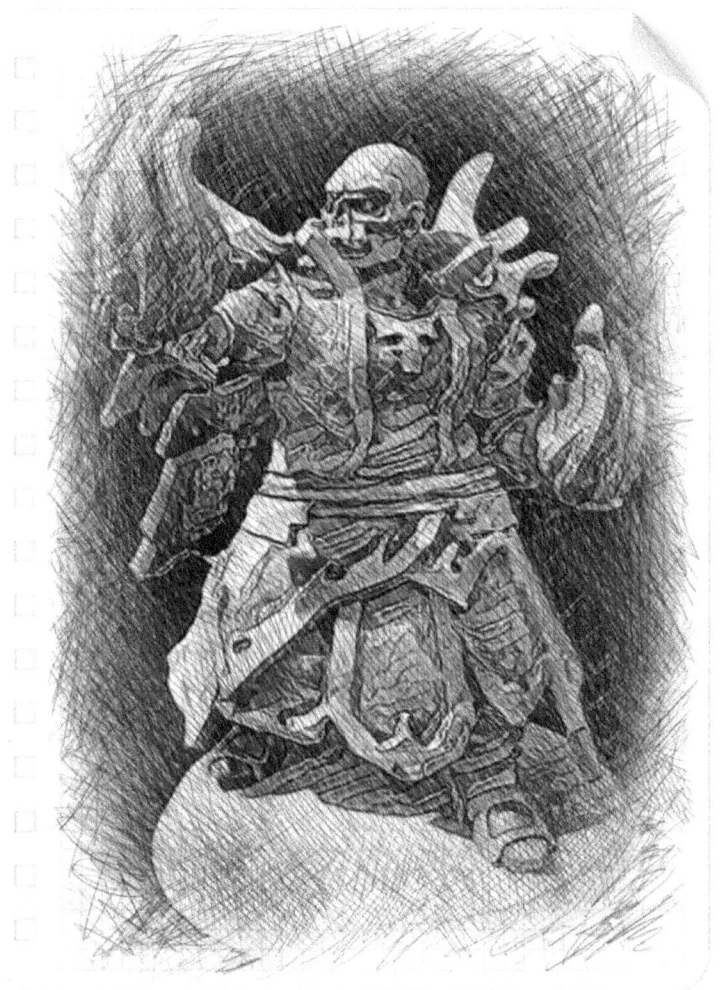

The Black Friar, high priest and the leader of the Hellmongers.

**Formerly Samrom of the Acolytes of Loa-Ra.*

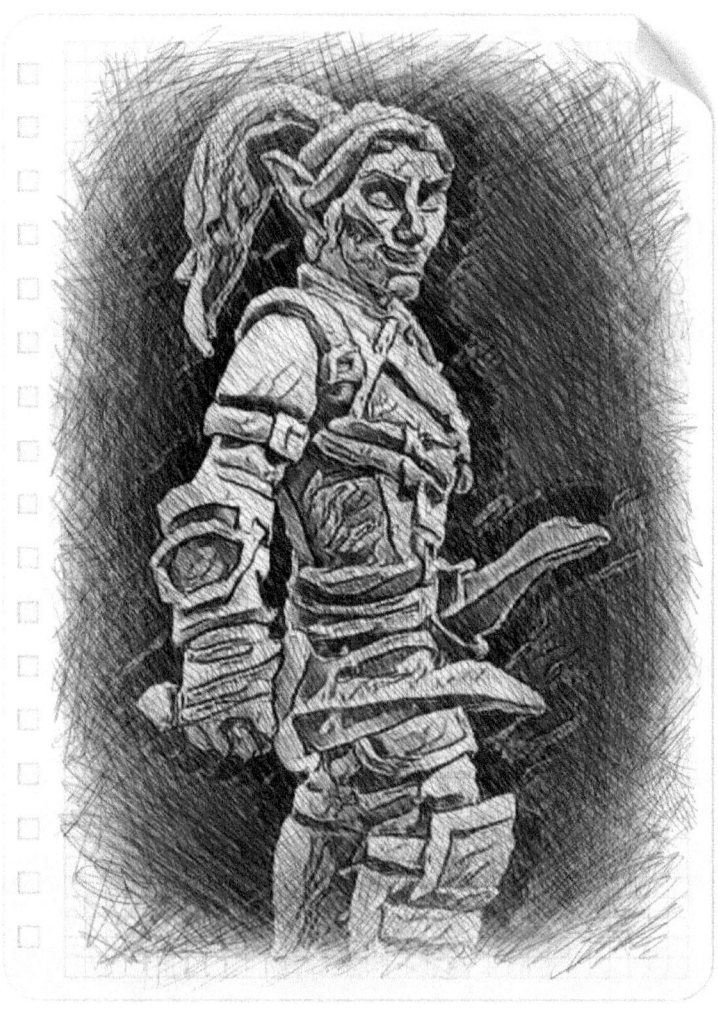

Blackfox (Zoesin) of the Nine Tails.

**Fox pooka in dark elf guise.*

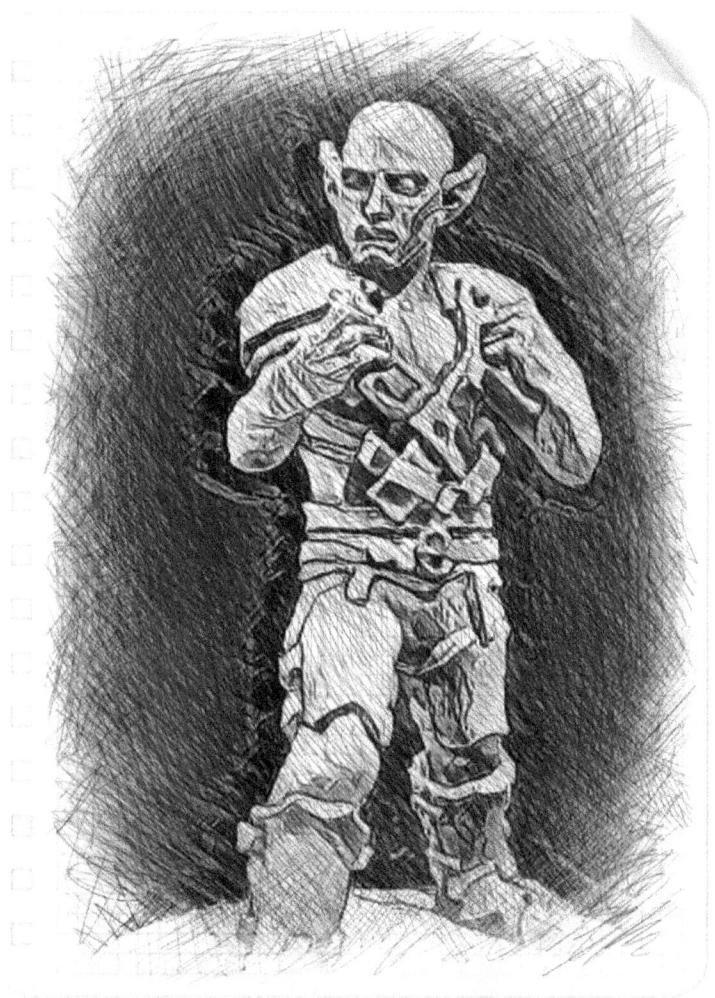

Hervil, from the changeling kingdom of Rancorvale, and assassin for the Gloam. Twin brother to Henque.

**a.k.a. The Blood Brothers.*

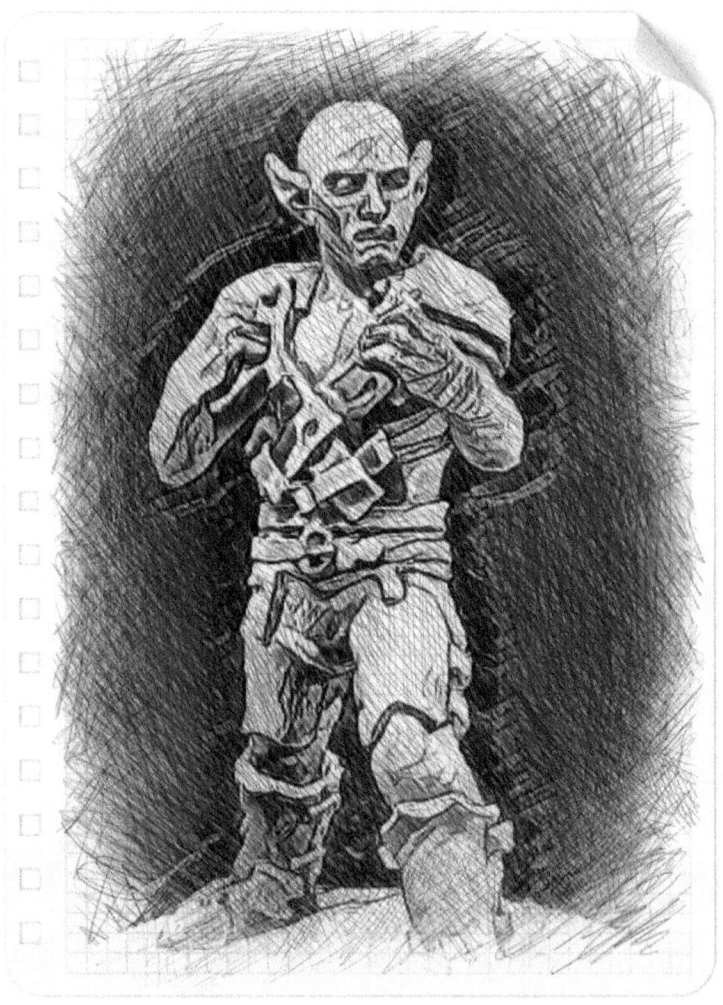

Henque, from the changeling kingdom of Rancorvale, and assassin for the Gloam. Twin brother to Hervil.

*a.k.a. The Blood Brothers.

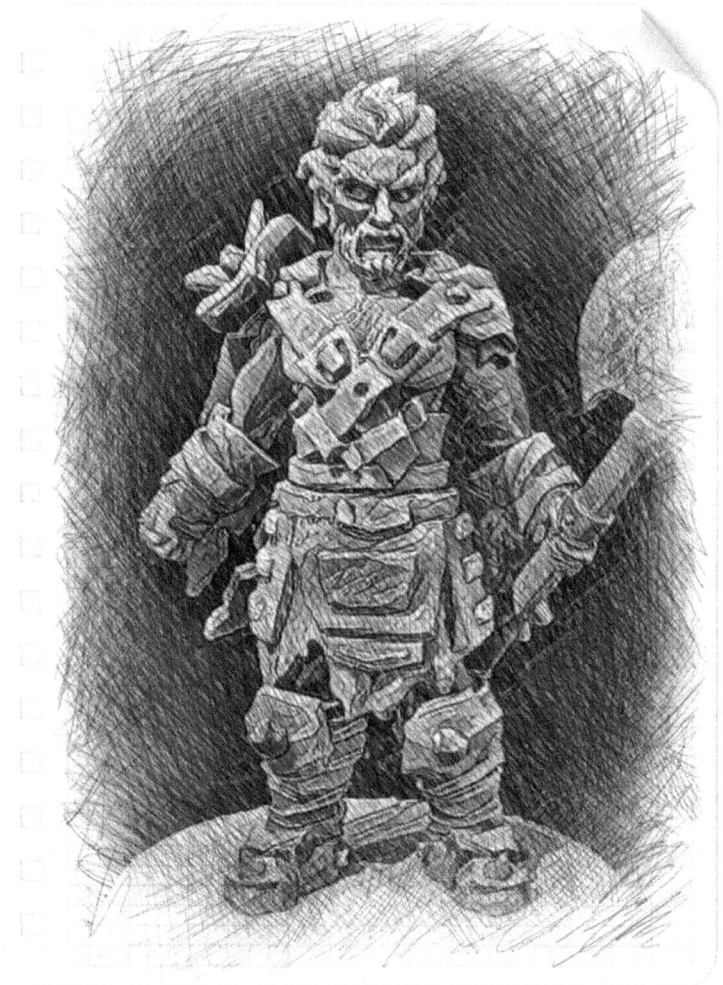

Jarl Bodai Mjolnirson from Iron Icevale, and the leader of the Siberakh clan.

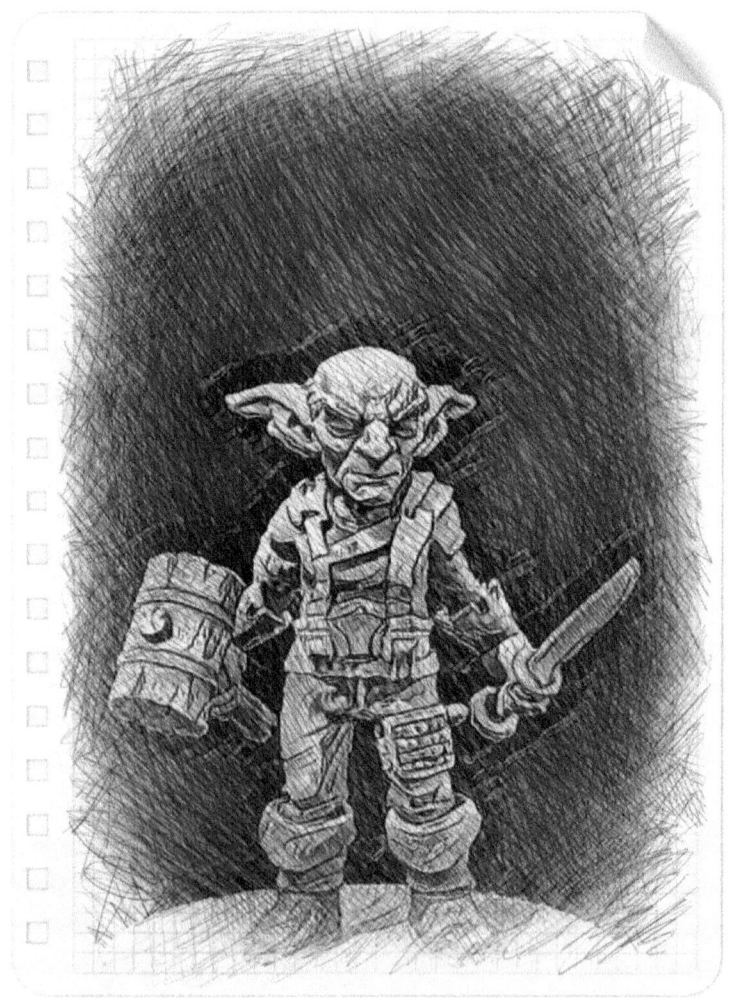

Boetticher, goblin Technomancer and the Lord Rector of Bogglehold Academy.

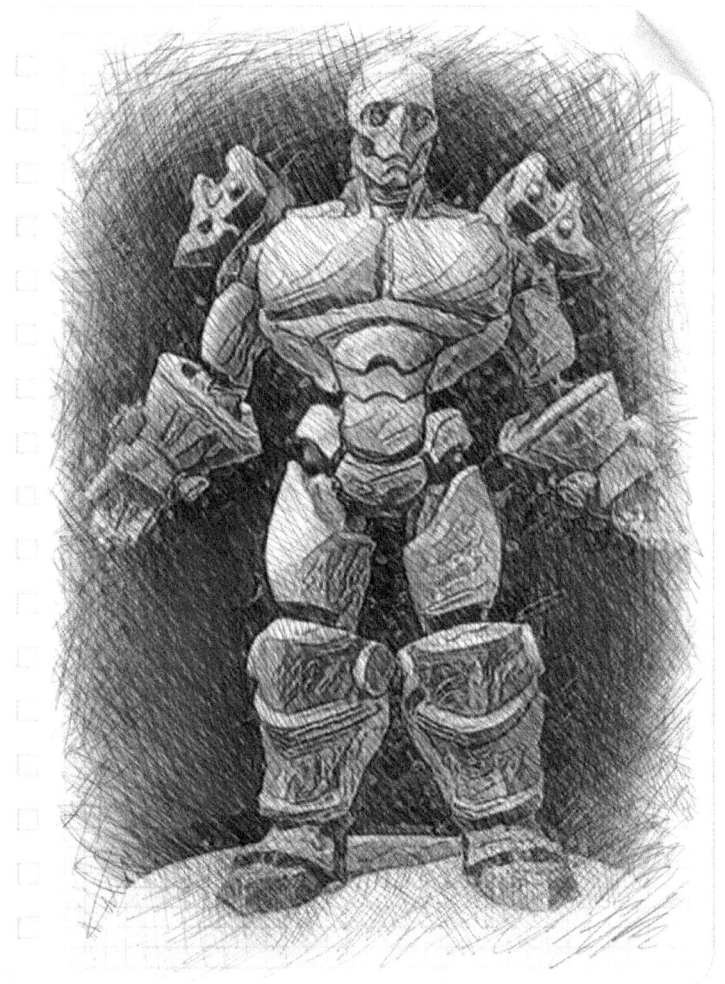

Box (Biological Oriculum Xenomorph), sentient automaton.

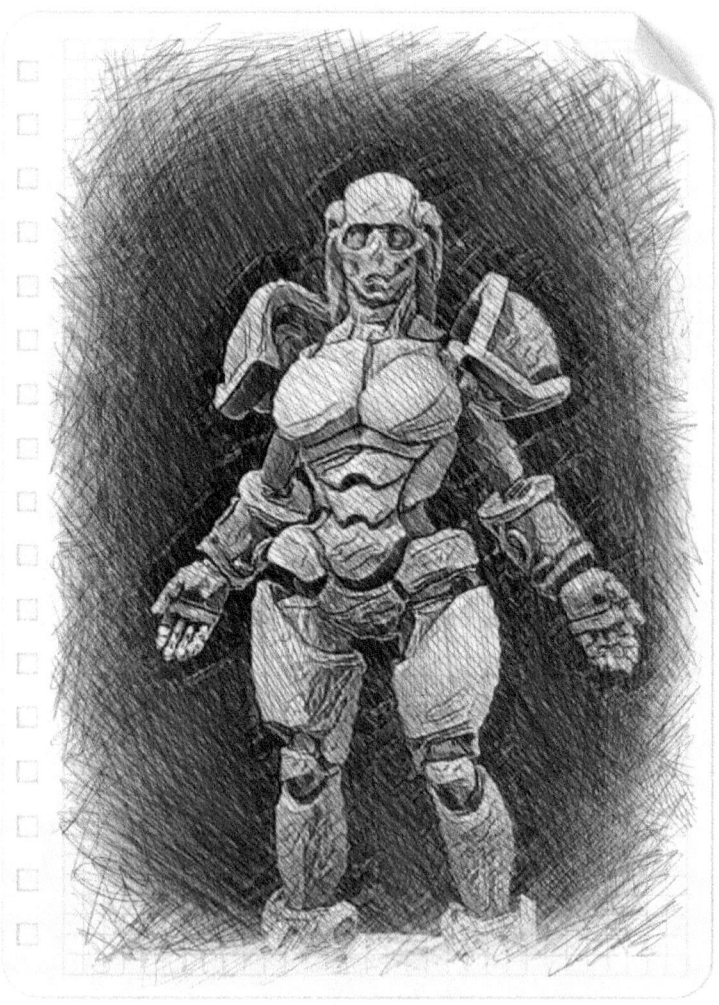

Boxxane (Biological Oriculum Xenomorph), sentient automaton.

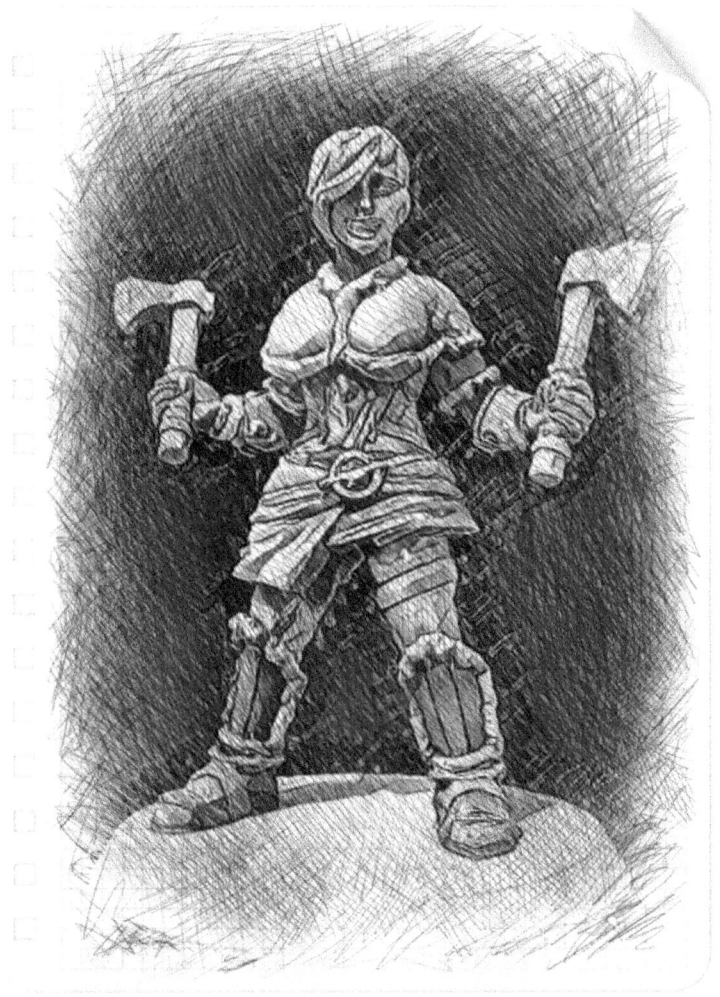

Brooke from Iron Icevale and member of the Dust Men. Twin sister of Rutger.

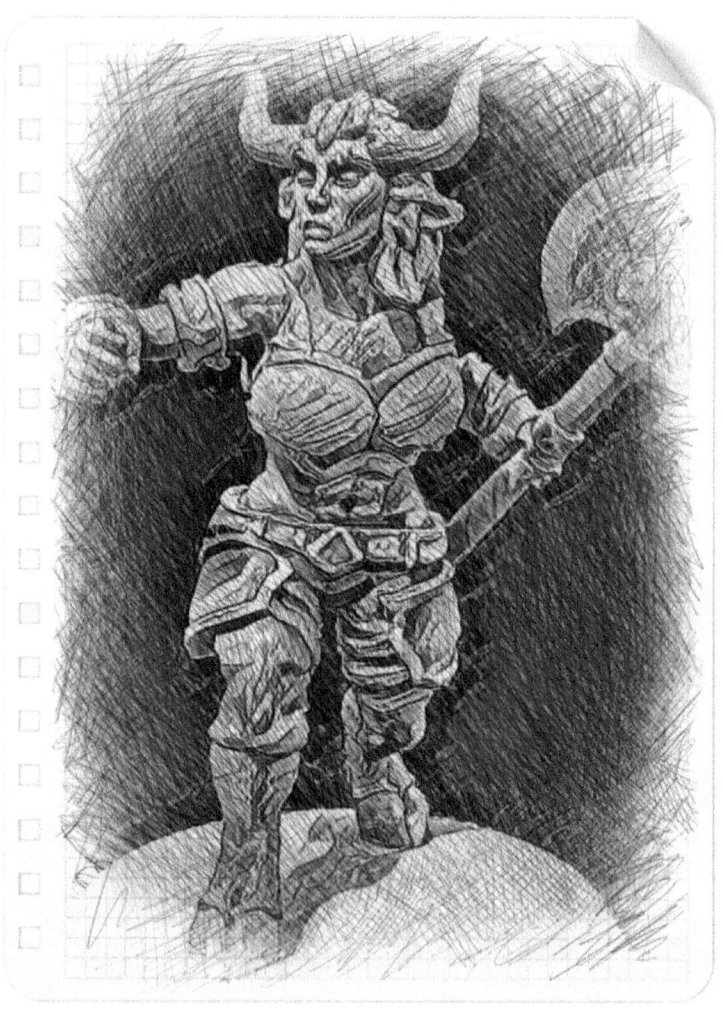

Brungilda, metis of the Eventide kumpani.

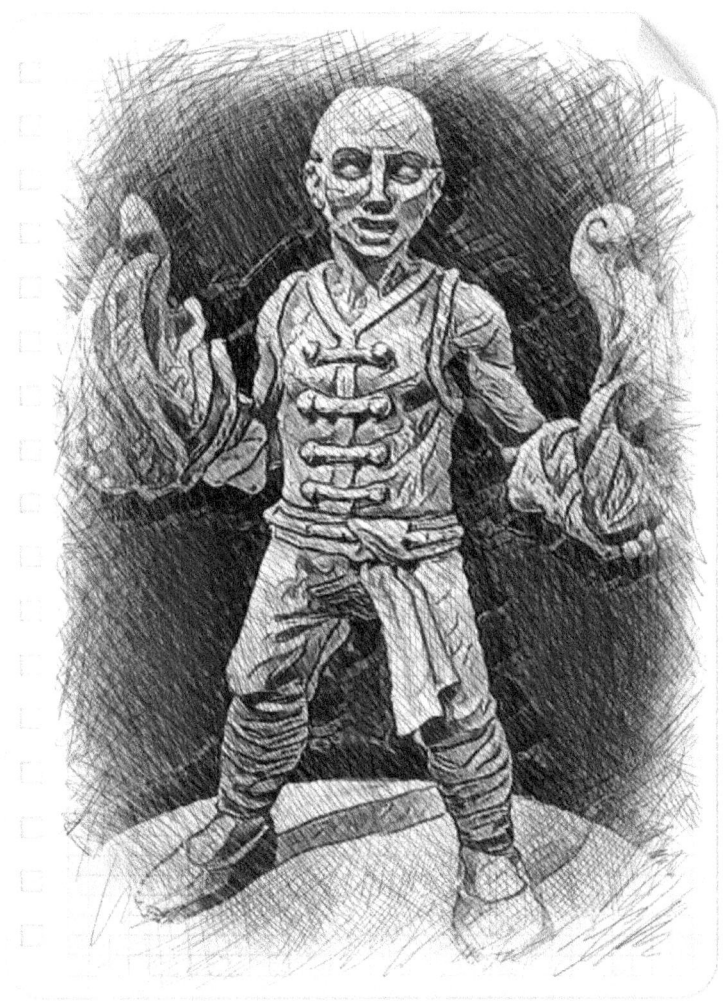

Bryke, djinnling from Kong Tur, and shugenja of the Seven Rings of Harmony.

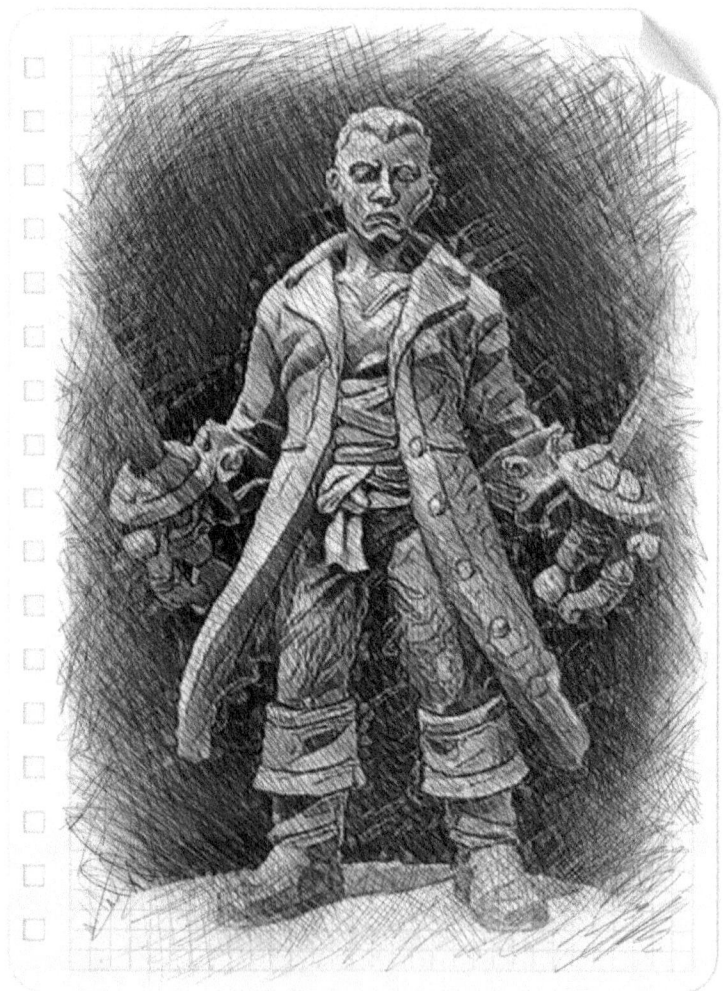

Cameron Pena from the Crossroads, and the captain of the Kingsbridge.

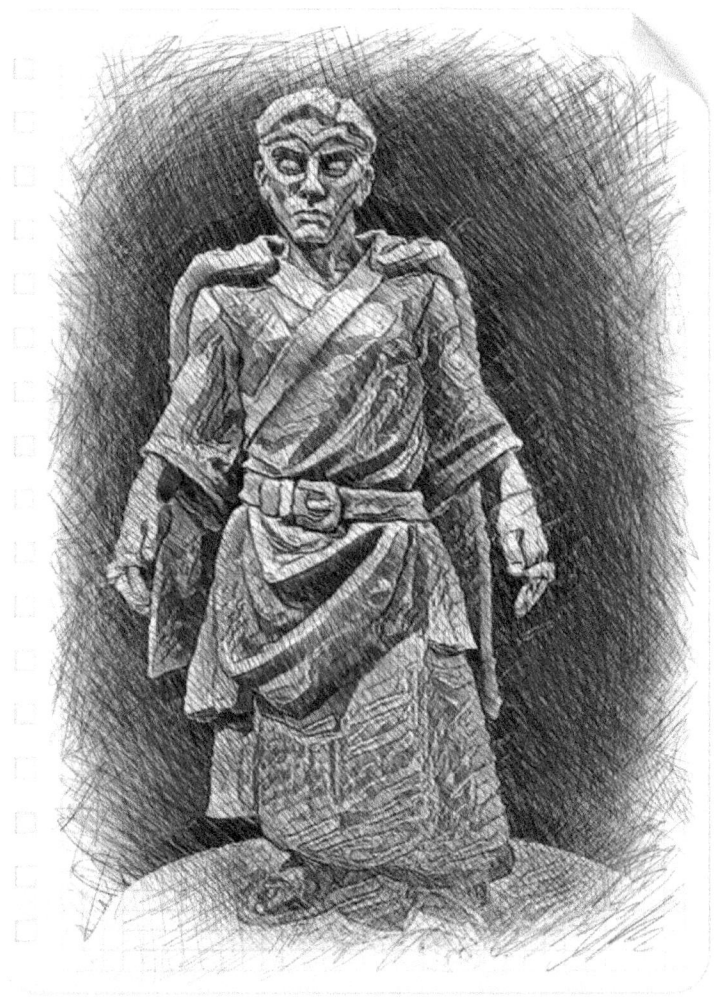

Emperor Capricus Caligula Caesares from Romopolis, and the ruler of the Nova Sparta Imperium.

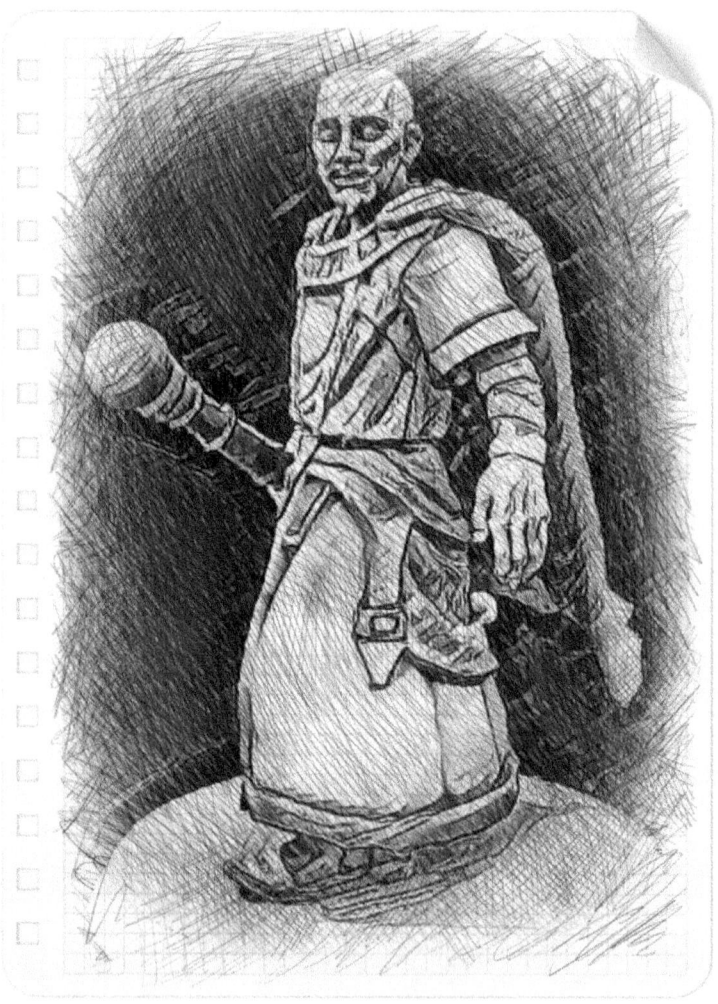

Grandmaster Cinque from Sudria. Member of the Acolytes of Loa-Ra, and an Archon of the Quorum.

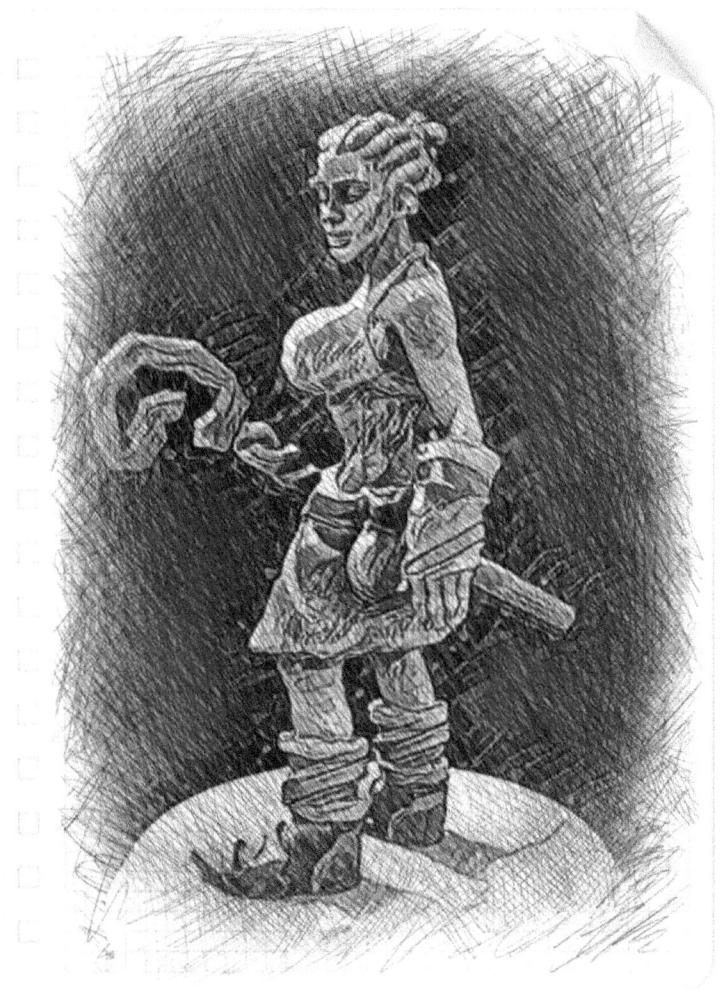

Clori from Congswana, and member of the Dust Men. Ship's healer of the Spellhammer.

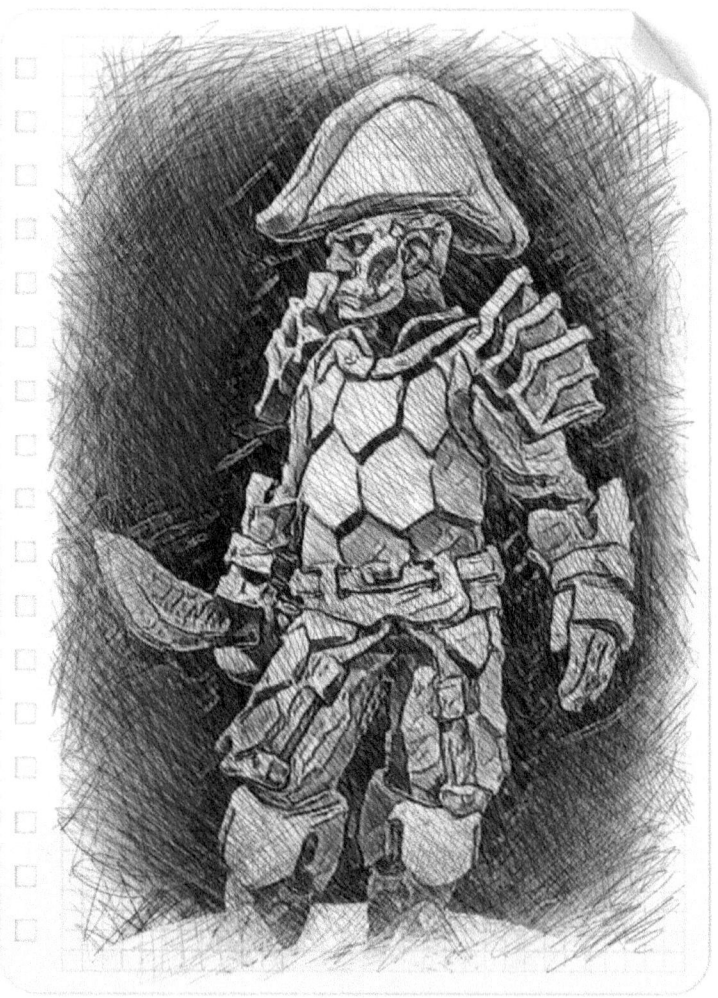

The Commodore, Bandit King of the Fort and the leader of the Dragoons.

**a.k.a. Hannibal Bey.*

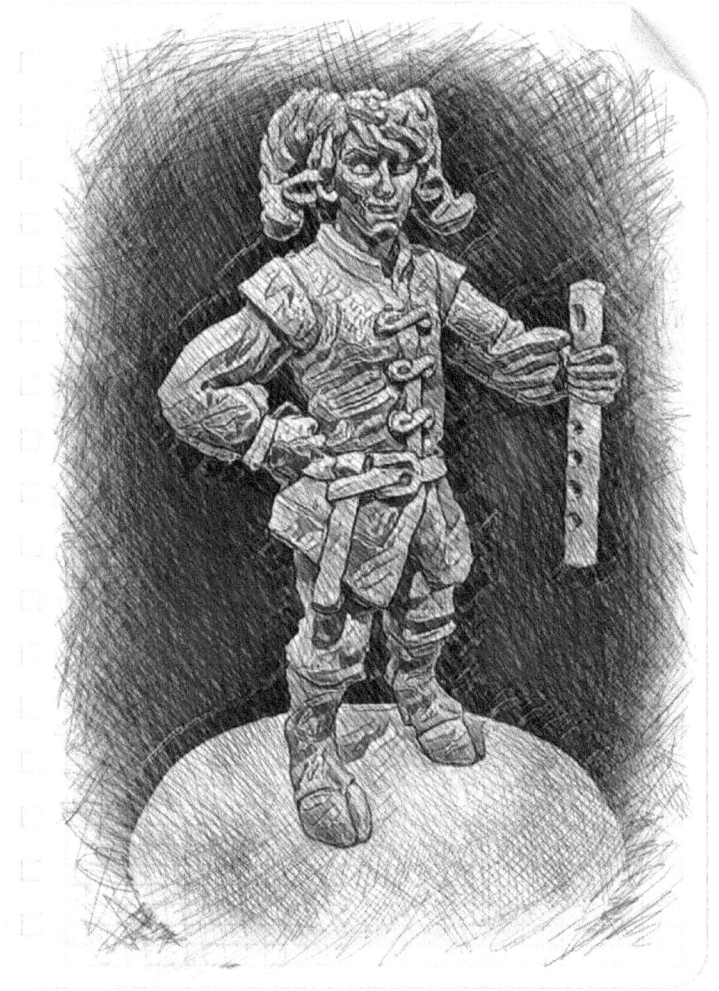

Copper from the satyr kingdom of Korred Keep, and druid of Tir Greene. Former bard of Coda Dai.

**a.k.a. Copernicus.*

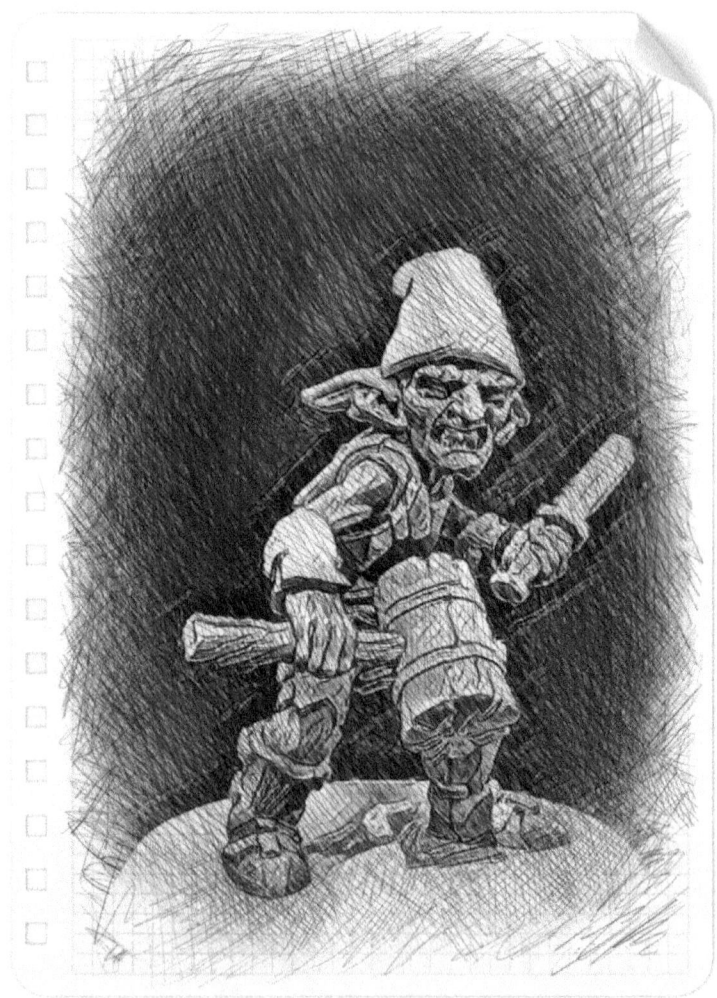

Crackerjax, redcap Technomancer of the Bogglehold Academy.

**a.k.a. Jaxster Bonecracker.*

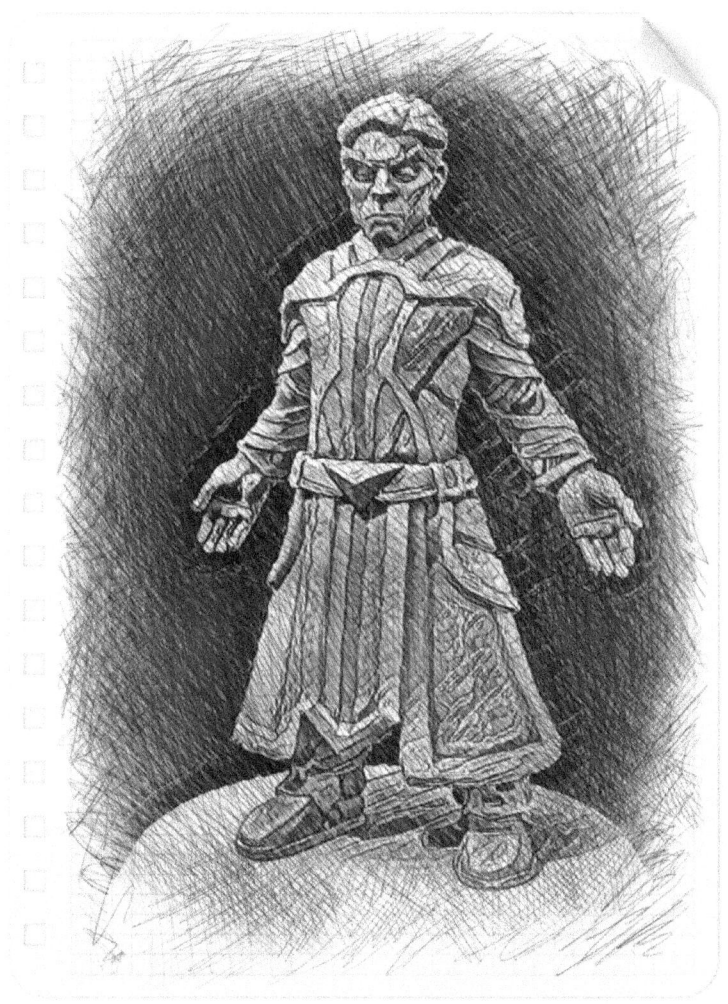

Lord Cardinal Cristiano Trujillo of the Curia.

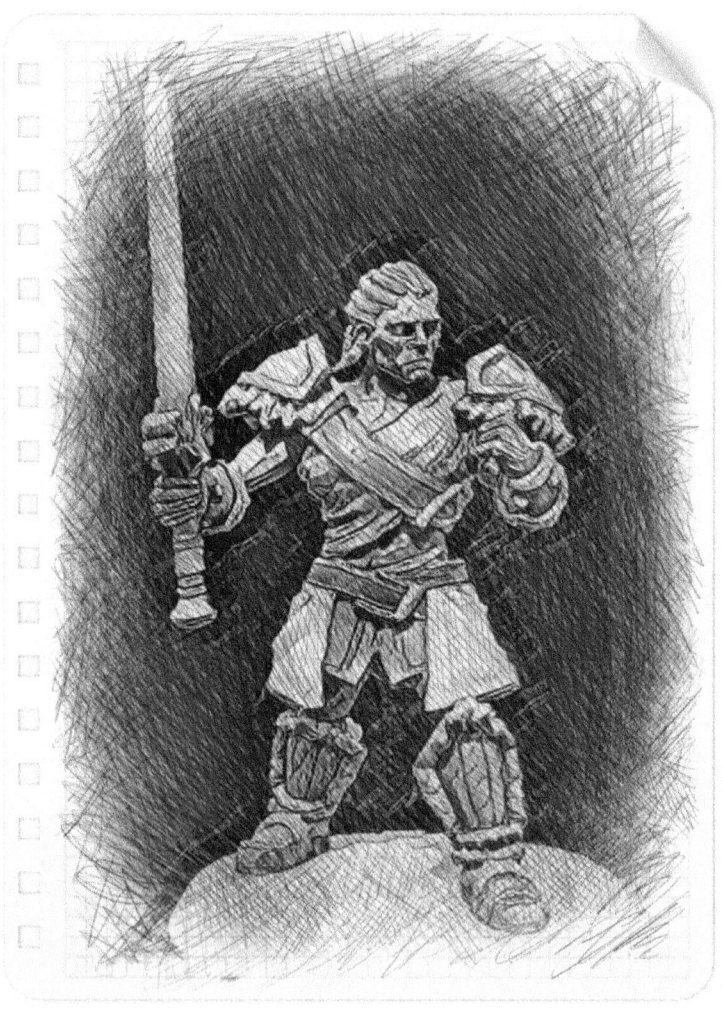

Crullak Bloodstone from San Mirandal, the leader of the Dust Men and the captain of the Spellhammer.

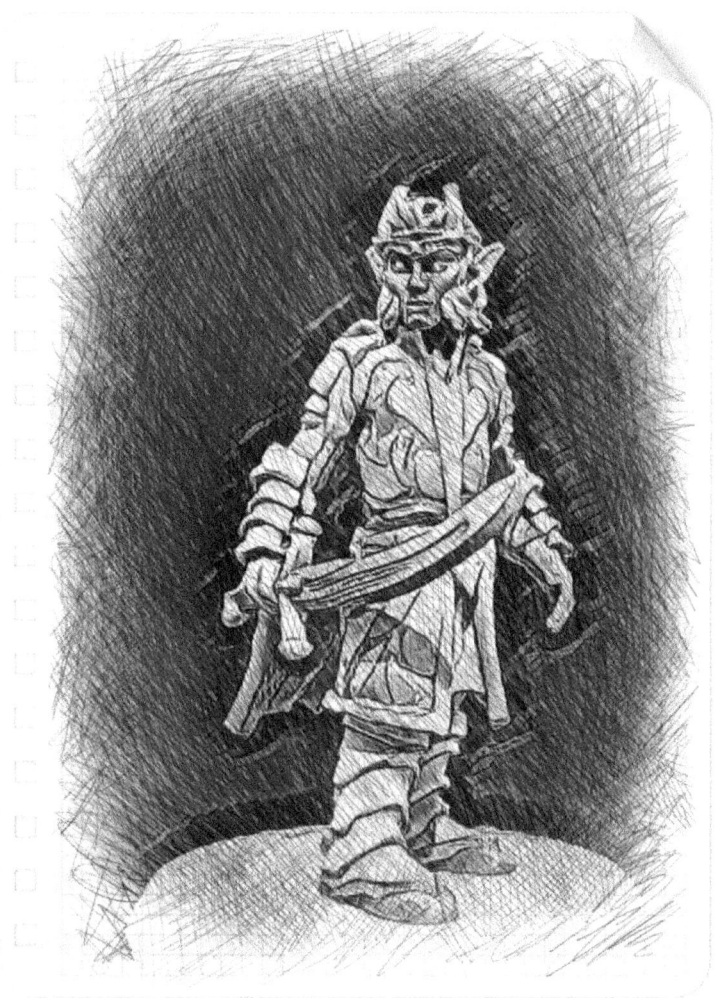

King Dalan Hazelhawk from the light elf kingdom Sunkith, and the ruler of the Sidhe Court.

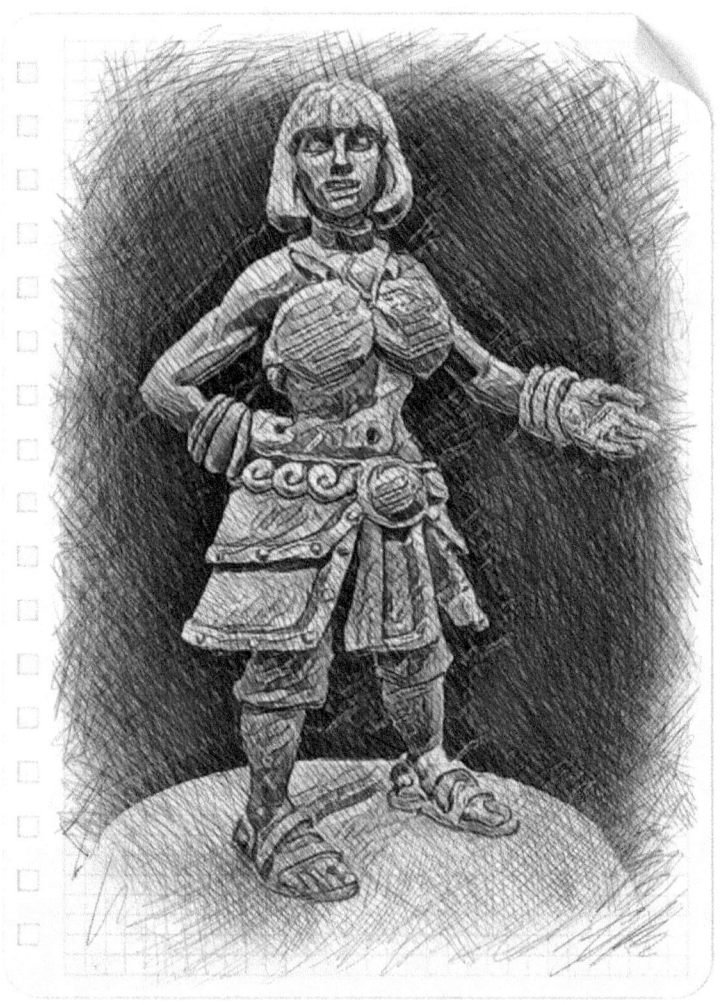

Matron Dalny Margalis, high priestess of the Qaddeshi.

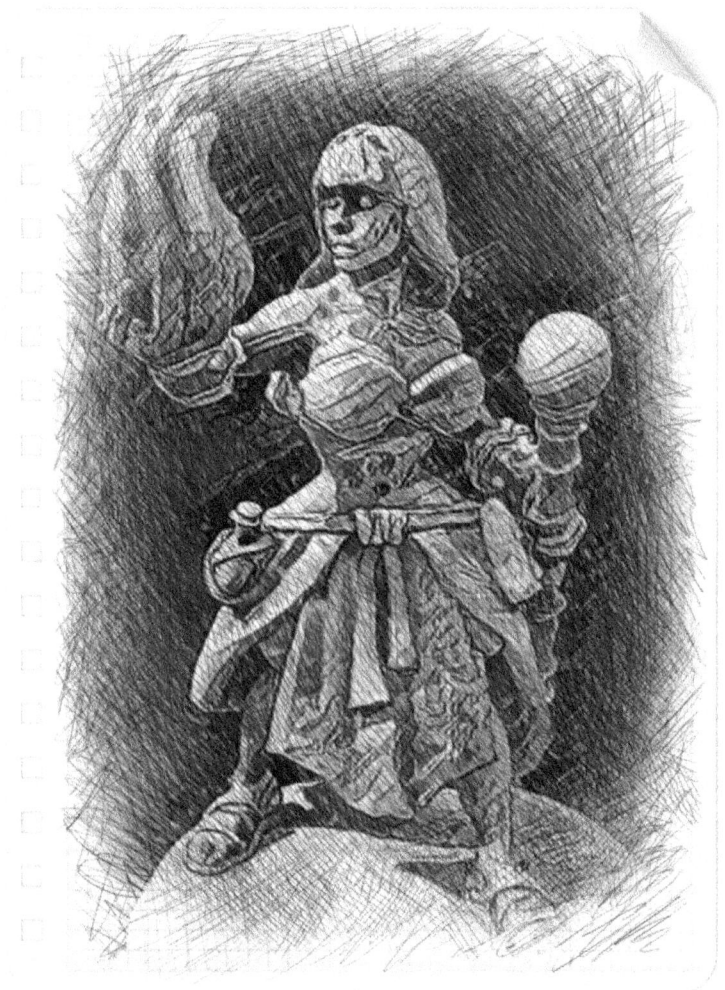

Darlia Villalobos from San Tainoqua, santera of La Sociedad Santo and a member of the Dust Men. Ship's mage of the Spellhammer.

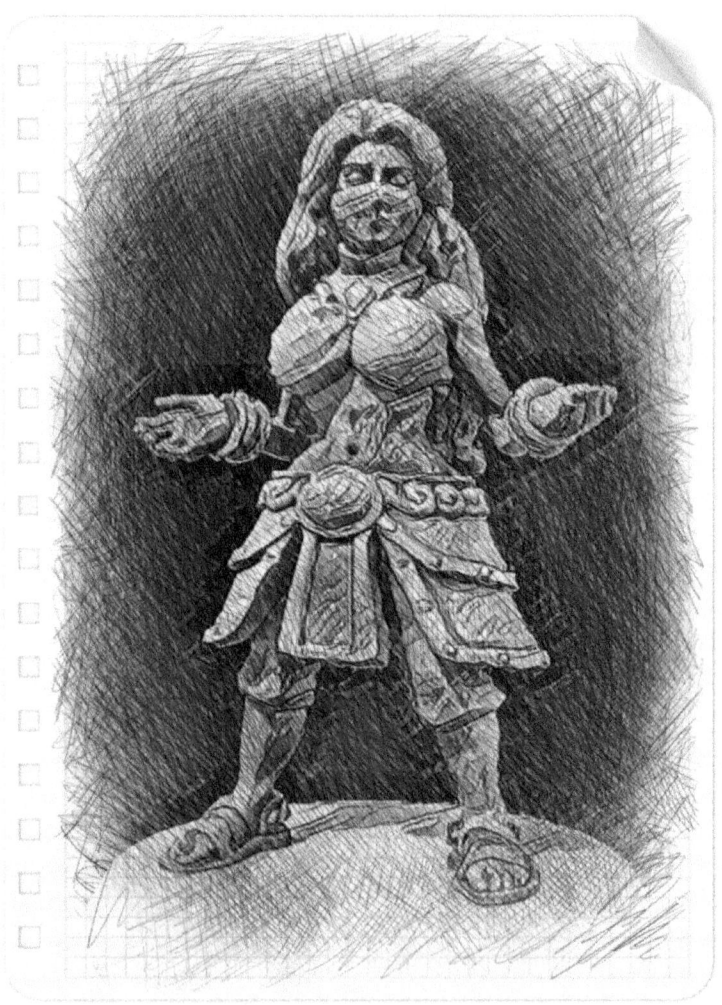

Mamba Dhamballa, half nymph/half incubus high priestess from Ishtaria, and the ruler of the Qaddeshi.

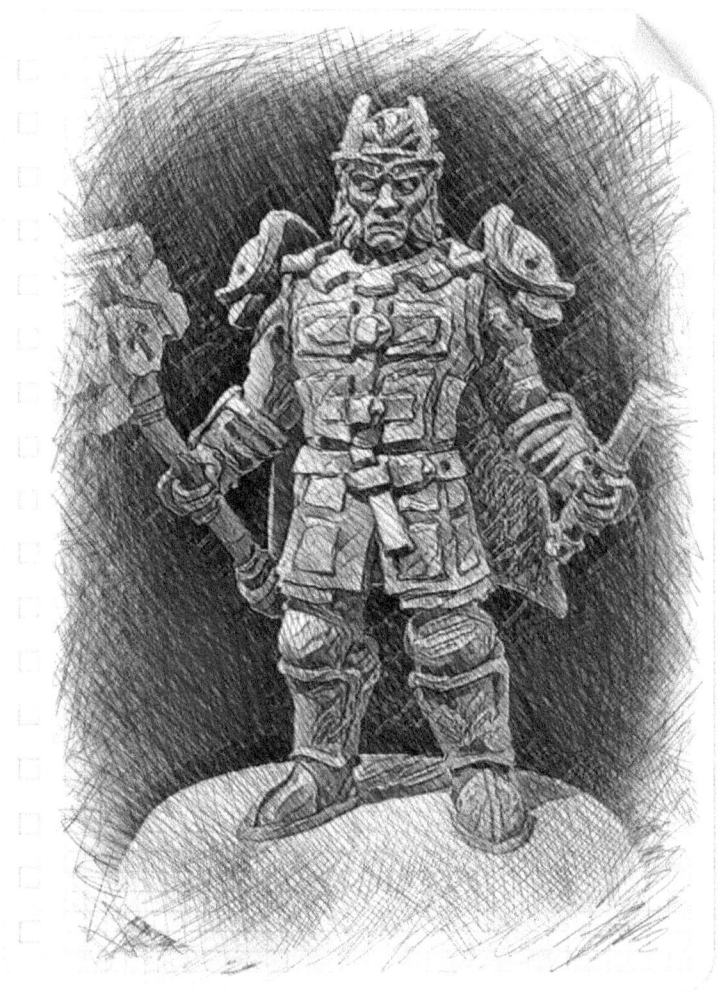

Tsar Dmitric Dragokov, ruler of Slavale and leader of the Iron Union bogatyrs.

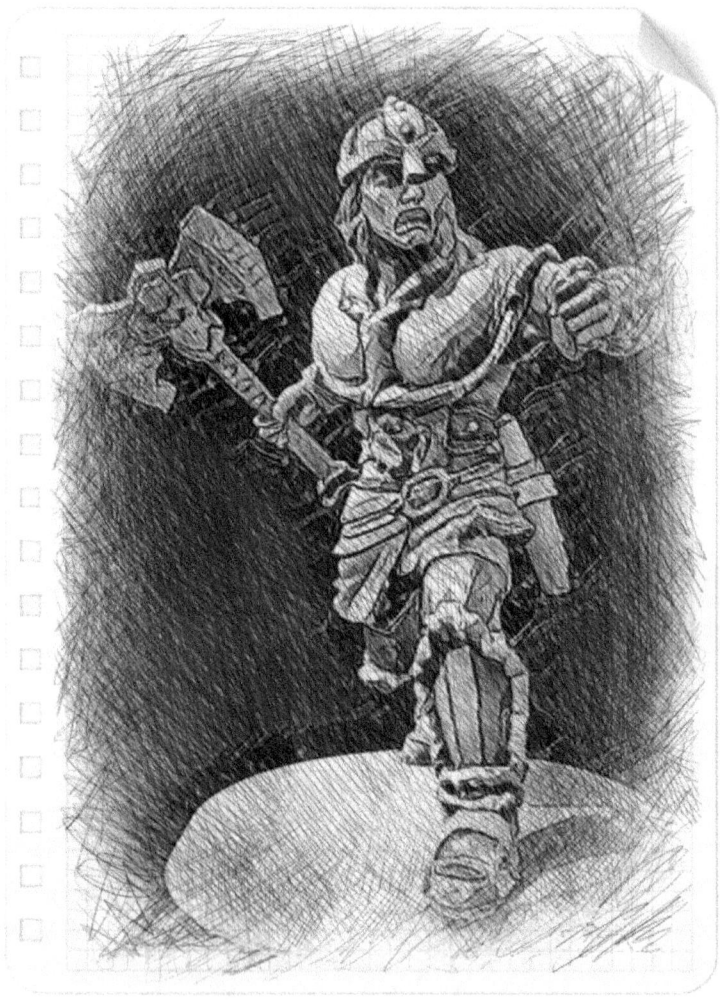

Donovan from Iron Icevale, member of the Dust Men and man-at-arms of the Spellhammer.

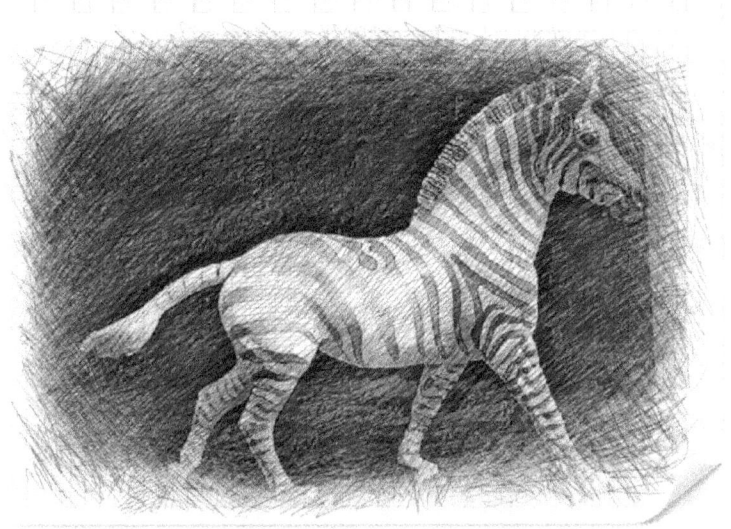

Dragoan, Haizium (dire zebra) war-mount of Crullak Bloodstone.

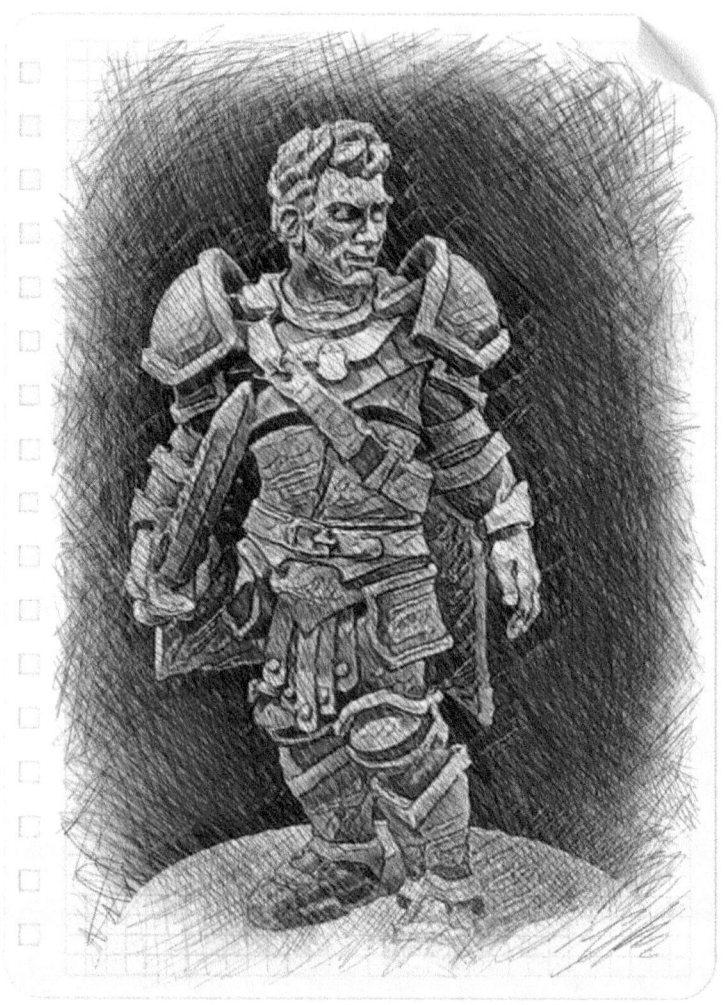

Prince Edzo Aethlvart Pendrake from Caerleon, and member of the Knights of Caerleon.

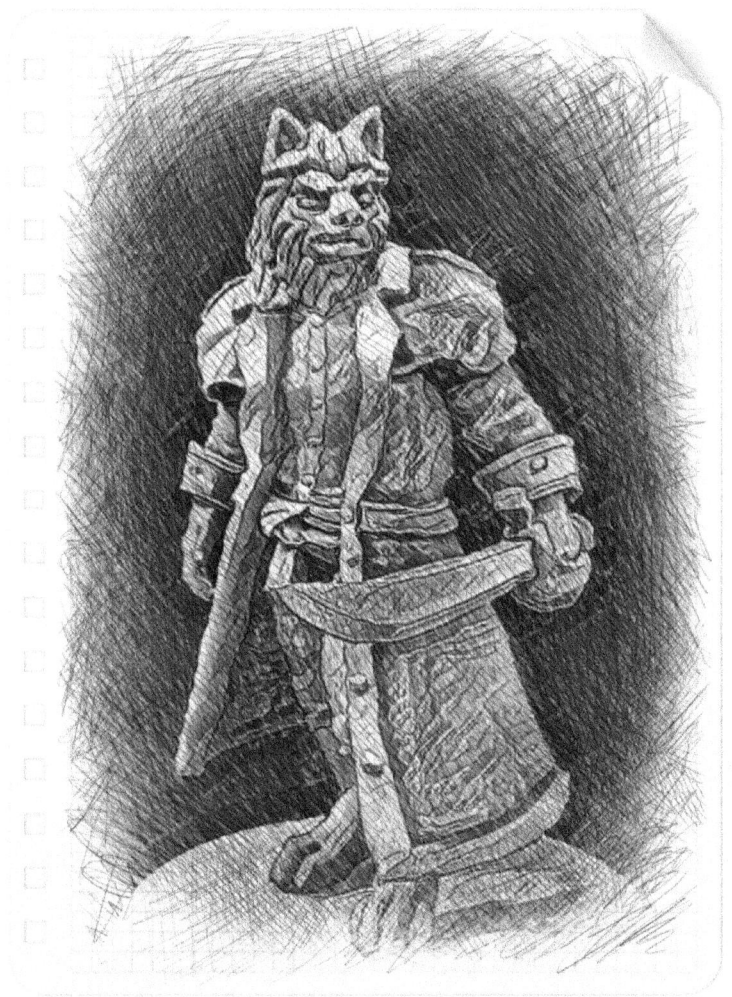

Elton the dog pooka and the captain of the Fordham.

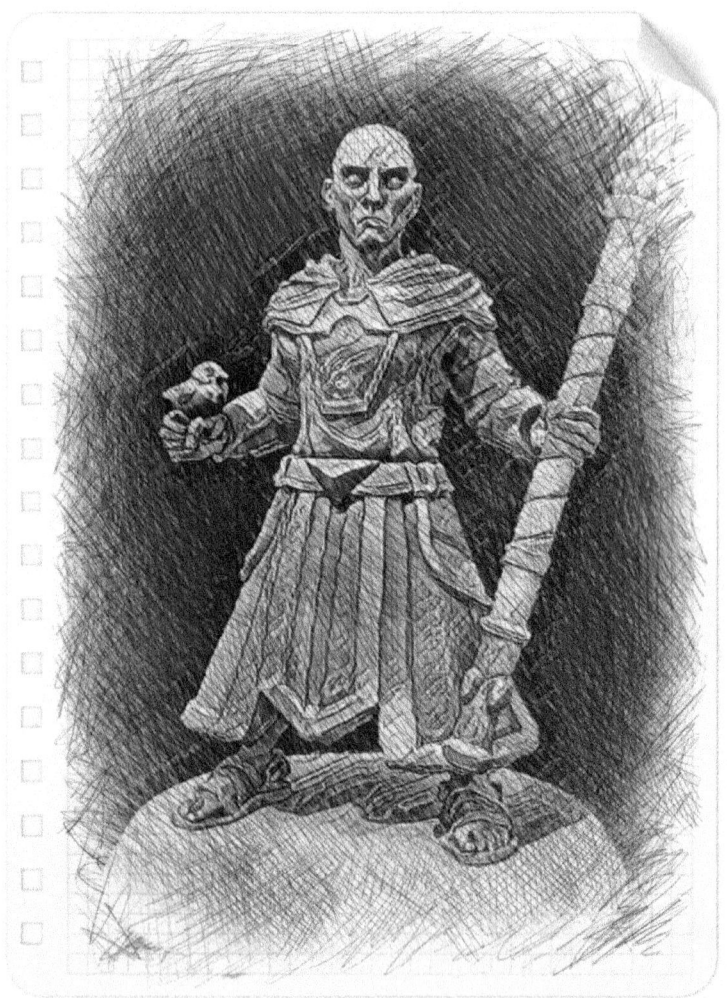

Emrys the seraphim and Arch Mage of the Grand Lodge of the Arcanum.

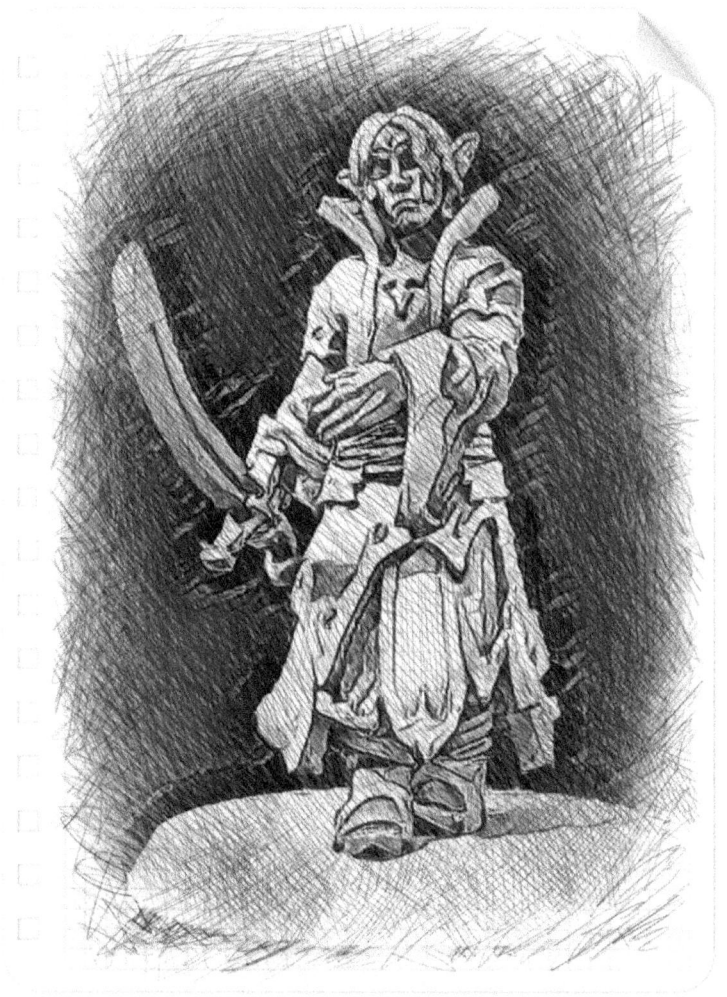

Prince Enovore Blackfell from the dark elf kingdom of Moonkith, of the Unsidhe Court.

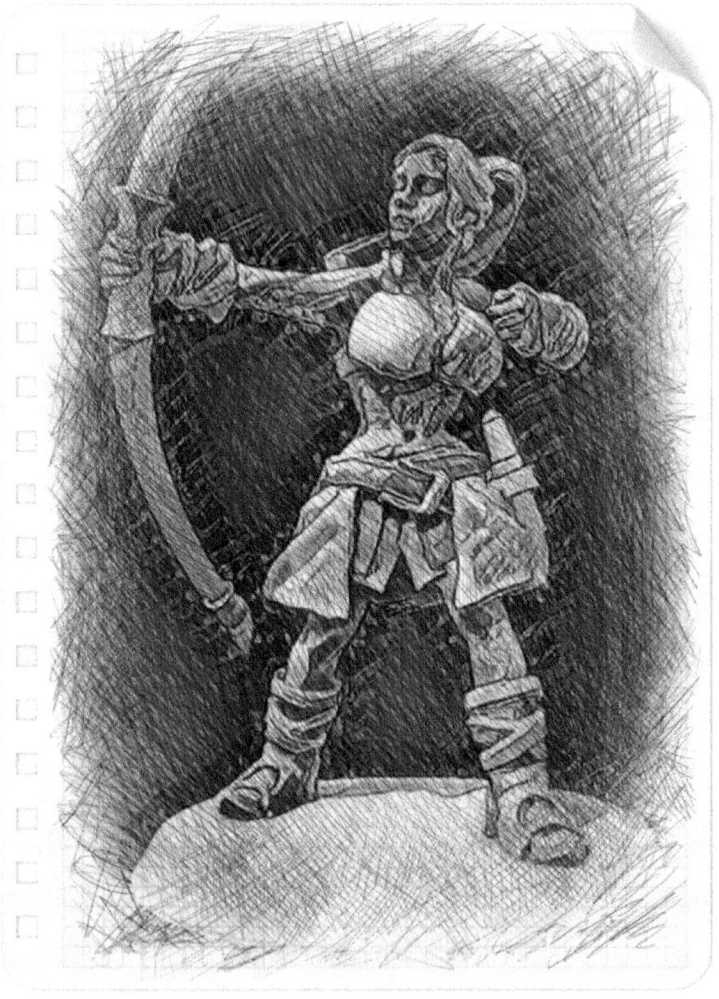

Fatima from Ishtaria, archer and member of the Dust Men. Formerly of the Dervish.

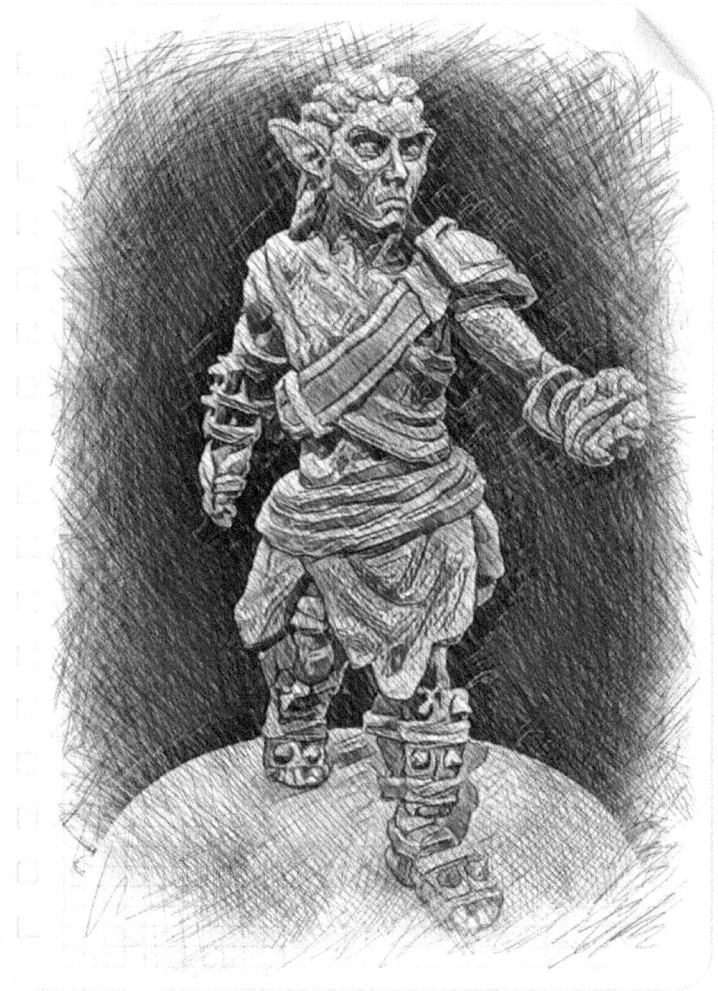

Fennec of the Nine Tails.

**Fox nagloper in jungle elf (wakyambi) guise.*

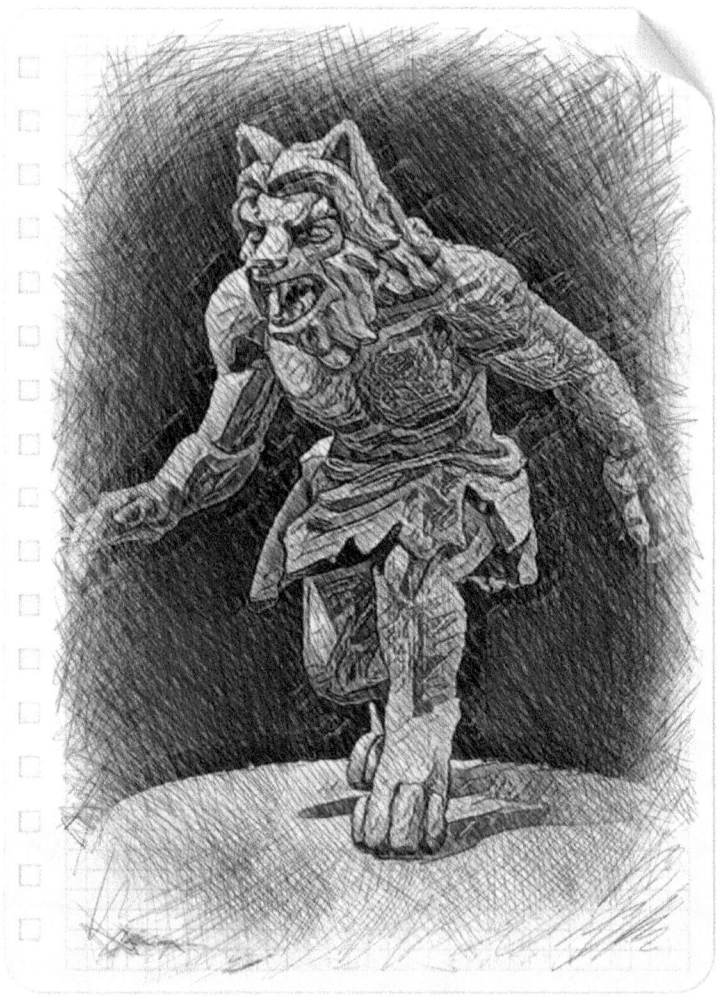

Fenris from Caern Fjord, were-wolf Alpha of the Ghet of Shuck.

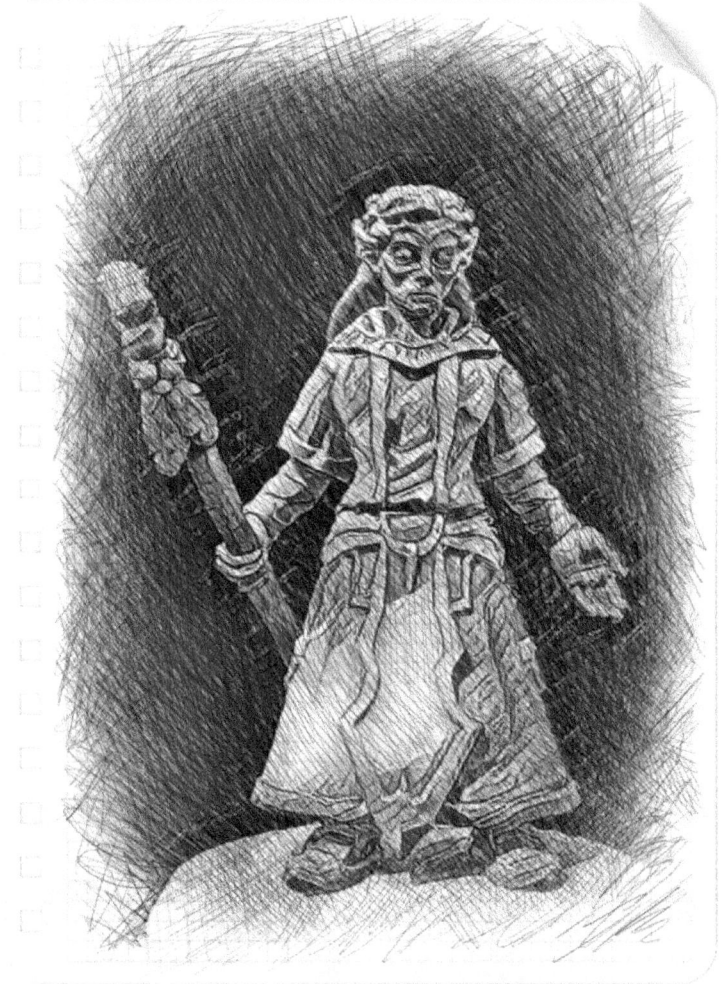

Fianna from the wood elf kingdom of Sylvankith, druid of Tir Greene and Hierophant of the Parliament.

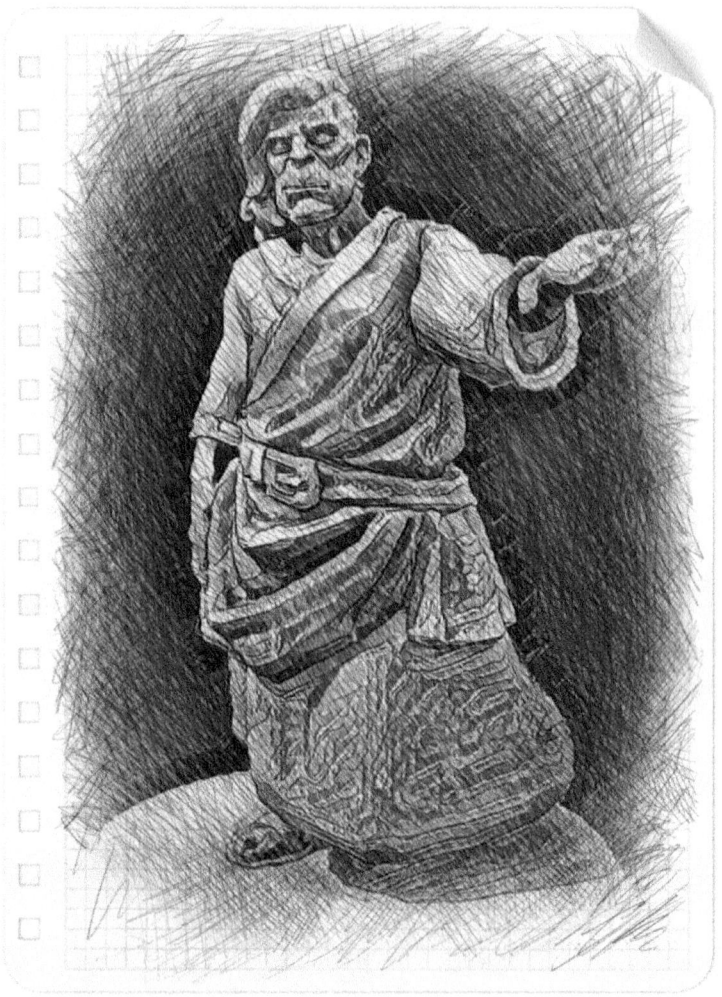

Flavius Barca from Romopolis, praeconsul of the Nova Sparta Imperium Senate.

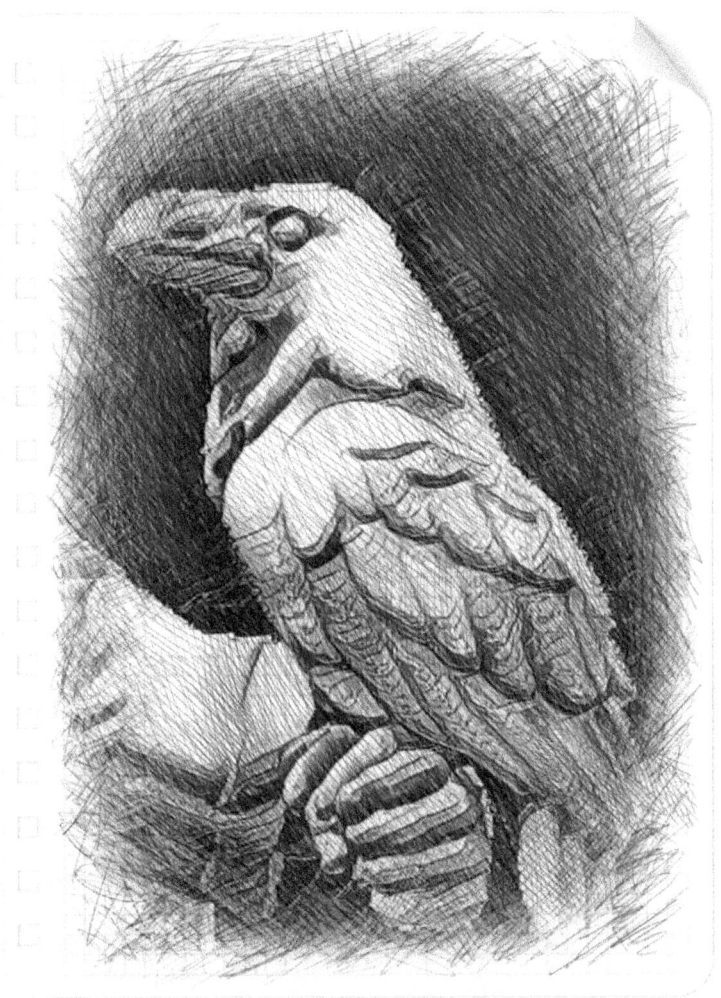

Fritz, raven familiar of Omar al Ptah.

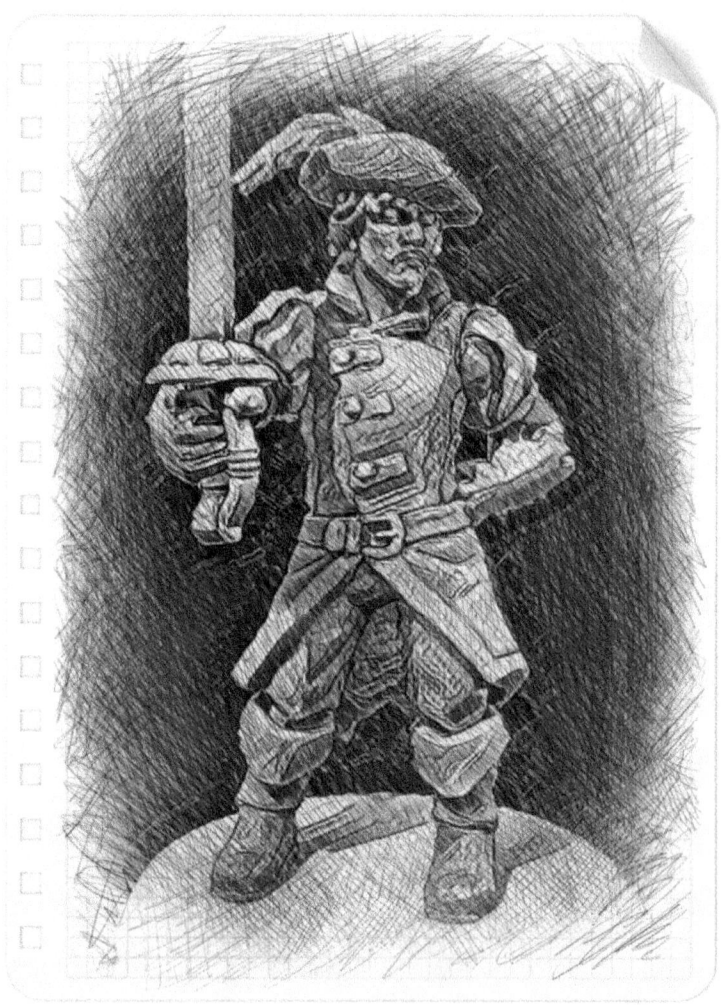

King Gaston Luc Girard ruler of Gualvale, and leader of the Sabreteers of the Guard.

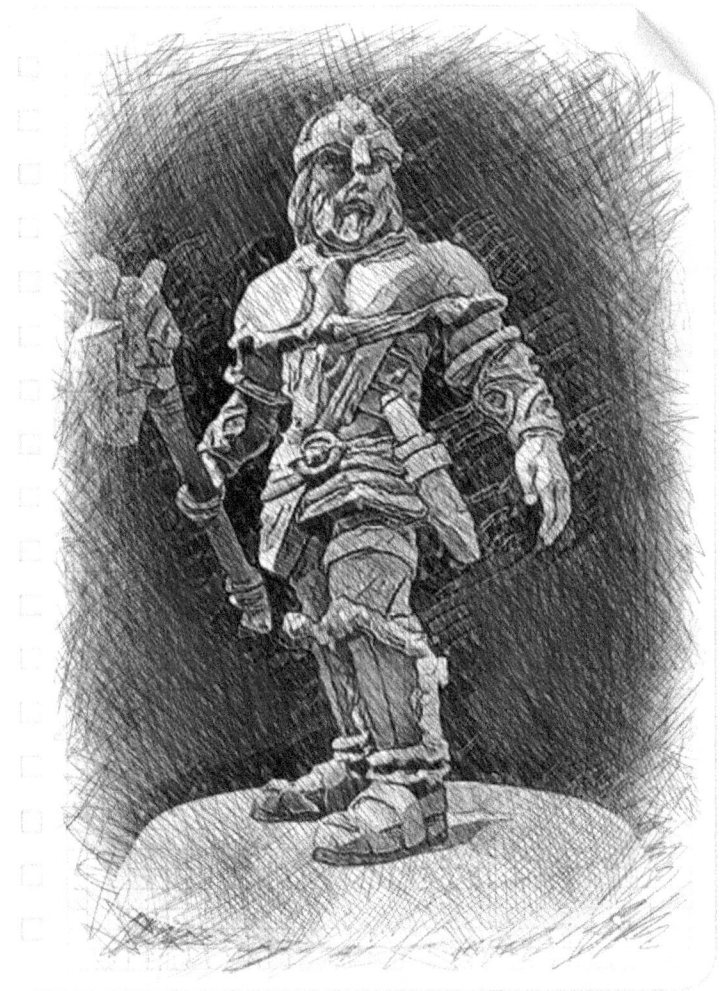

Gregor from Iron Icevale, member of the Dust Men and first mate of the Spellhammer.

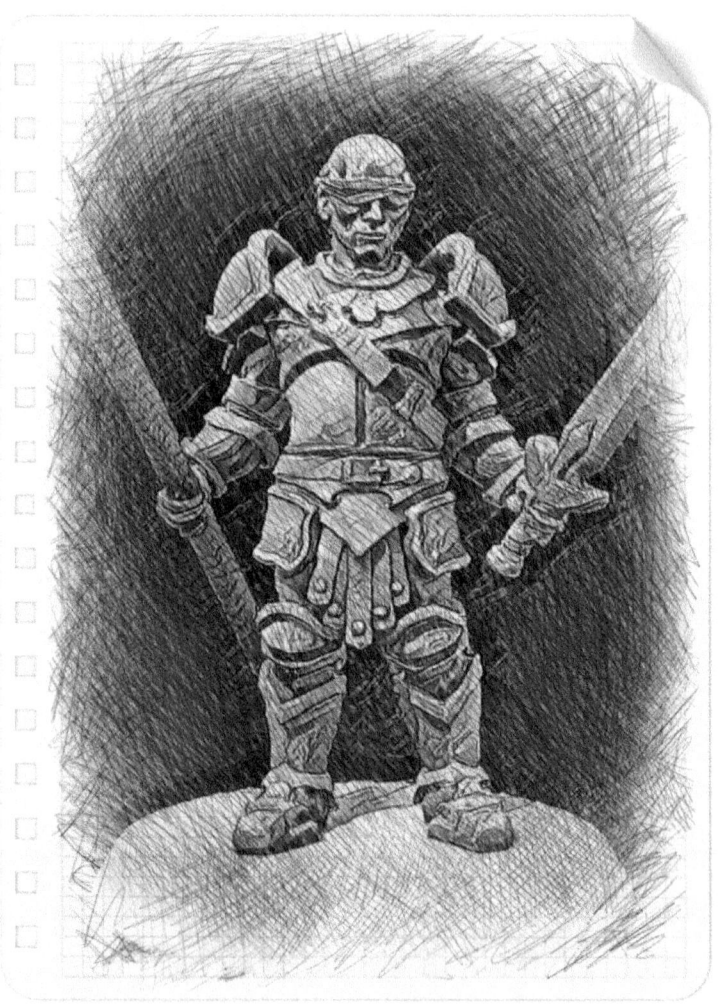

Sir Griffin McKaye from Caerleon, and member of the Knights of Caerleon.

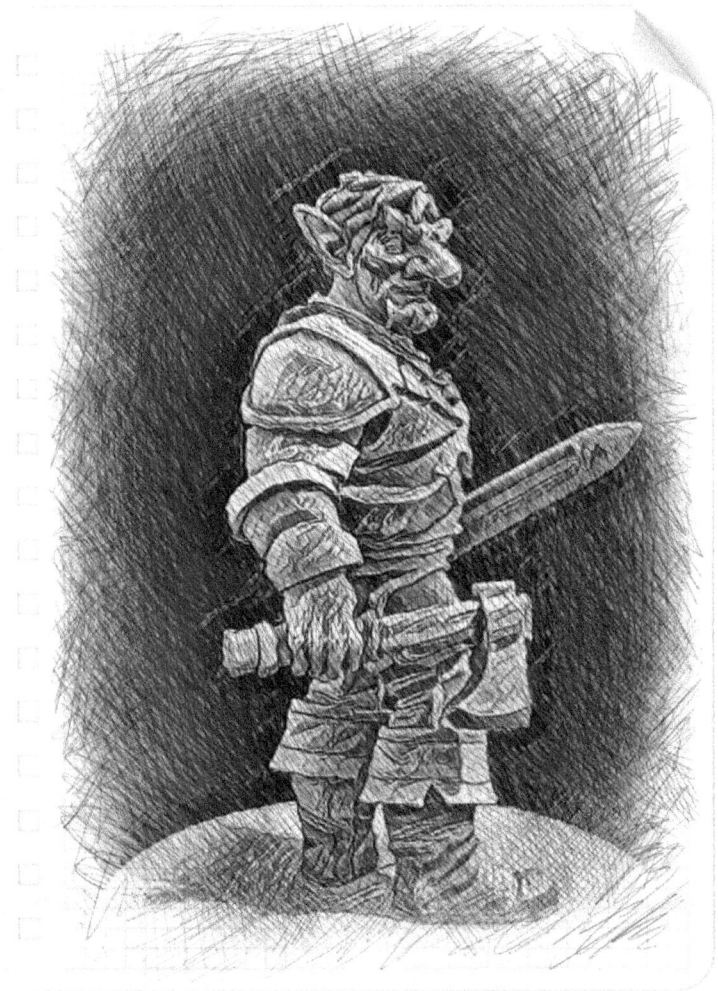

Grimlocke (Grim), metis and member of the Eventide kumpani.

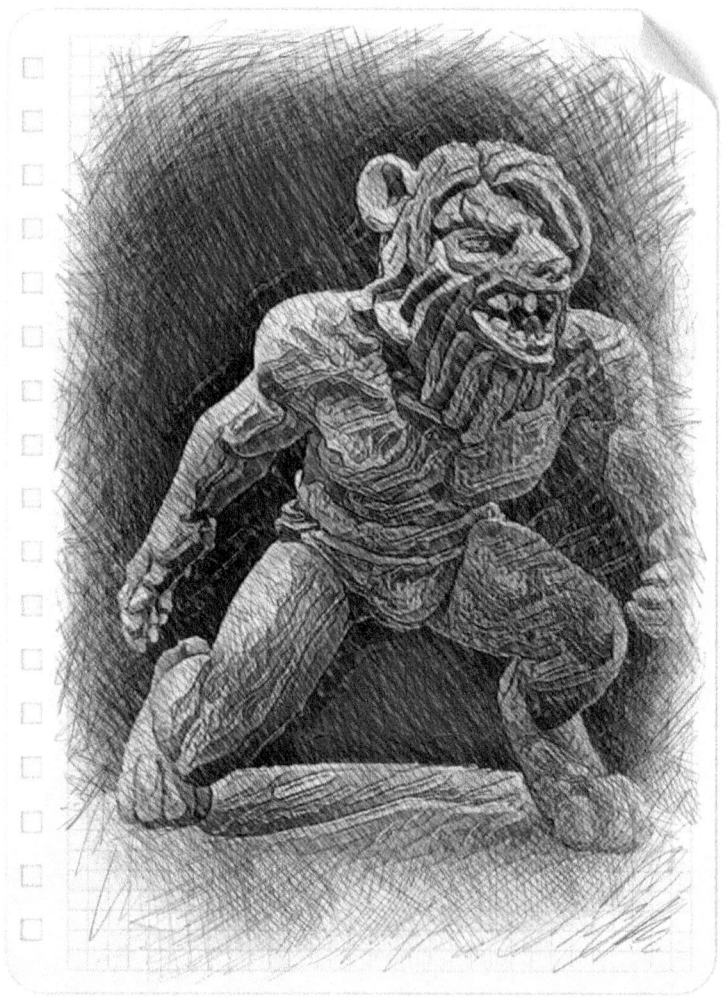

Gulo from Caern Fjord, were-wolverine and Beta of the Ghet of Shuck.

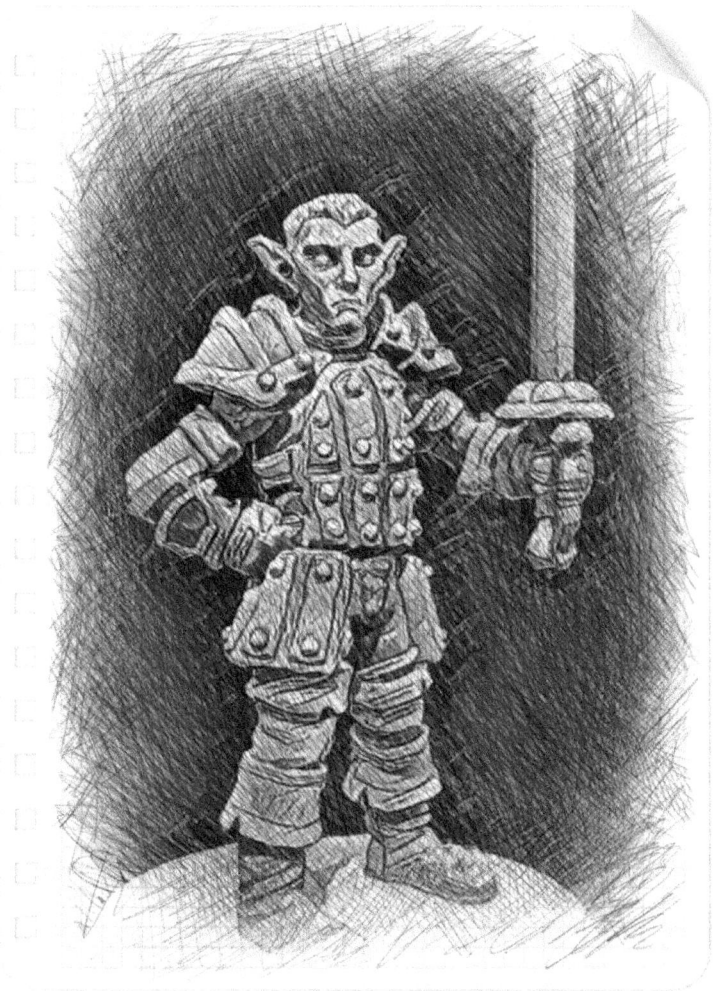

Ivon, "metis" and baro of the Eventide kumpani.

**Half light elf/half dark elf.*

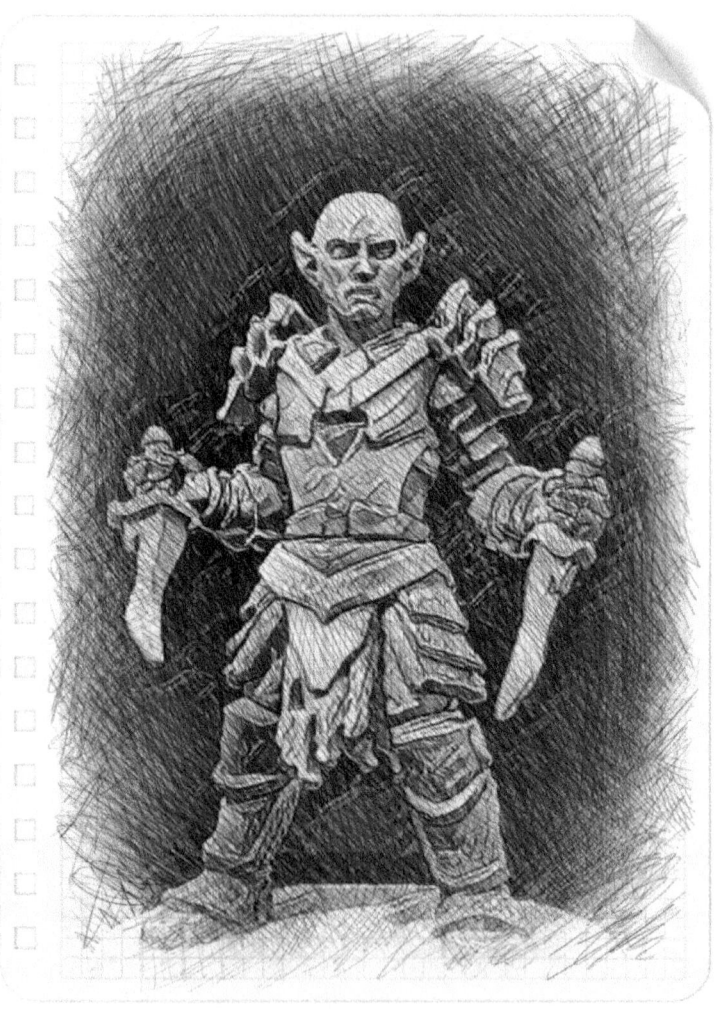

Janus from the changeling kingdom of Rancorvale, assassin and the guildmaster of the Gloam.

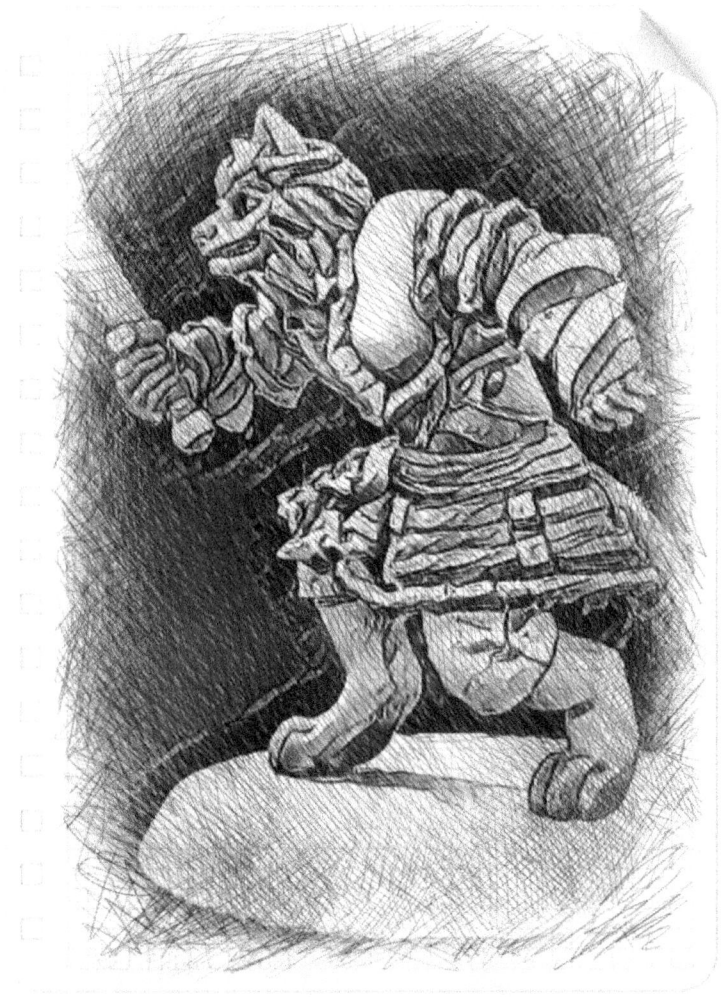

Jokerjaw, gnoll runt and member of the Dust Men.

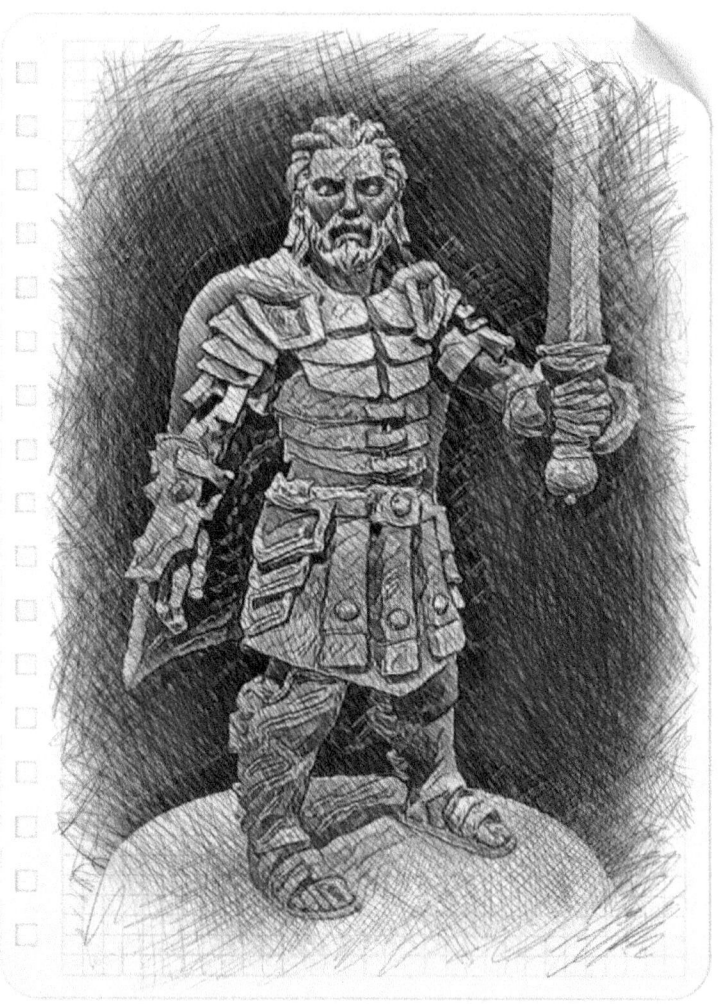

Jovius Servilus from Romopolis, and general of the Praetorian Guard centurians.

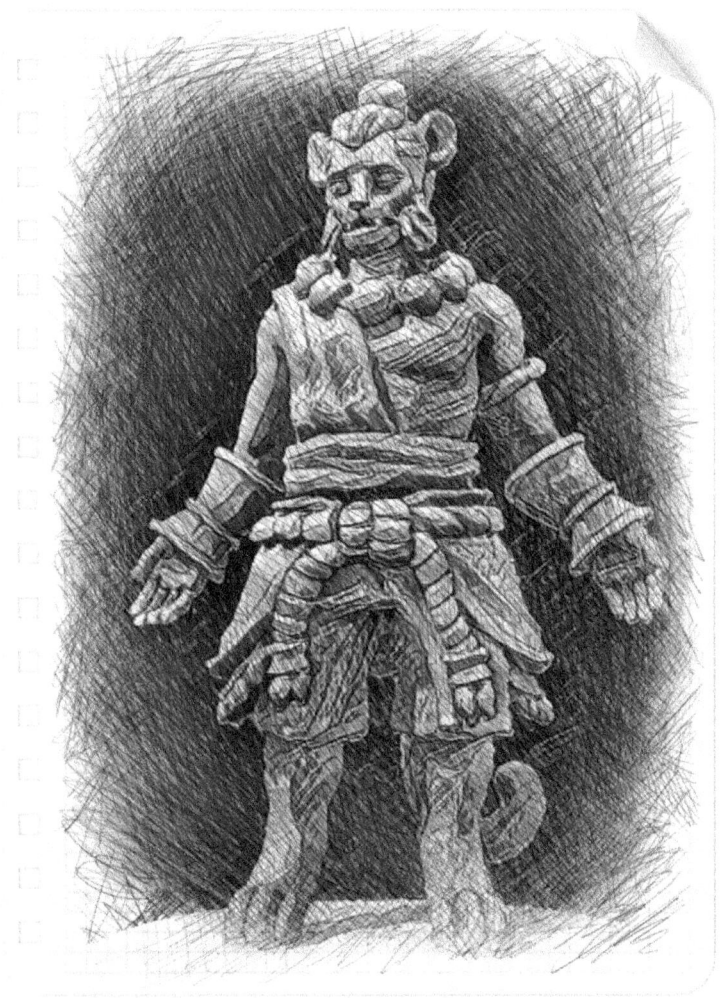

Kahno from the Motuo Briar. Maltese tiger hengeyokai monk and the Beta of the Eastern Protectorate.

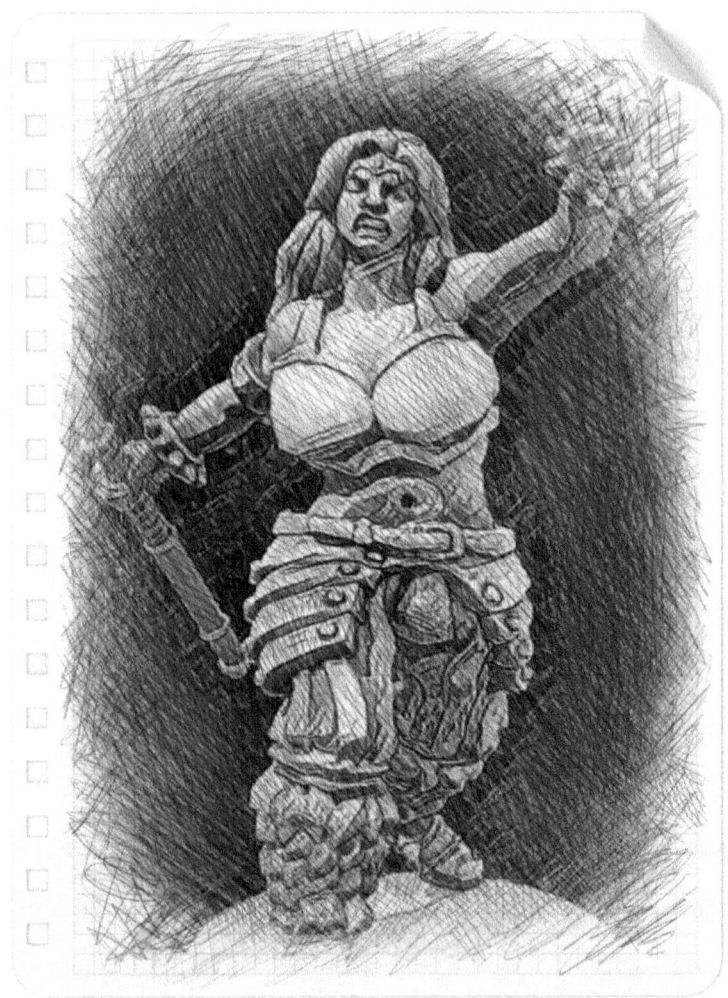

Kassinovia from Grecopolis, bacchae mercenary.

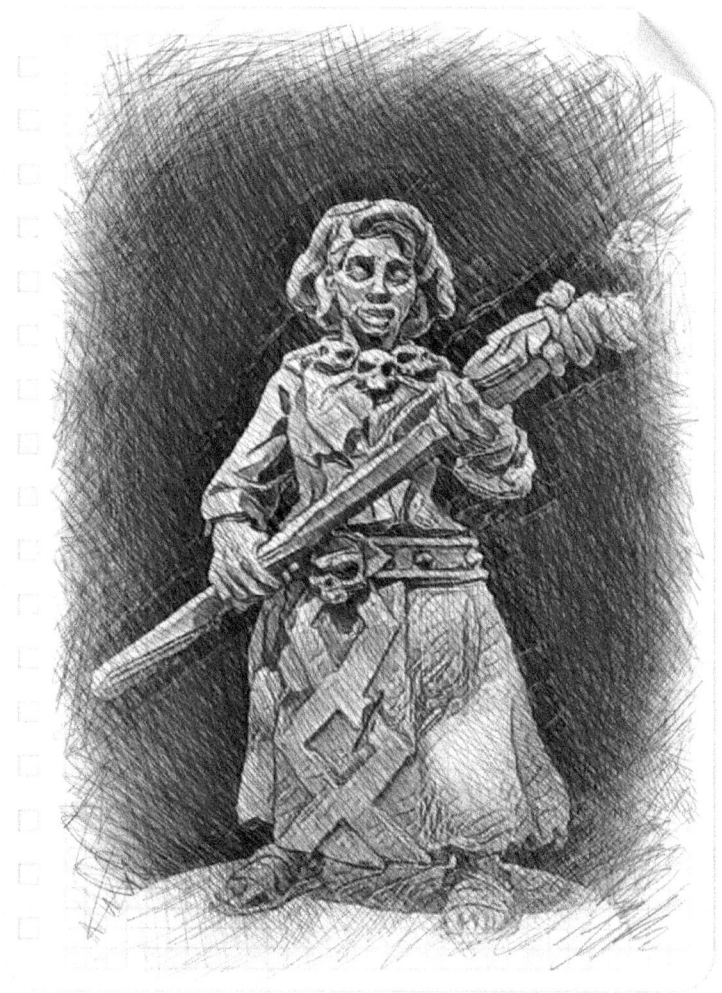

Auntie Kira from Port-au-Samedi, and member of the Krew du Vodun.

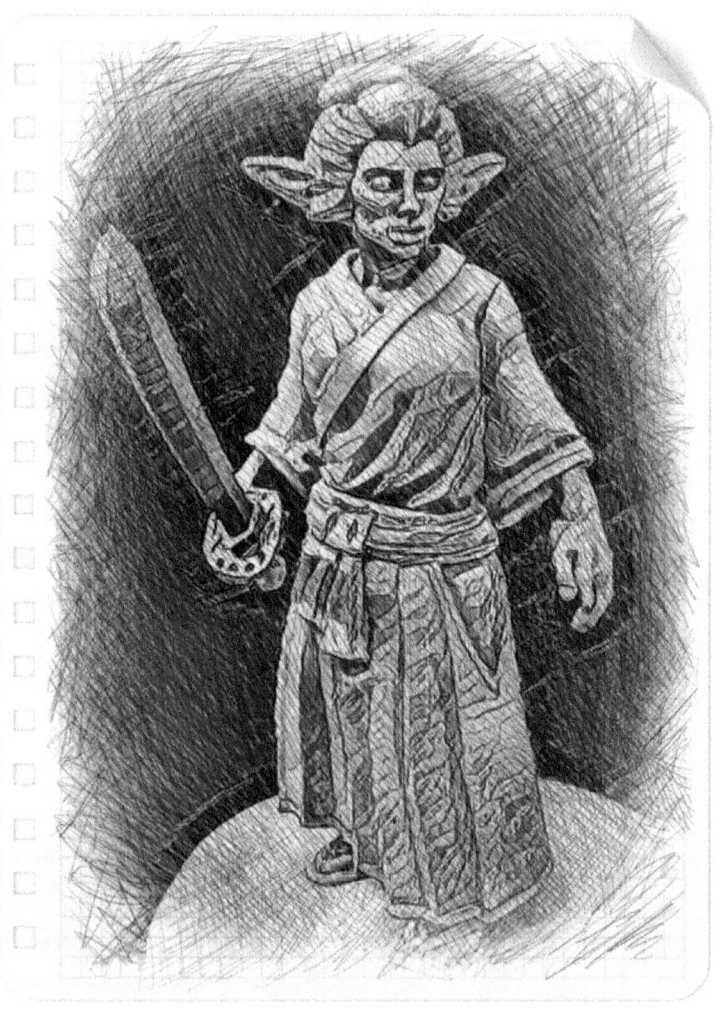

Kitsune, leader of the Nine Tails and Alpha of the Eastern Protectorate.

**Fox hengeyokai in lotus elf (Hsien) guise.*

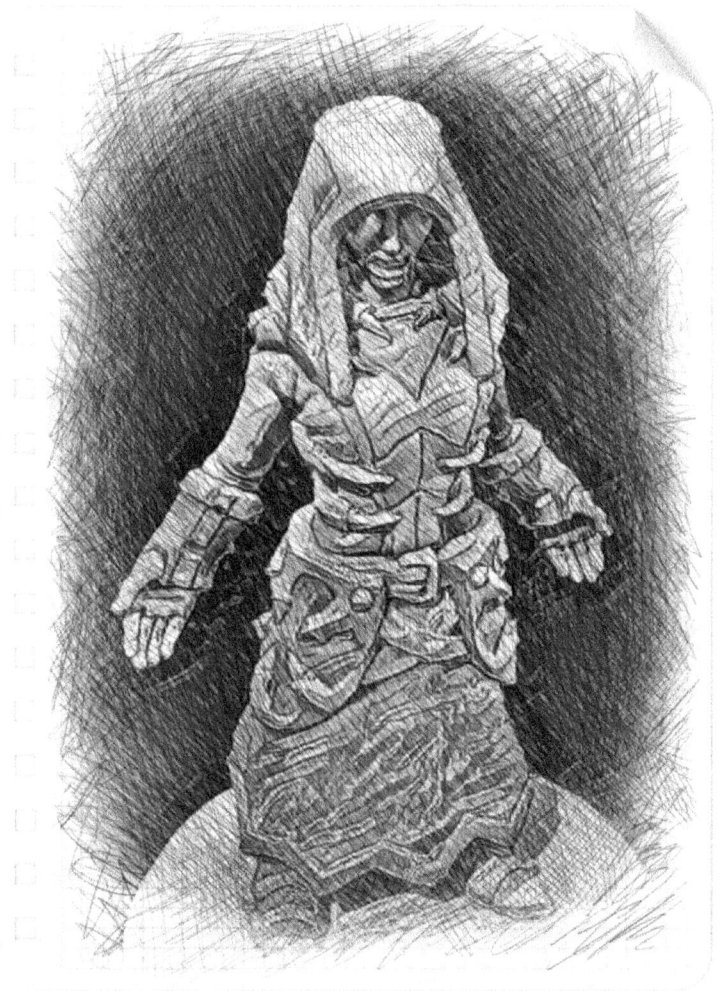

Klaia, oreiad leader of Cul Grey and member of the Hellmongers.

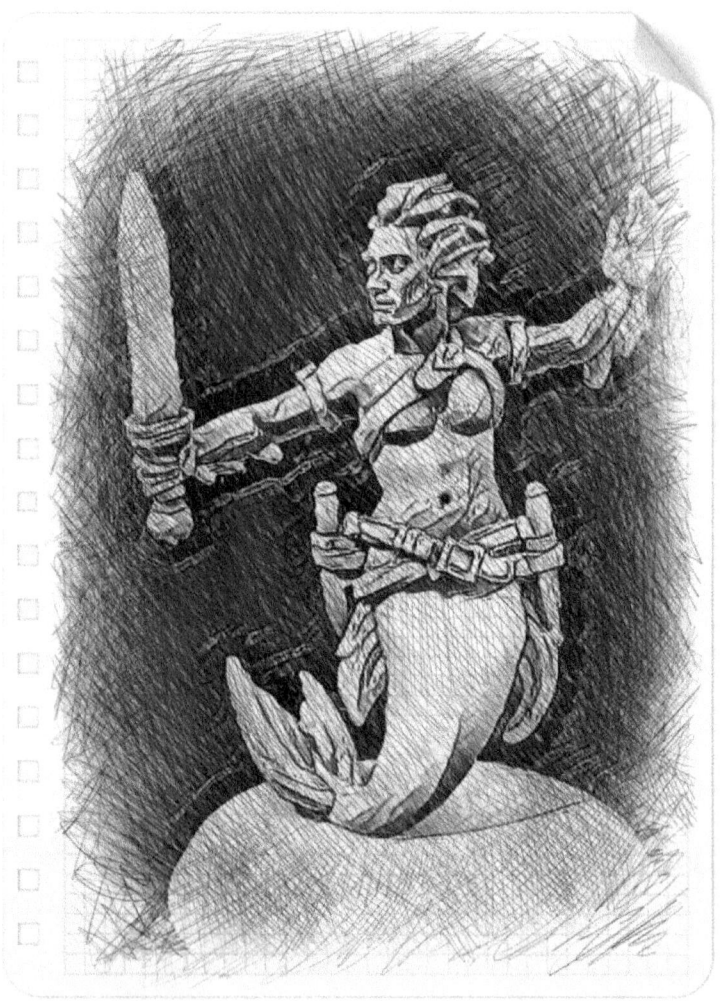

Kray from Jalakan the Realm of Water. Triton and member of the Dust Men.

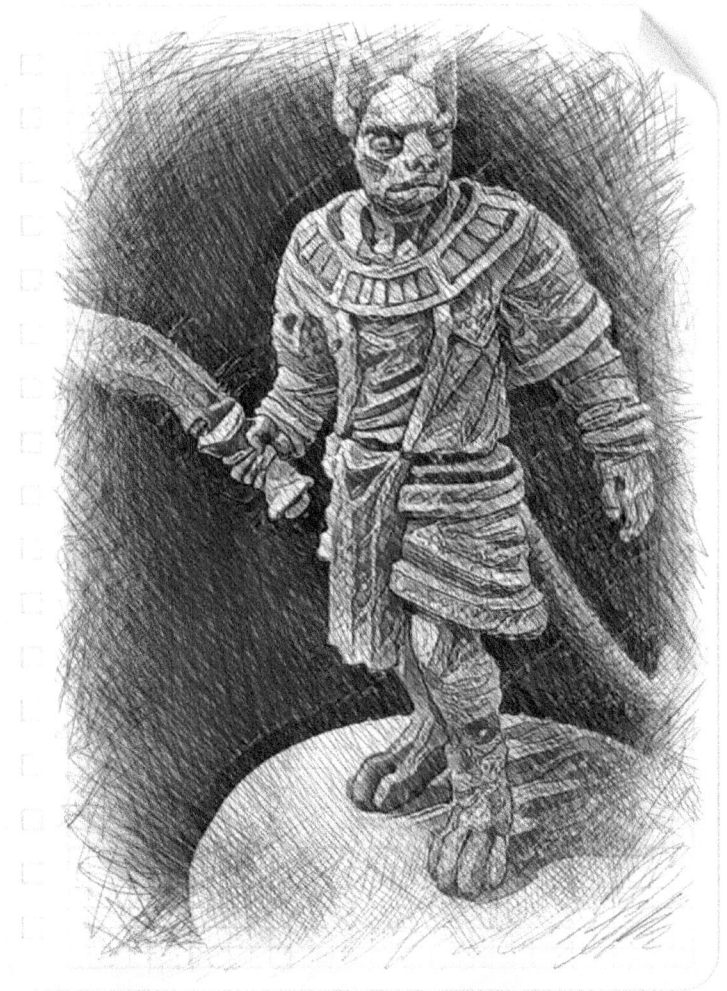

Crinos Mouro from Heliopolis, were-jackal and the captain of the Mulhorand.

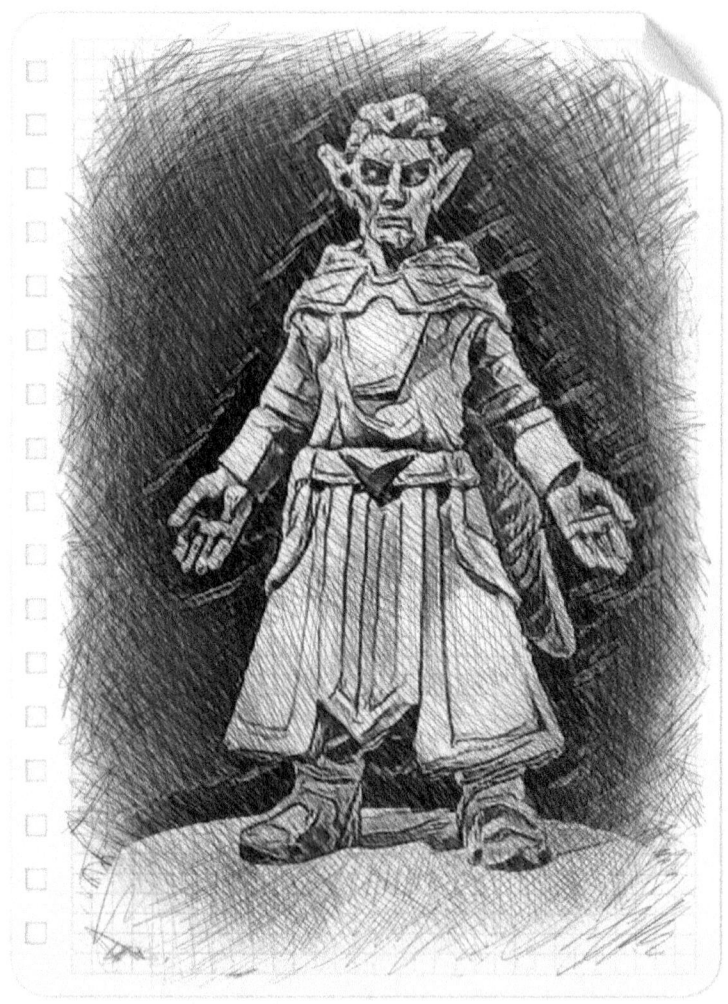

Master Crylon, half elf member of the Acolytes of Loa-Ra.

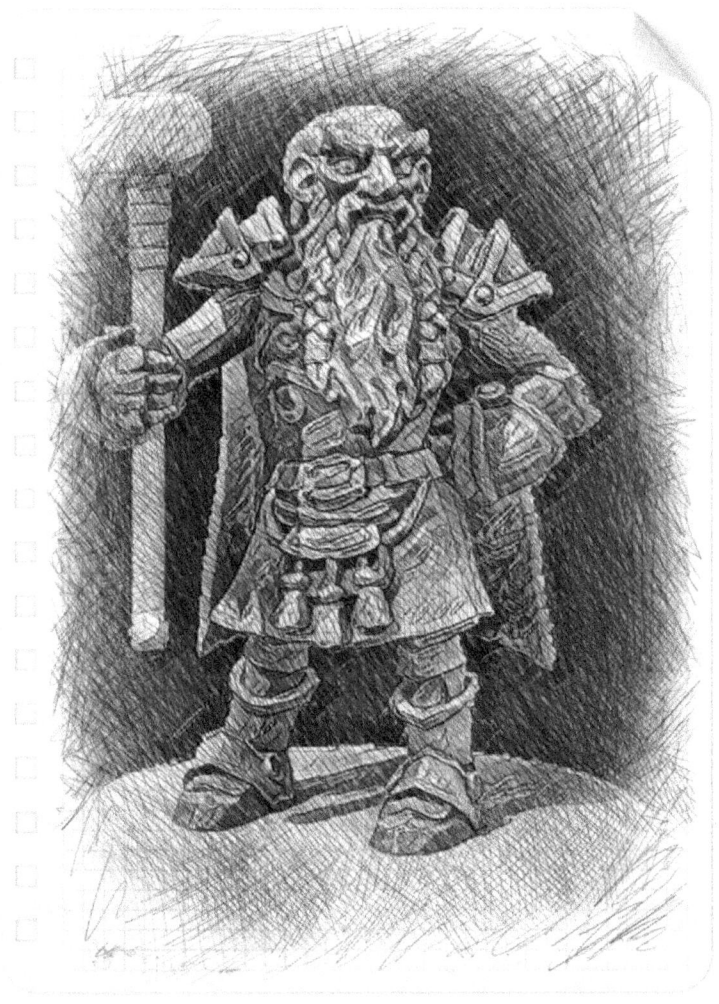

Lennox Buscuitsmith from the dwarven kingdom of Stonehold, and the Lord Rector of the Stonehold Academy.

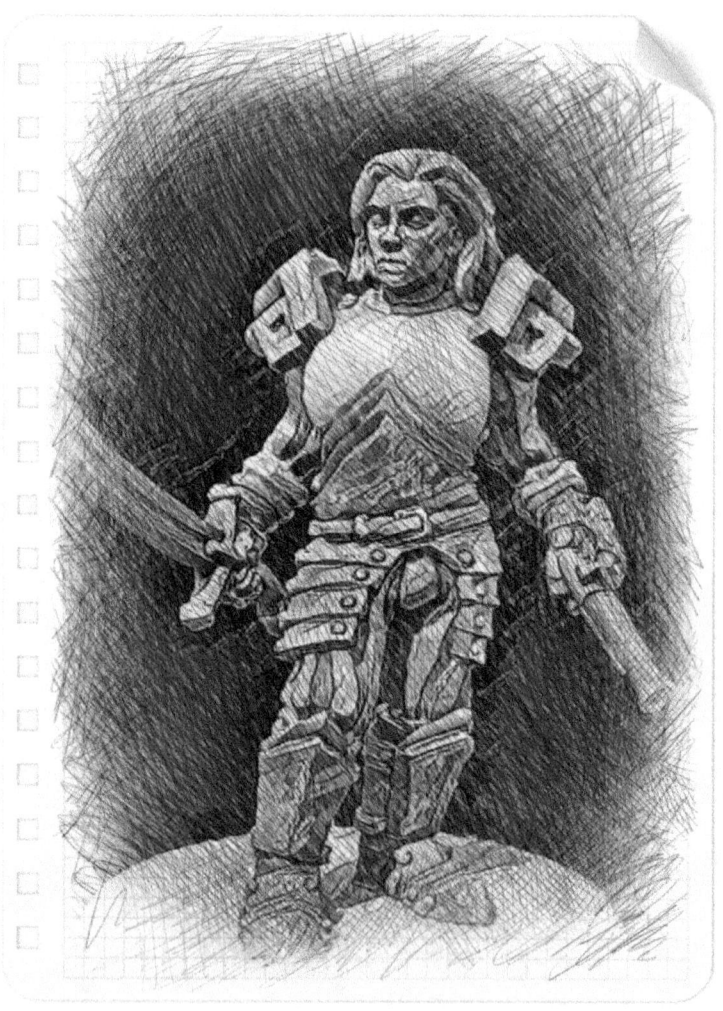

Doña Liza Diamónenz from Gran Caparra, and member of the Compania el Couatl conquistadors.

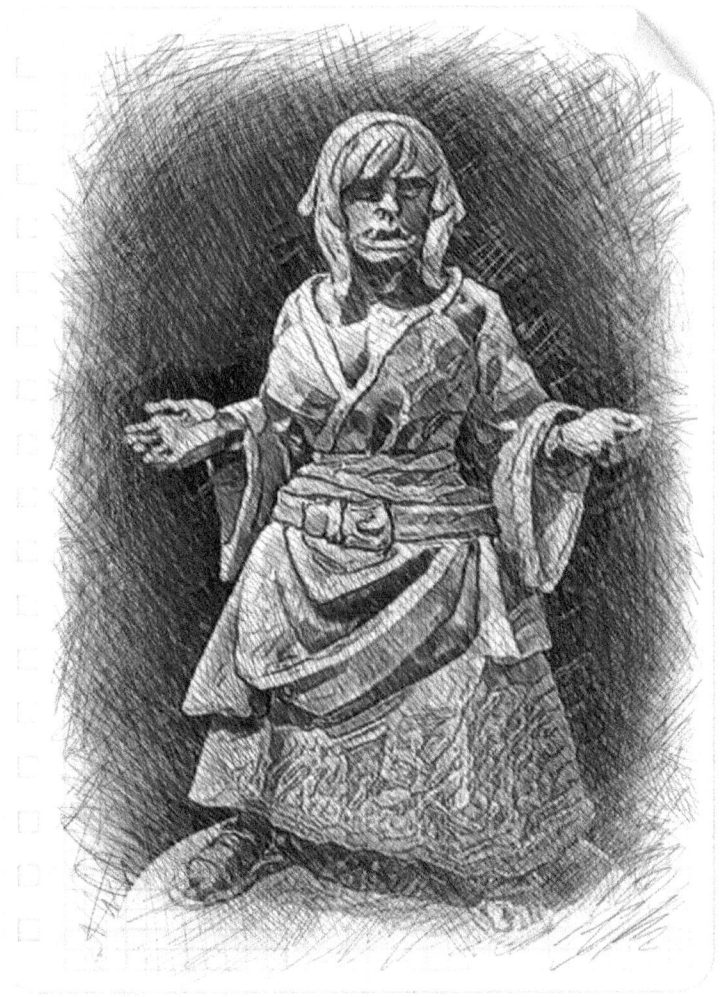

Lorin from Hellsport, half-orc seer.

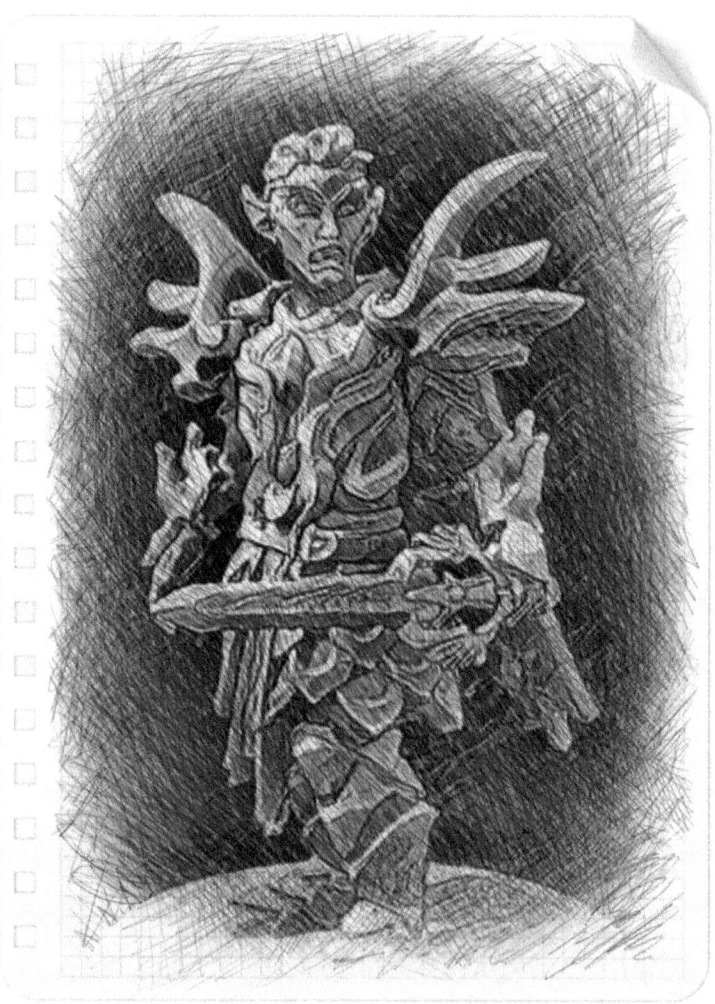

Sir Lucas Ventru from Caerleon, vampire member of the Hellmongers and captain of the Venger.

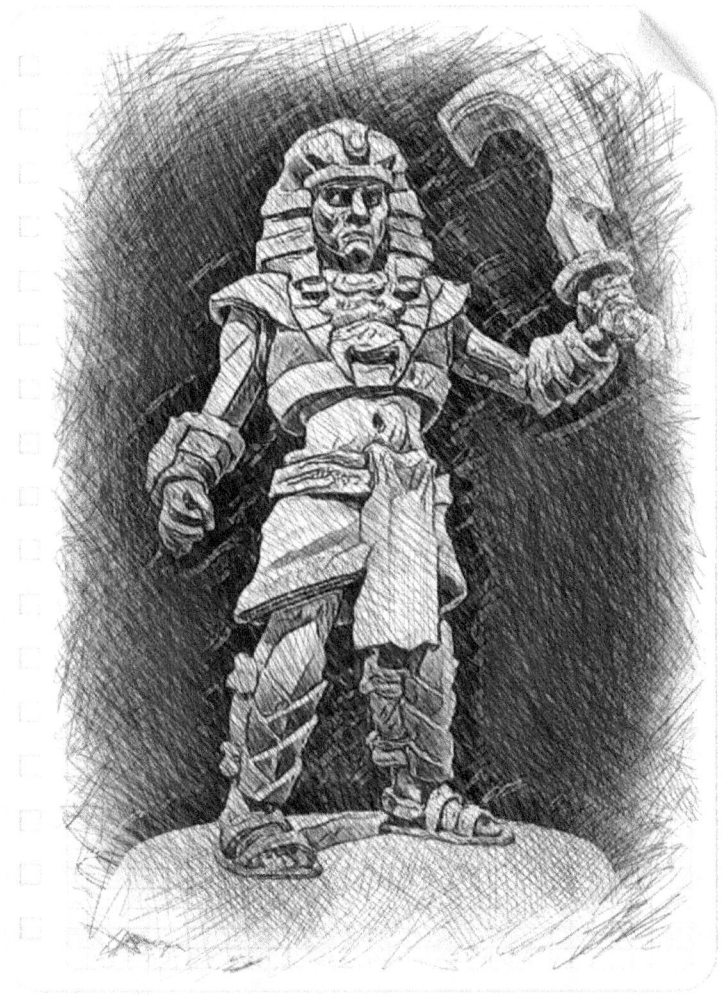

General Luctama el Thoth from Heliopolis, and leader of the Avengers of the Pharoah's Fist.

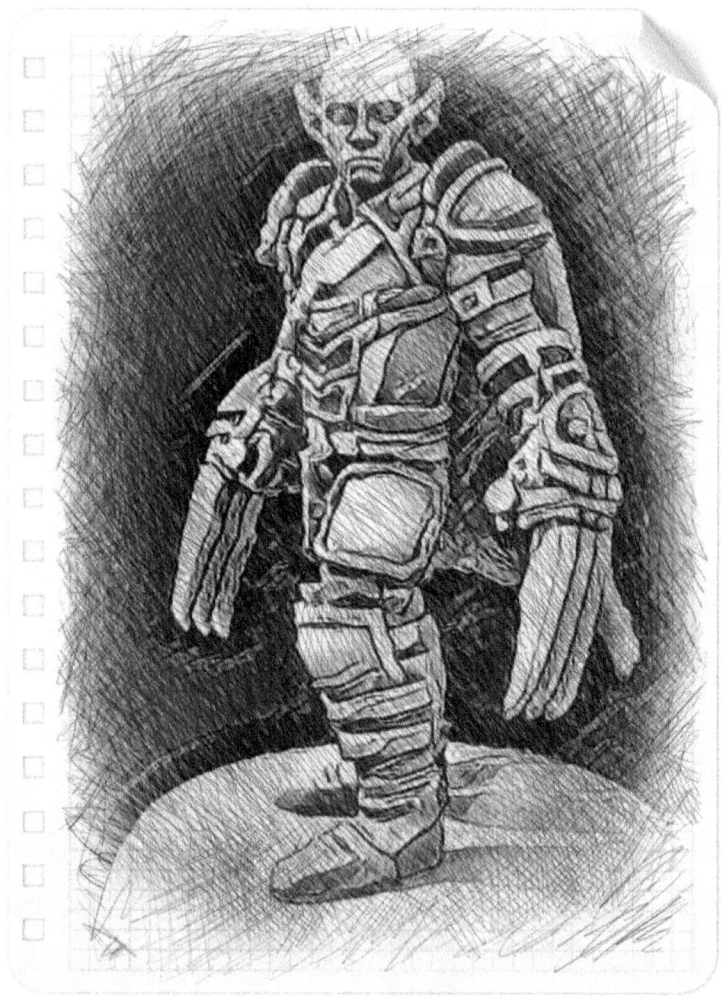

Madcrave from the changeling kingdom of Rancorvale and assassin of the Gloam.

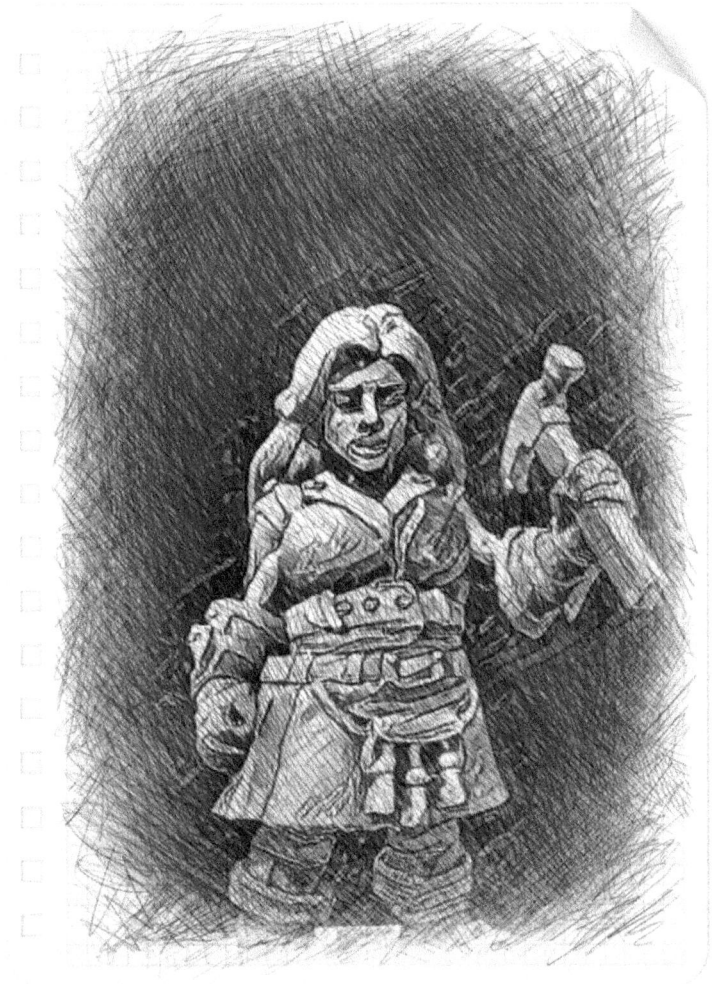

Magda from the dwarven kingdom of Stonehold, member of the Dust Men, and chief engineer of the Spellhammer.

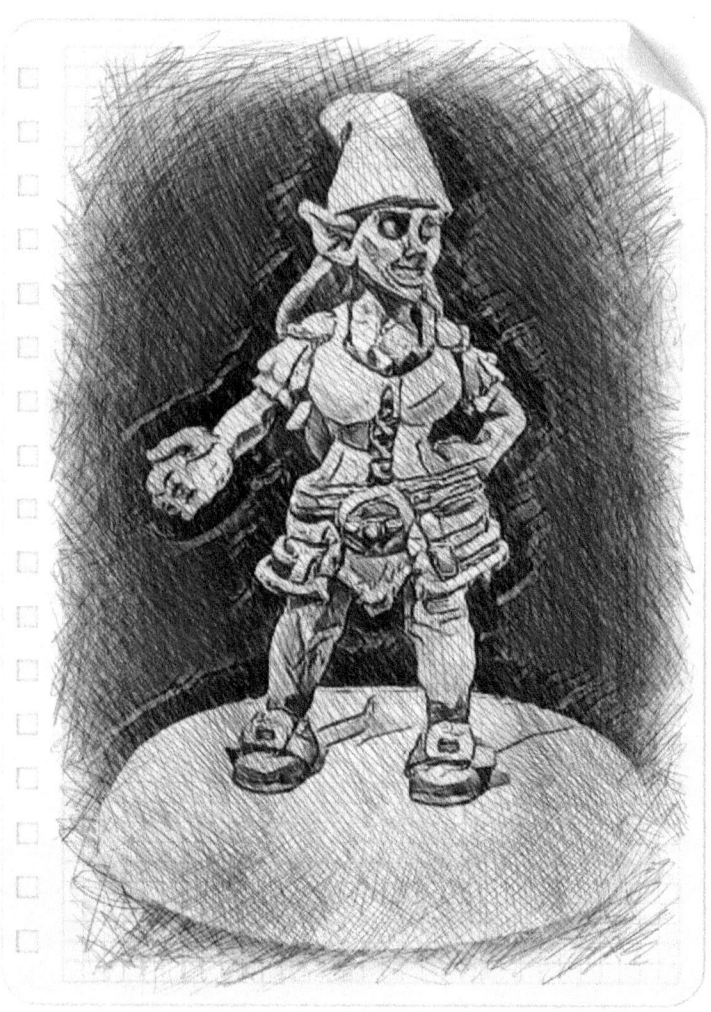

Marlabelle Foxfingers from the gnome kingdom of Tinkerhearth, and Technomancer.

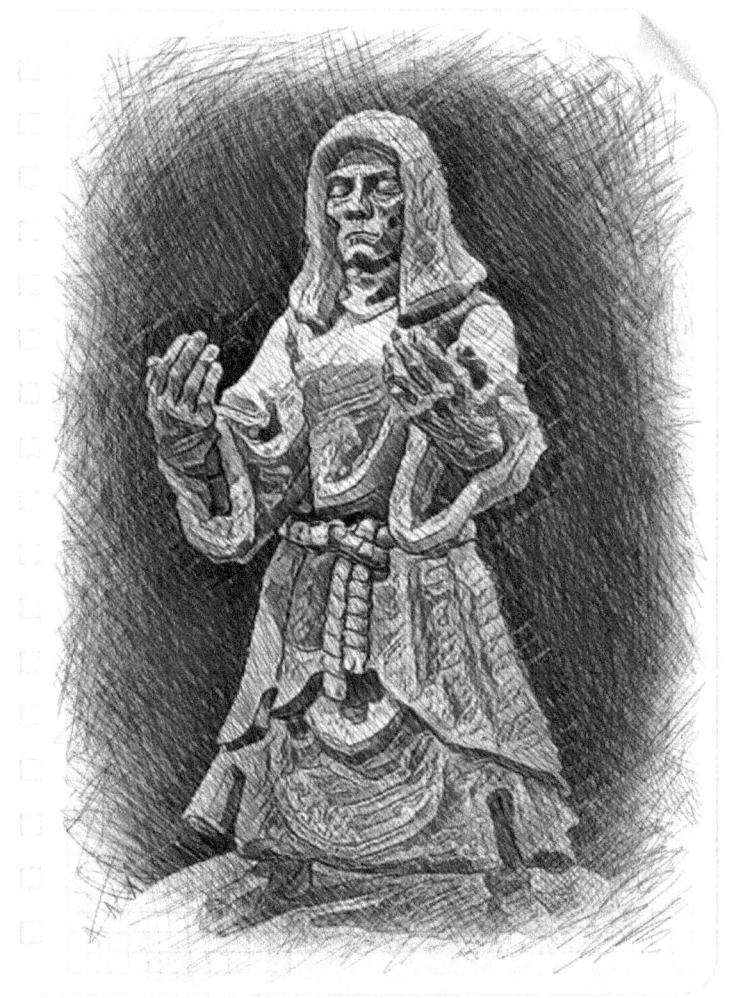

Marsebon the Progenitor of the vampire race.

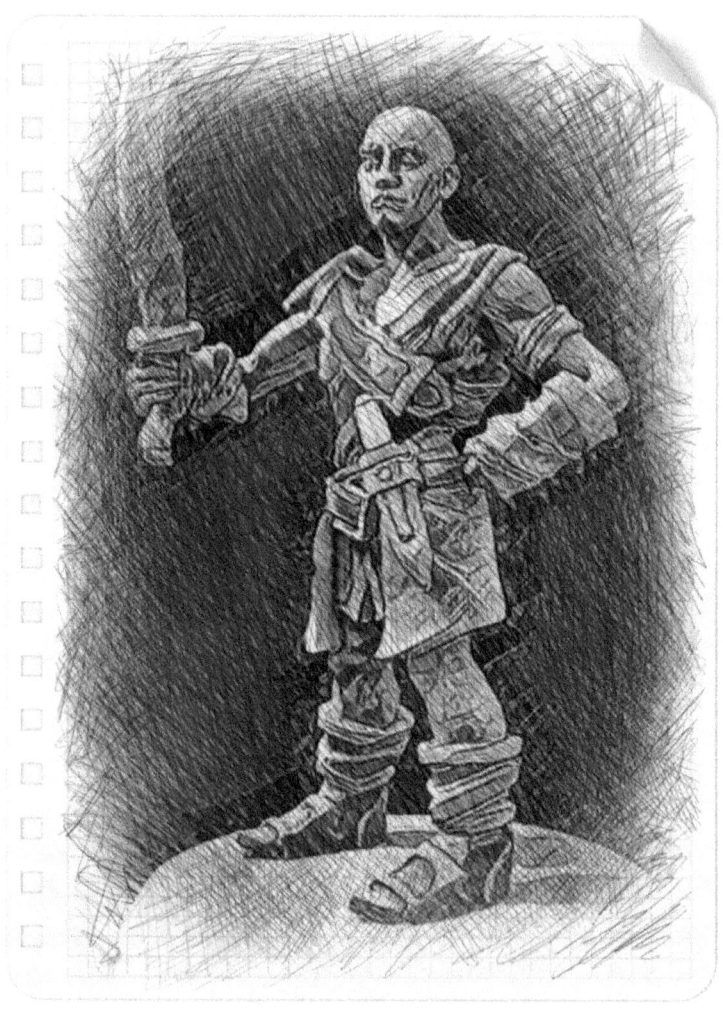

M'Bog from Congswana, and member of the Dust Men.

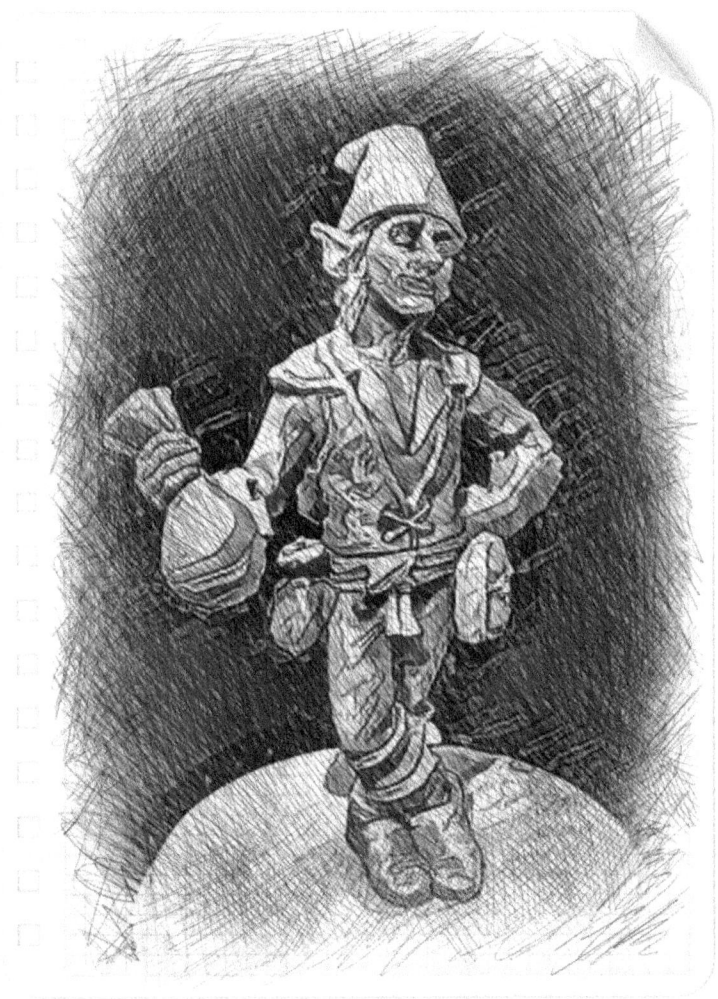

Mik Aloysius Foxfingers from the gnome kingdom of Tinkerhearth, and a Technomancer.

**a.k.a. Mikello.*

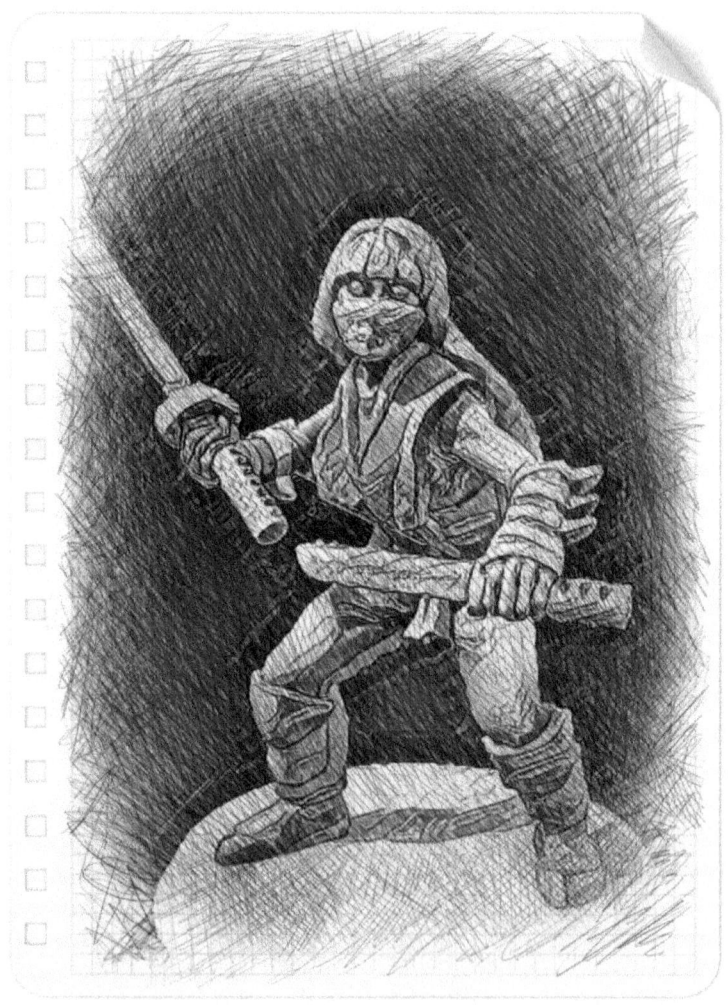

Mika from Kong Tur, and ninja of the Dragon Rose clan.

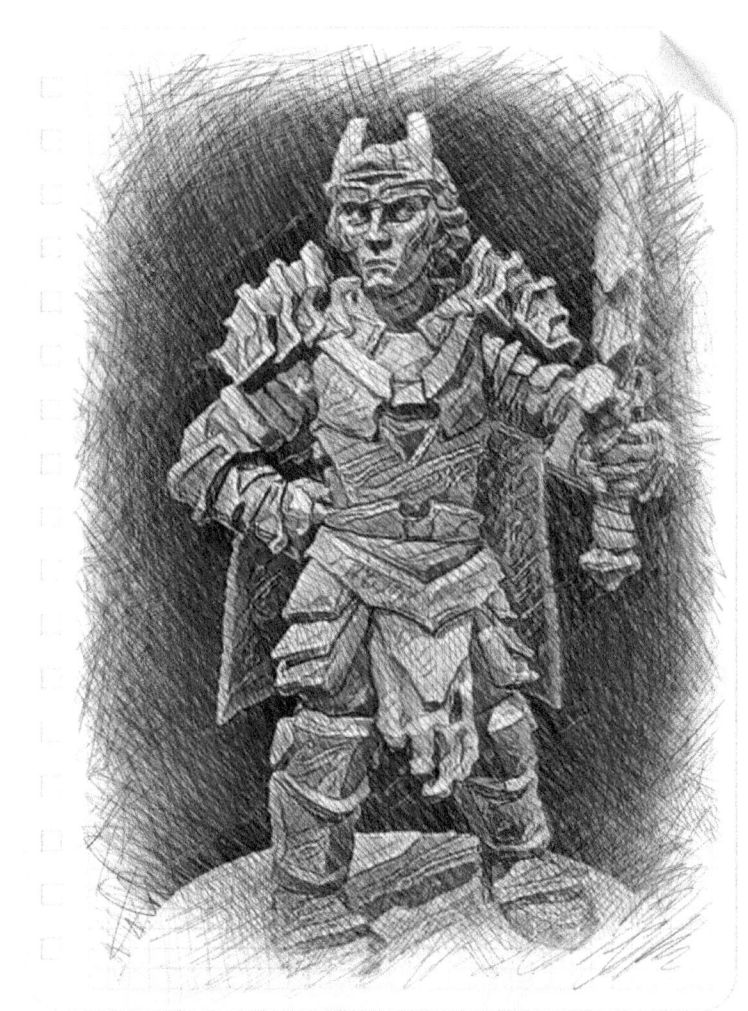

King Moritz von Liechtenstein ruler of Rhinevale and leader of the Jaeger Reich ritters.

Nebuchanezar, sphinx guardian of the lost city of Khemuhura.

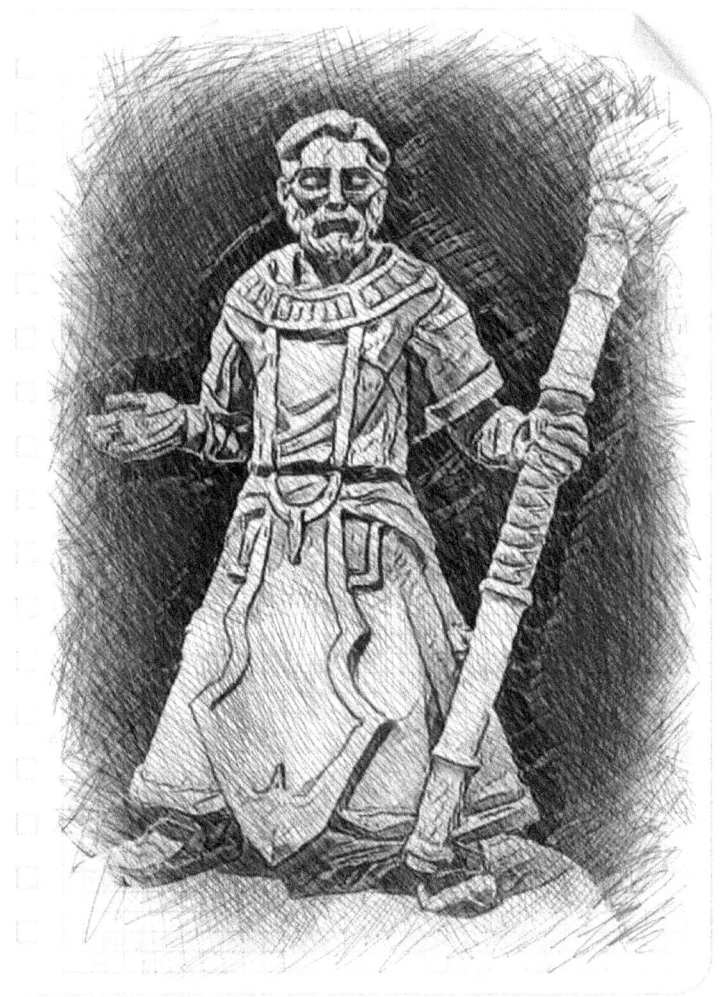

Grandmaster Nelrym Grisroca from San Tainoqua, and member of the Acolytes of Loa-Ra.

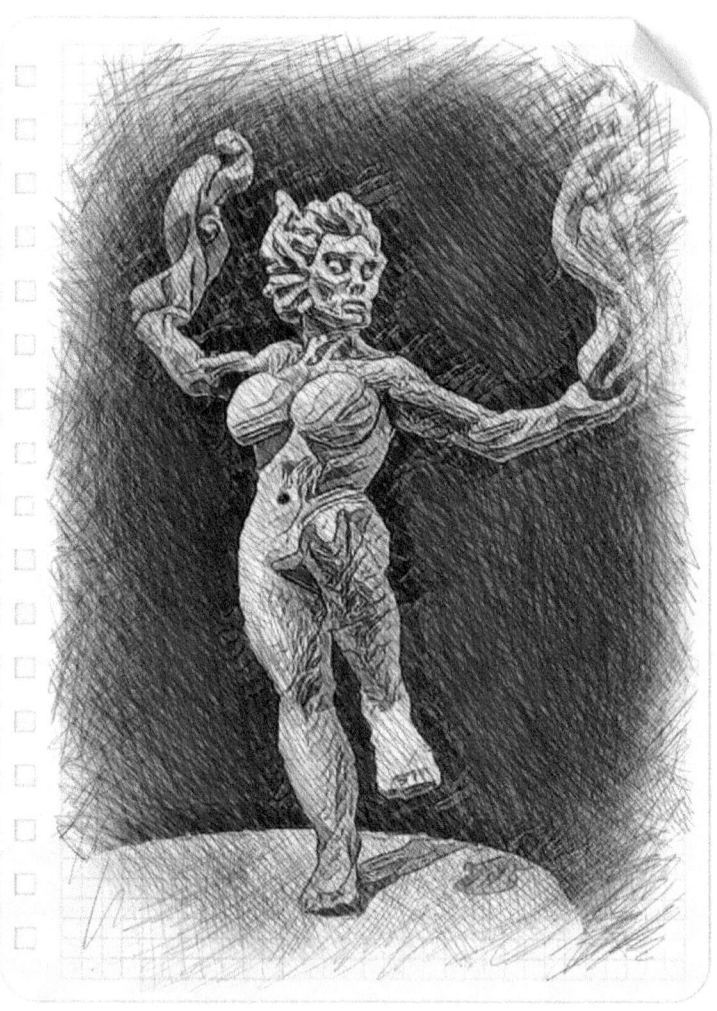

Nyvene, the Lady of the Loch and the Primordial Elemental of Water.

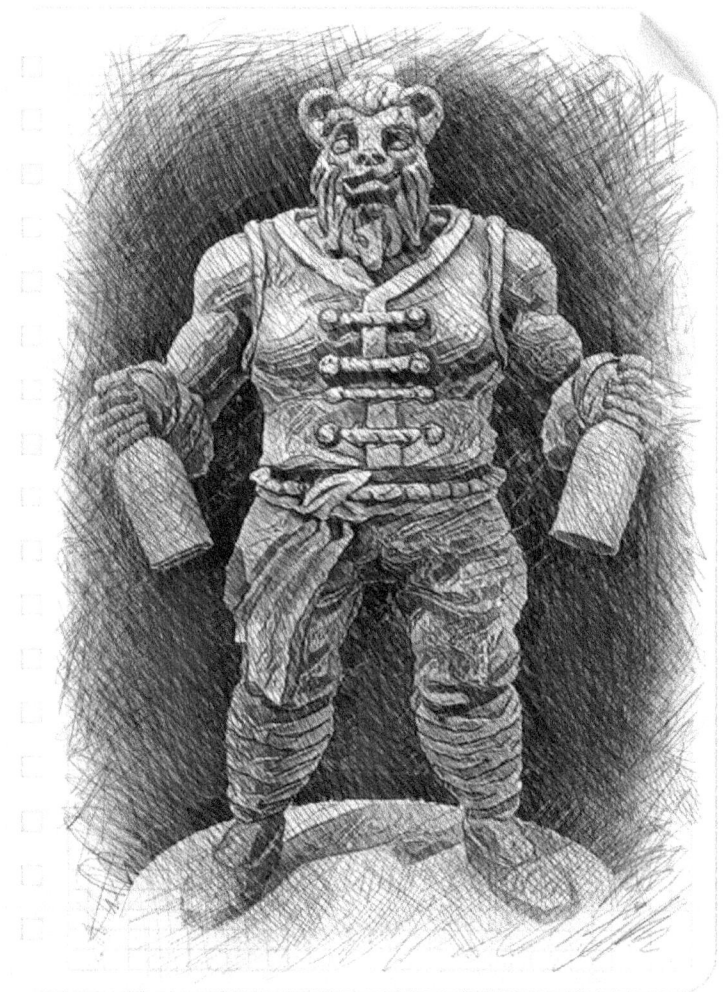

Okooma from the Motuo Briar. Panda hengeyokai sumo of the Eastern Protectorate.

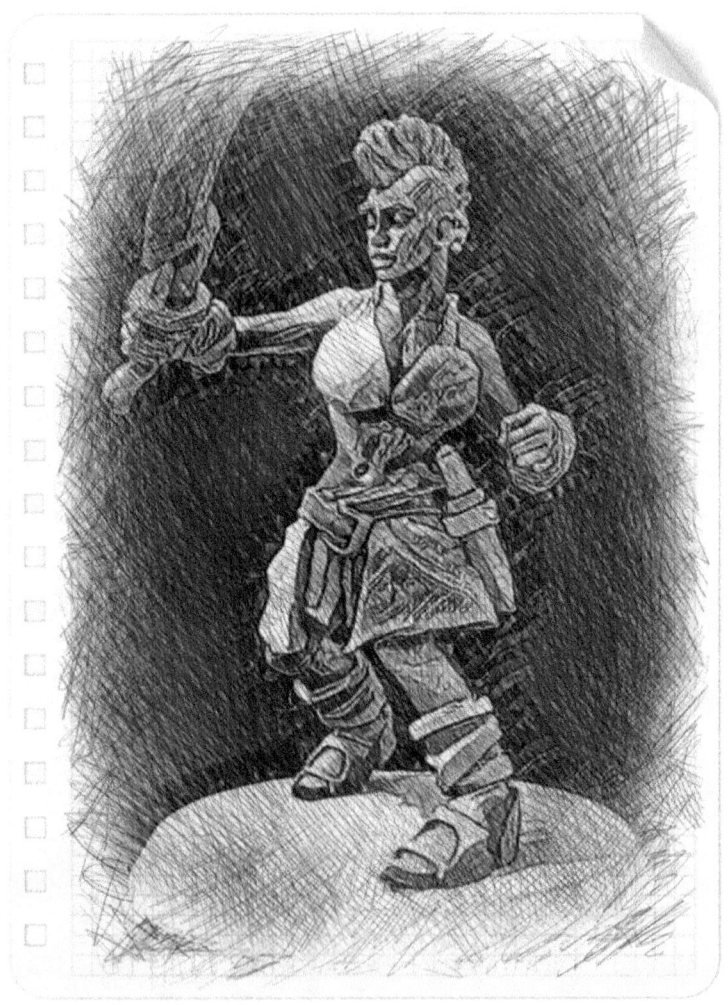

Ola from Congswana and member of the Dust Men.

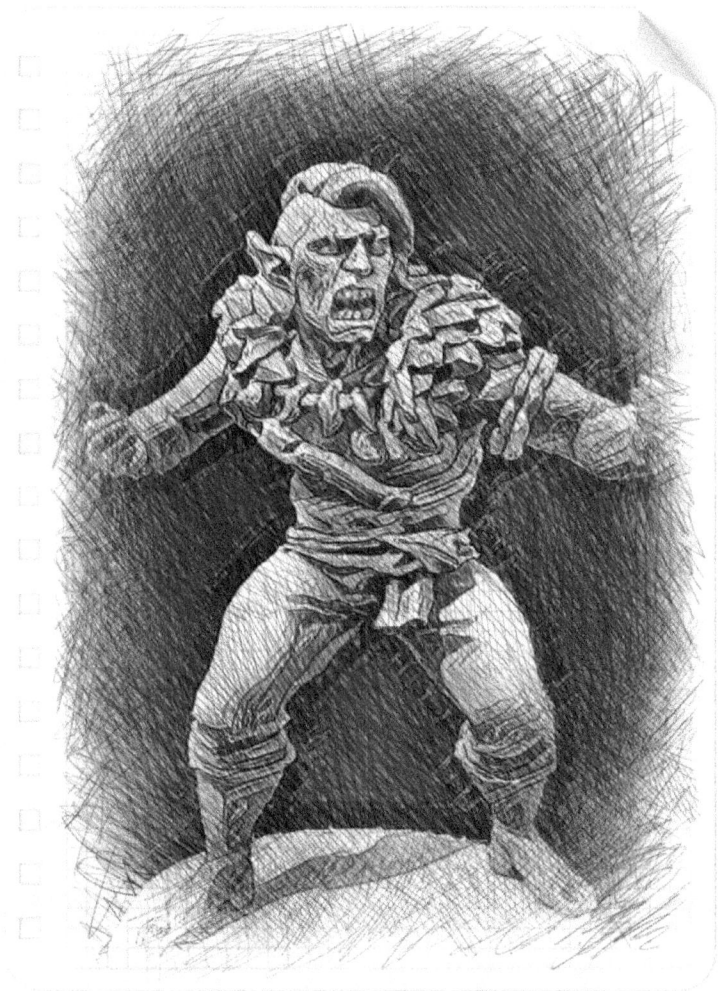

Old Shuck the Progenitor of the Barghest race.

** Half vampire/half were-wolf.*

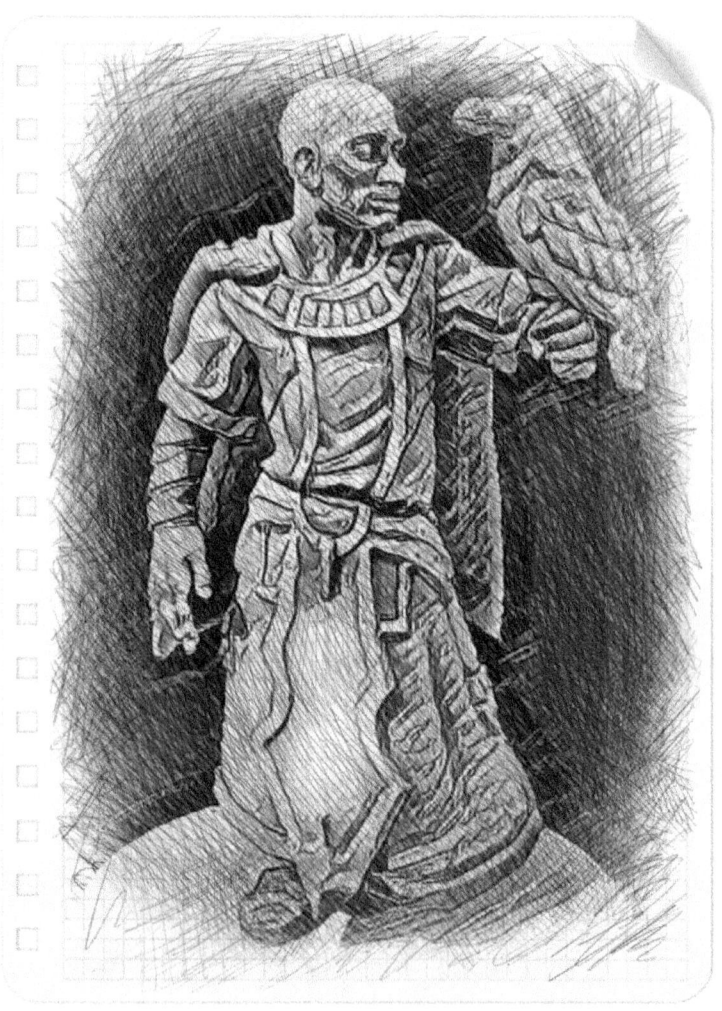

Master Omar al Ptah of Sha'Malon, and member of the Acolytes of Loa-Ra.

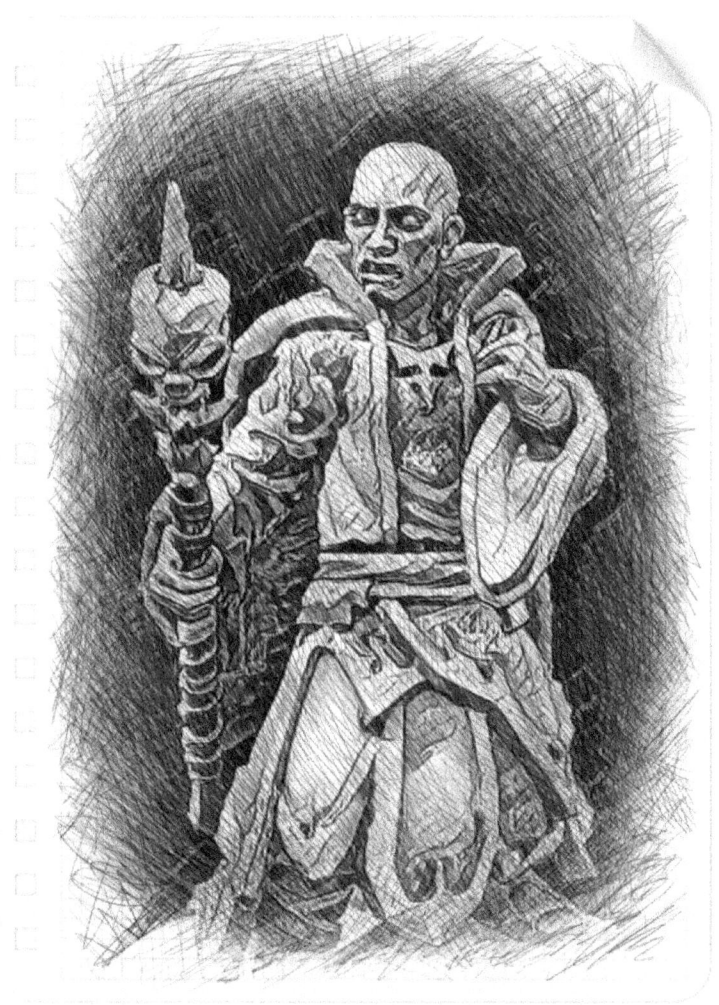

Ozark al Ptah, magical doppelganger of Omar al Ptah. A Warlock of Azadeus, and leader of the Unholy Horde.

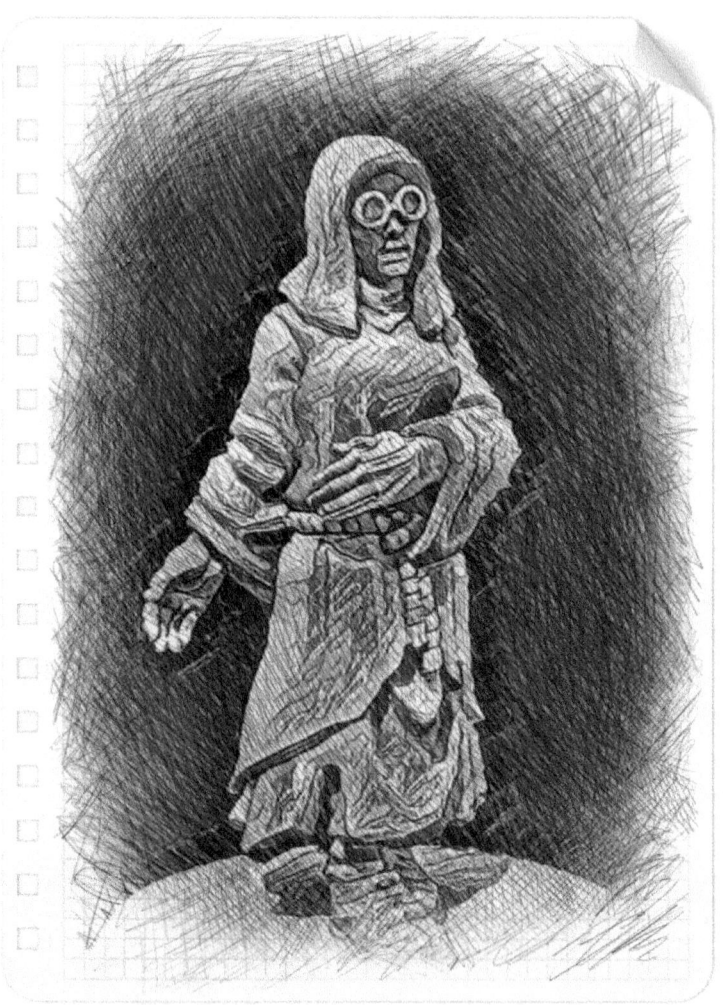

Lordess Sister Pamelope Aragones, nun of the Curia.

**a.k.a. Phantasma of Los Rodeleros.*

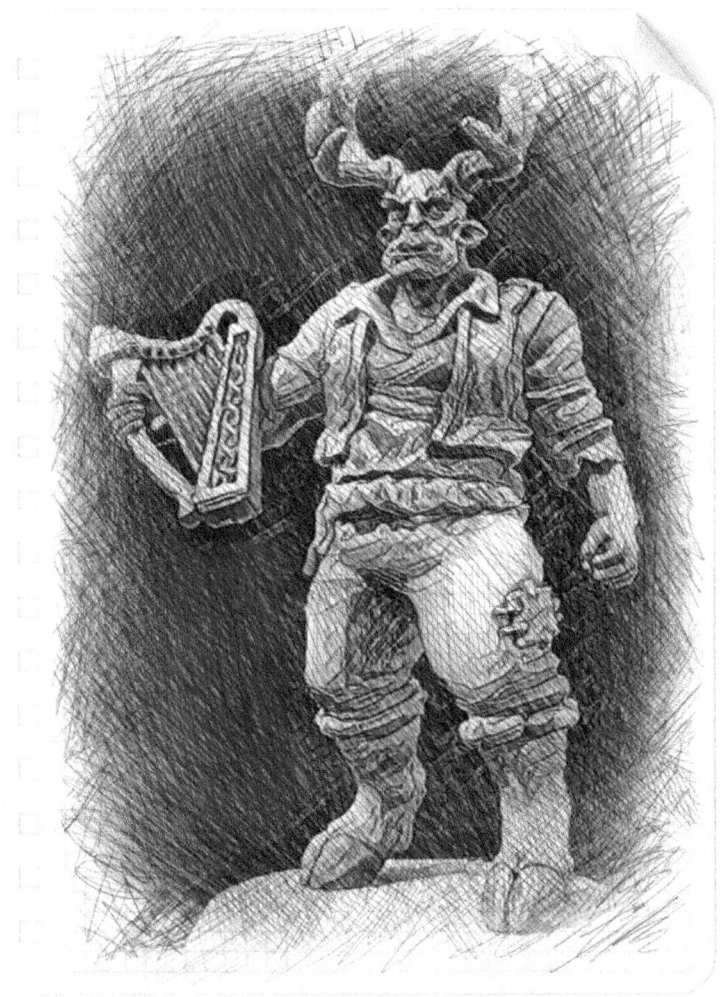

Pether from the troll kingdom of Bludkraal, and bard.

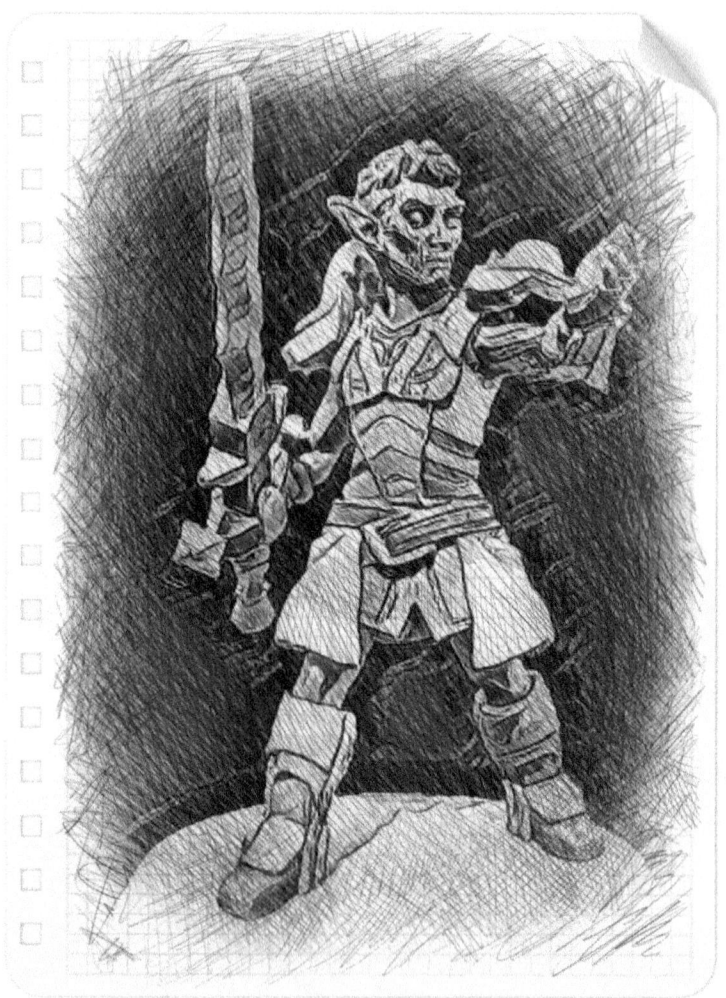

Prince Qrom Blackfell from the dark elf kingdom of Moonkith of the Unsidhe Court. Leader of the Shadow Flight.

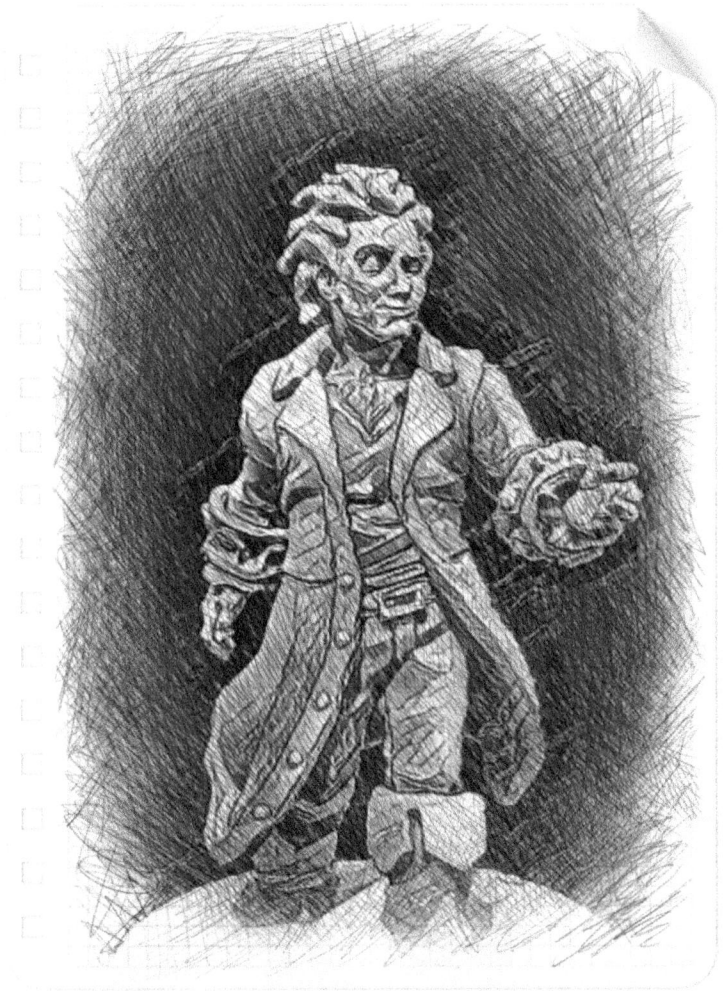

Izachary Ramrocke, bard and Bandit King of Silkshore.

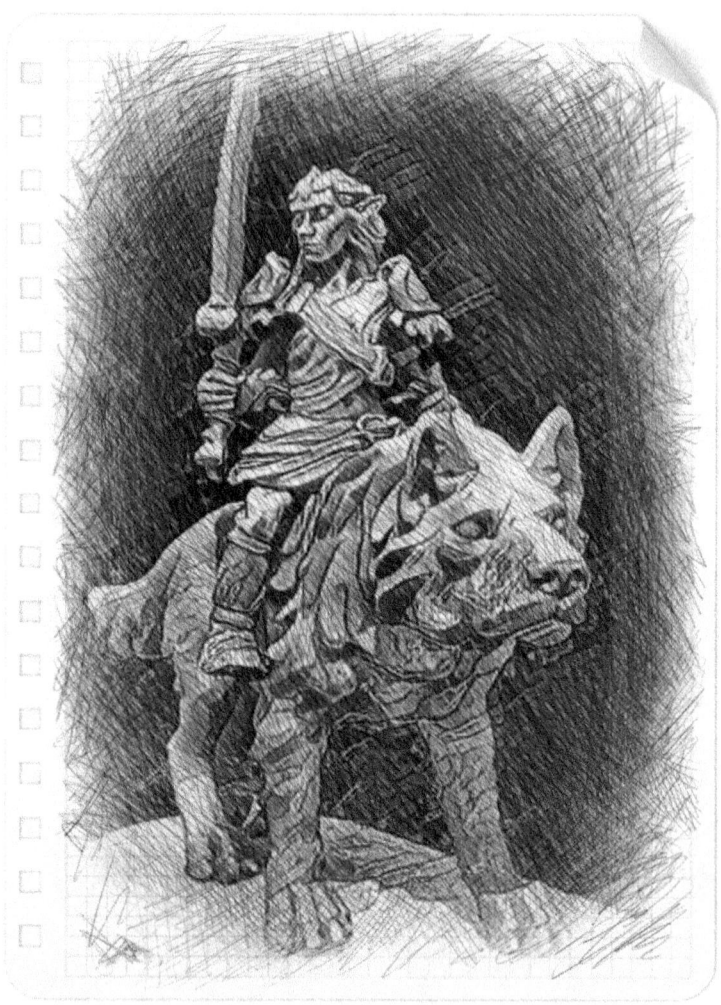

Lord Rexus Ironwulf from the wood elf kingdom of Sylvankith, and leader of the Wolfenguard.

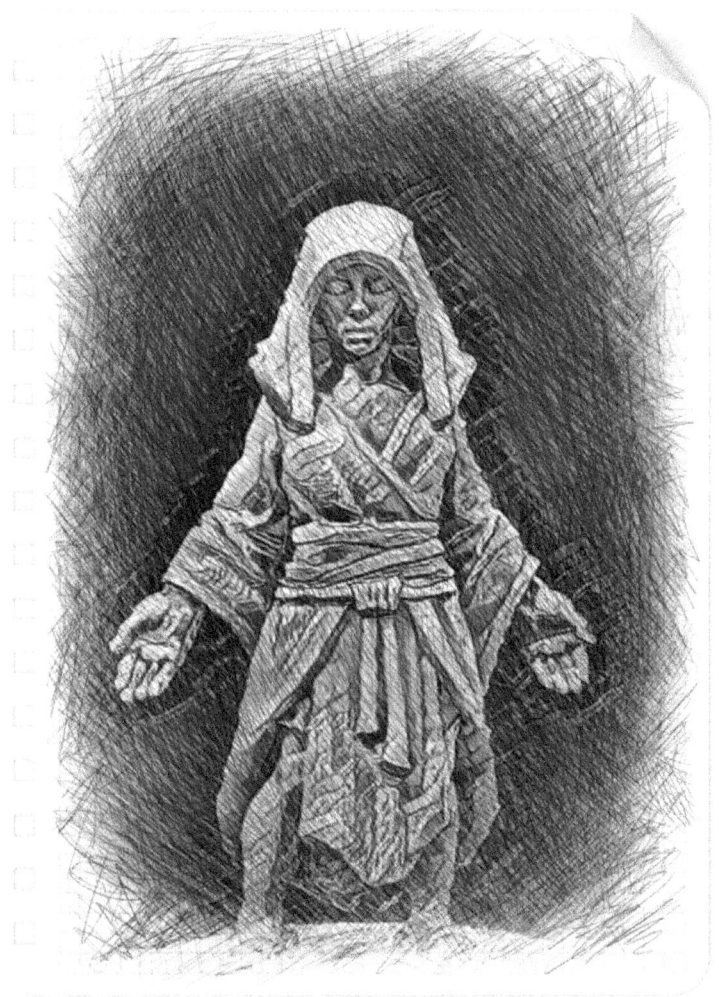

Rheata from Romopolis, and the Oracle Rex of the Oracles of Olympia.

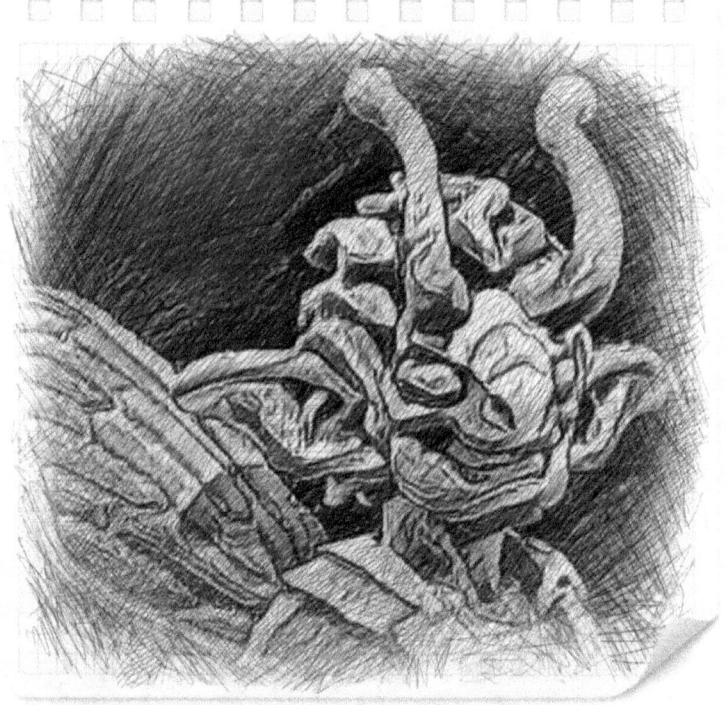

Roach, a grig from Marutui the Realm of Air. A member of the Dust Men and assistant engineer of the Spellhammer.

** a.k.a. Vrusk'Kaliklak'tik.*

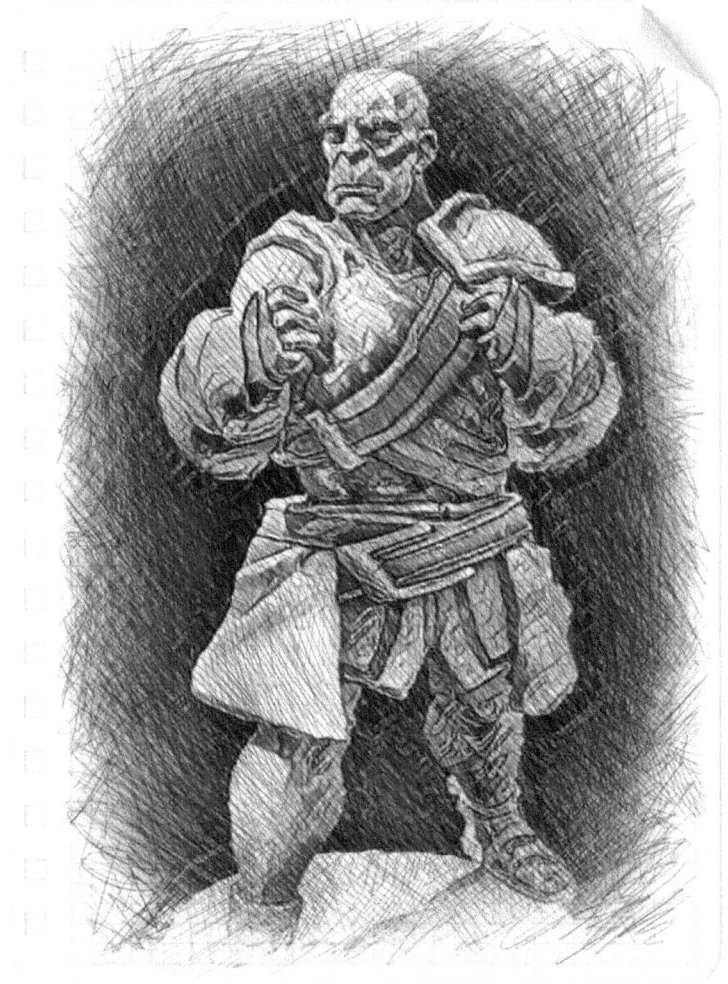

Rodimus from the plains of Djiopia. Half fire giant/half human.

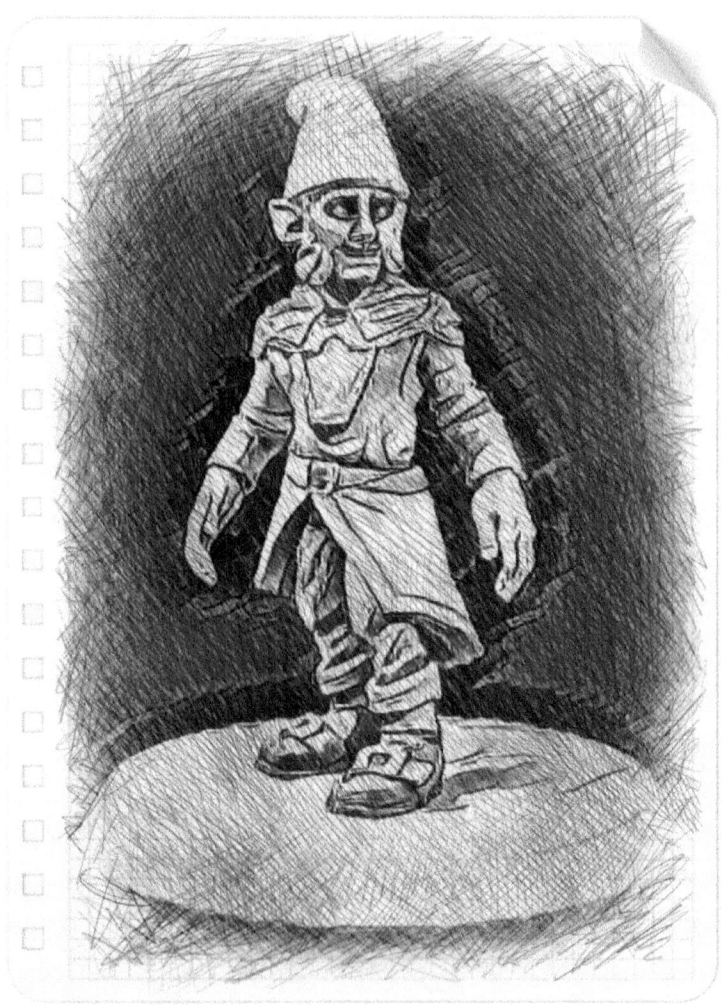

Romero Foxfingers from the gnome kingdom of Tinkerhearth, and retired Trumpmaster.

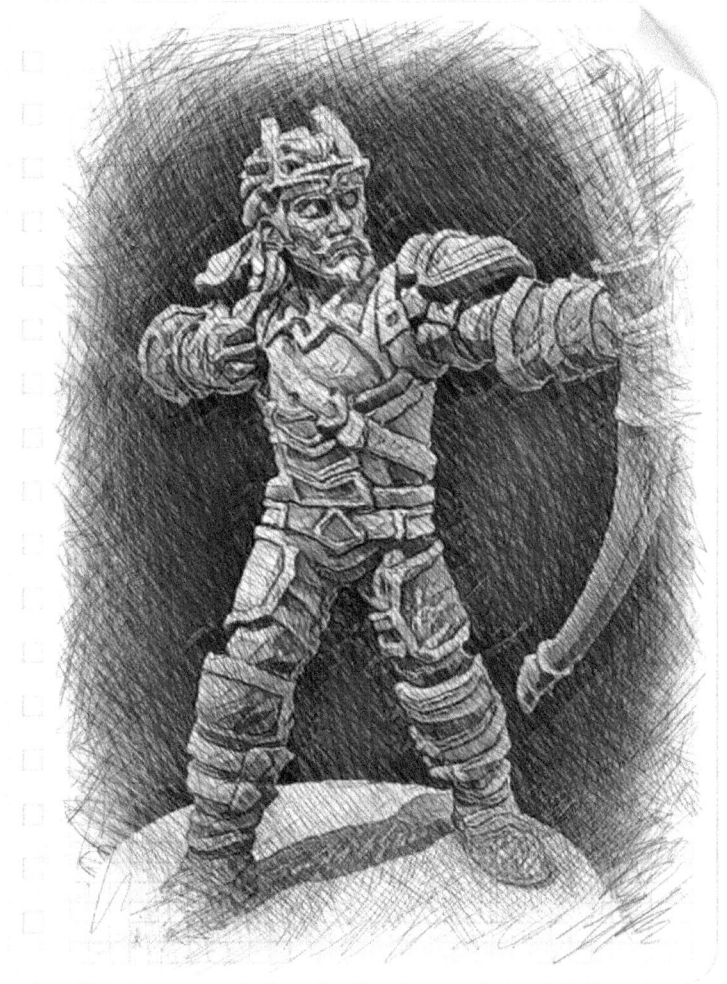

King Rowan Loxley, ruler of the kingdom of Celtvale, and leader of the Morrigan Bowmen.

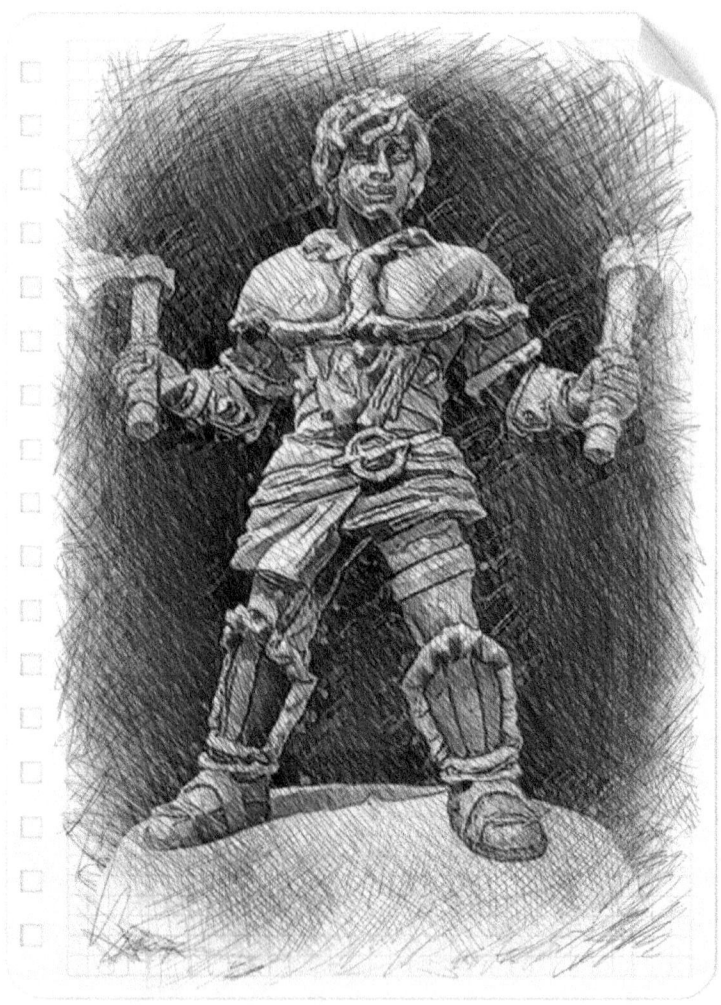

Rutger from Iron Icevale and member of the Dust Men. Twin brother of Brooke.

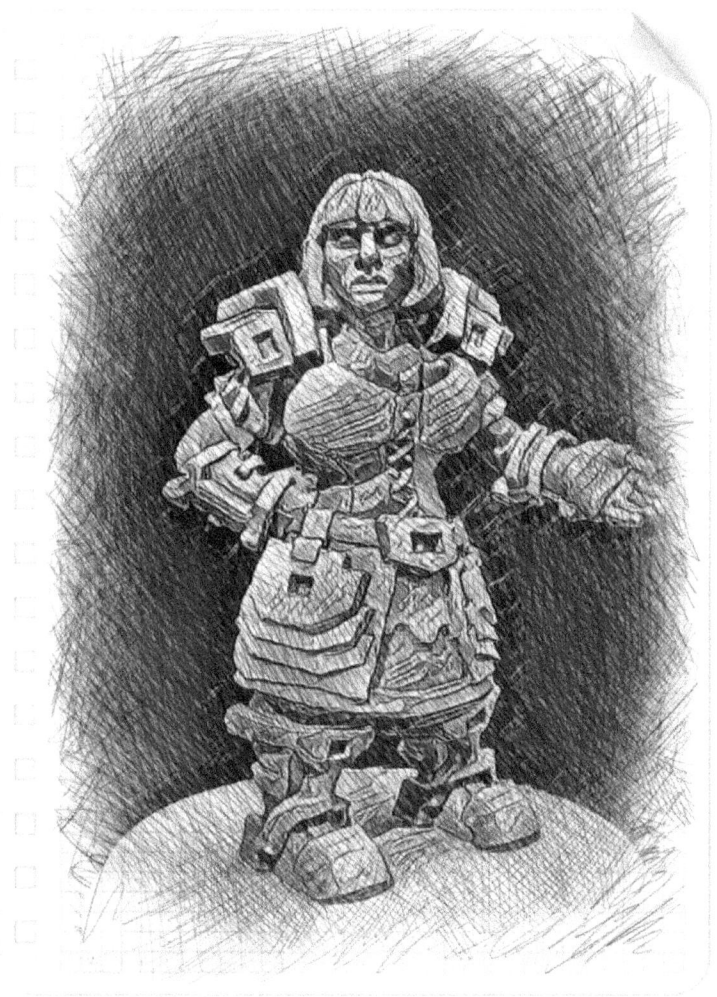

Sable Longbosom from the dwarven kingdom of Stonehold, and captain of the Ironbottom.

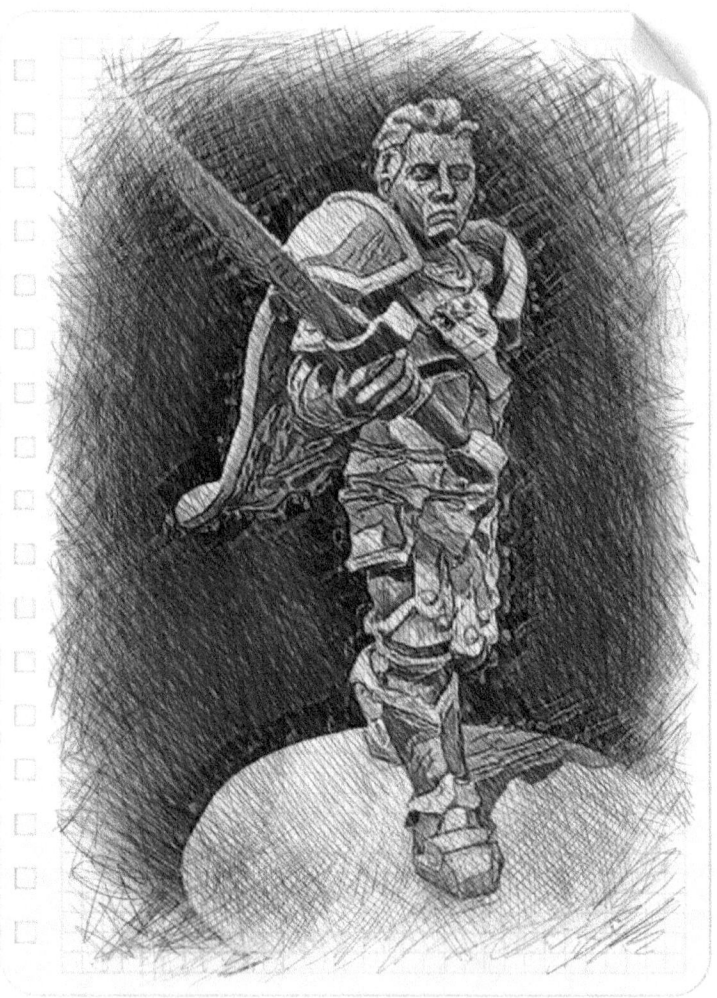

Prince Saulel Pendrake from Caerleon, and member of the Knights of Caerleon.

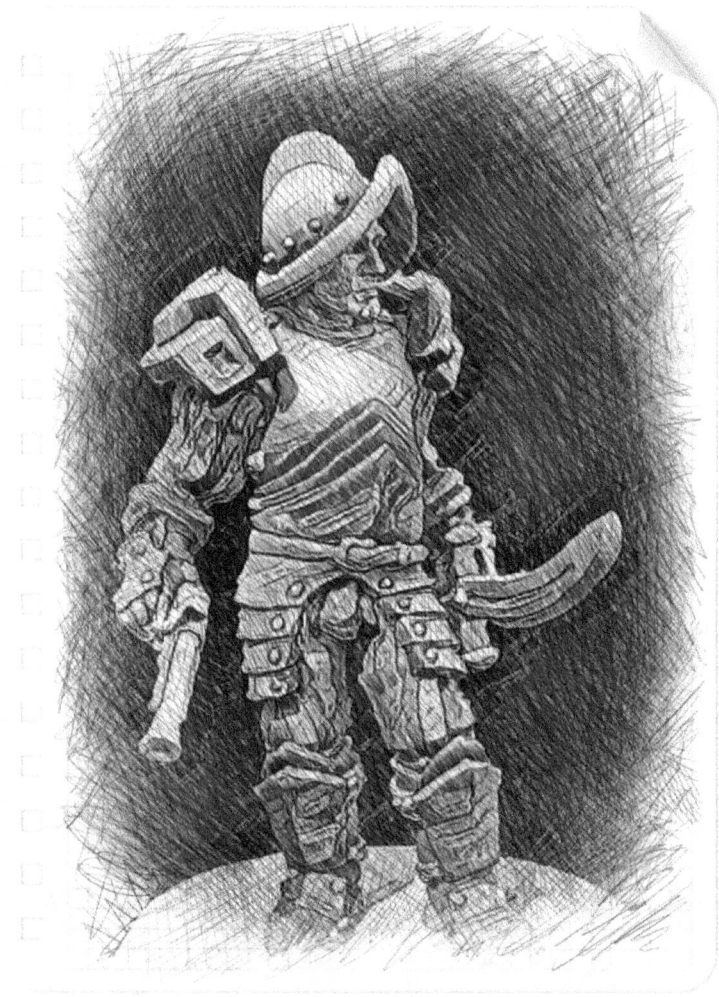

Don Sebastian Armengol Orengo from San Lenape, and member of the Compania el Couatl conquistadors.

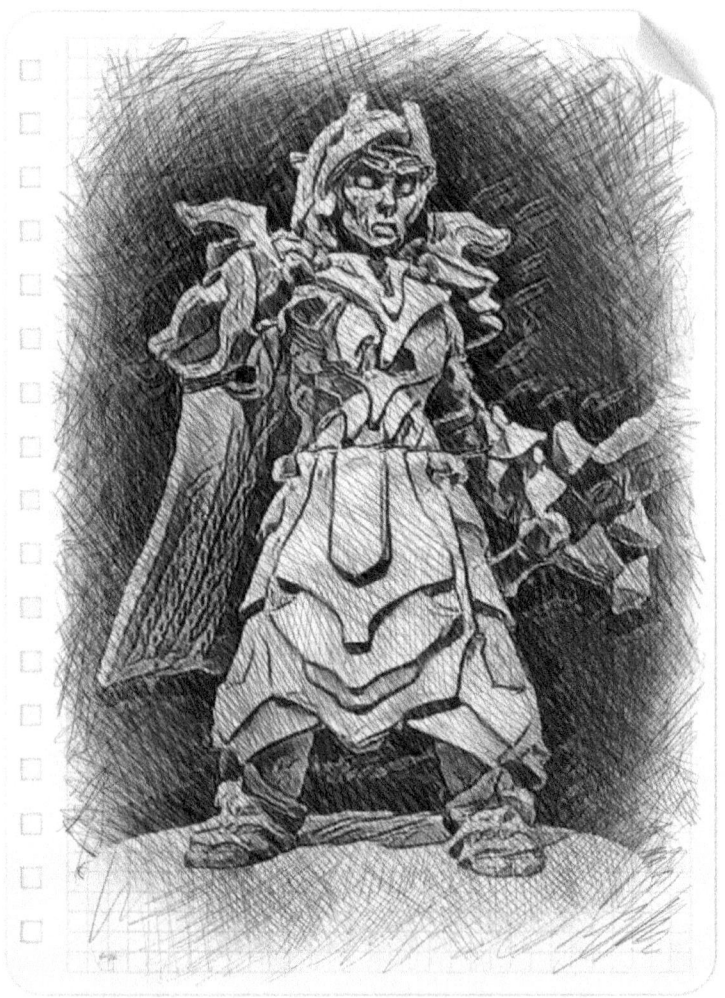

Queen Sepsis Blackfell of the dark elf kingdom of Moonkith of the Unsidhe Court.

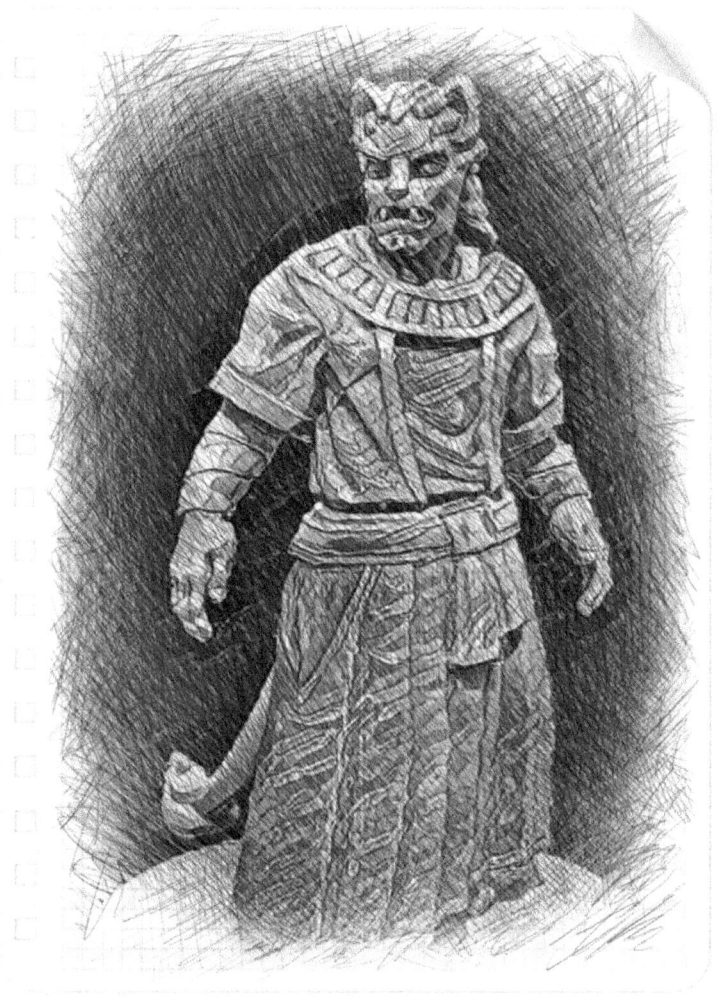

Sethotep, lion nagloper and Alpha of the Southern Protectorate.

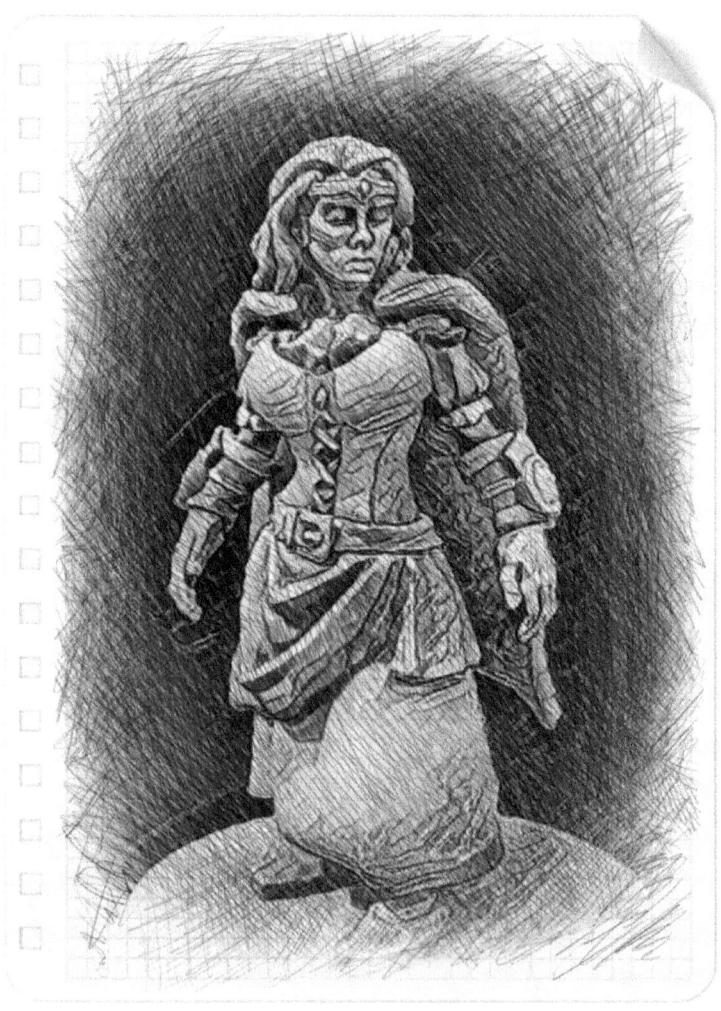

Princess Sigourney Pendrake from Caerleon.

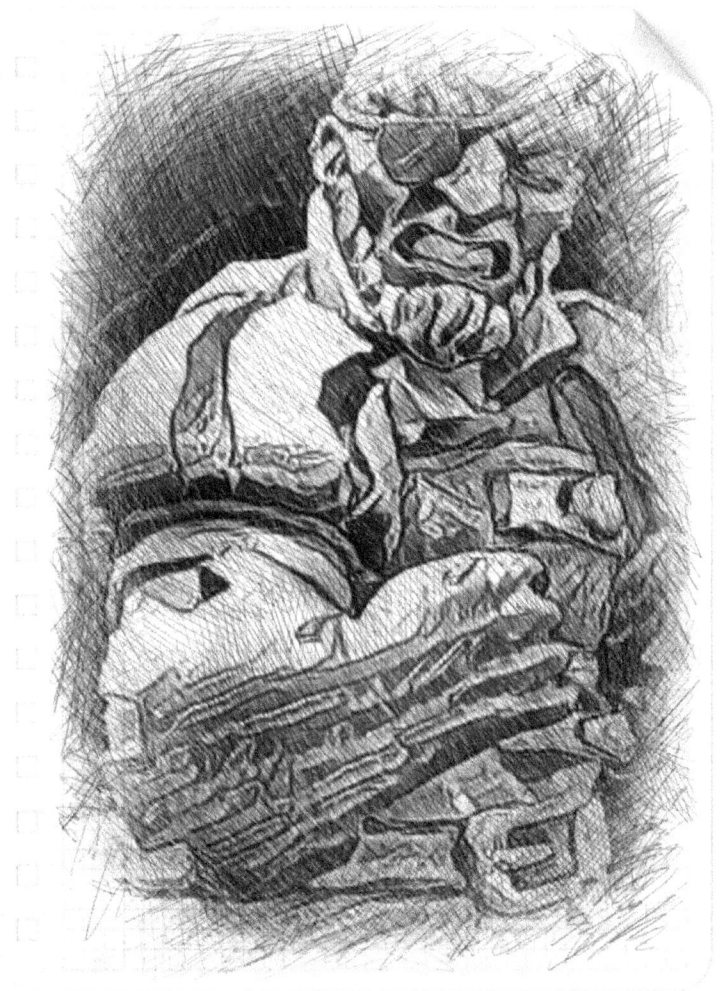

Silenus, Bandit King of Thieves' Town and the guild master of the Jolly Reapers.

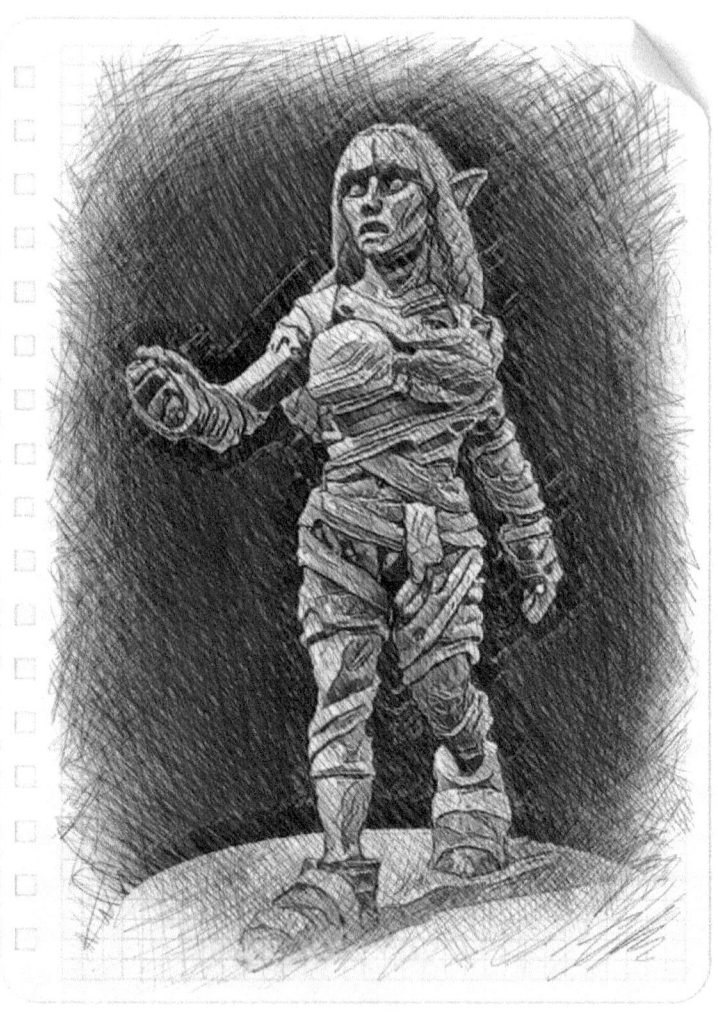

*Sinestra from the sluagh kingdom of Svartlfar, and assassin of the Hush. *a.k.a. Mistress of Spies.*

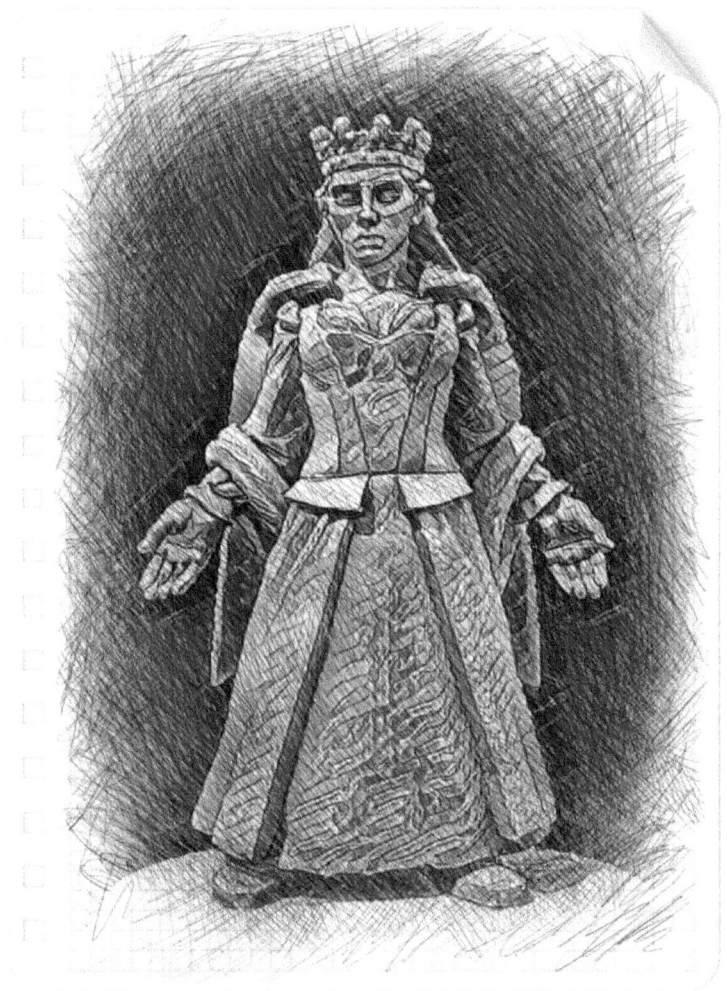

Queen Siobhan Pendrake from Caerleon.

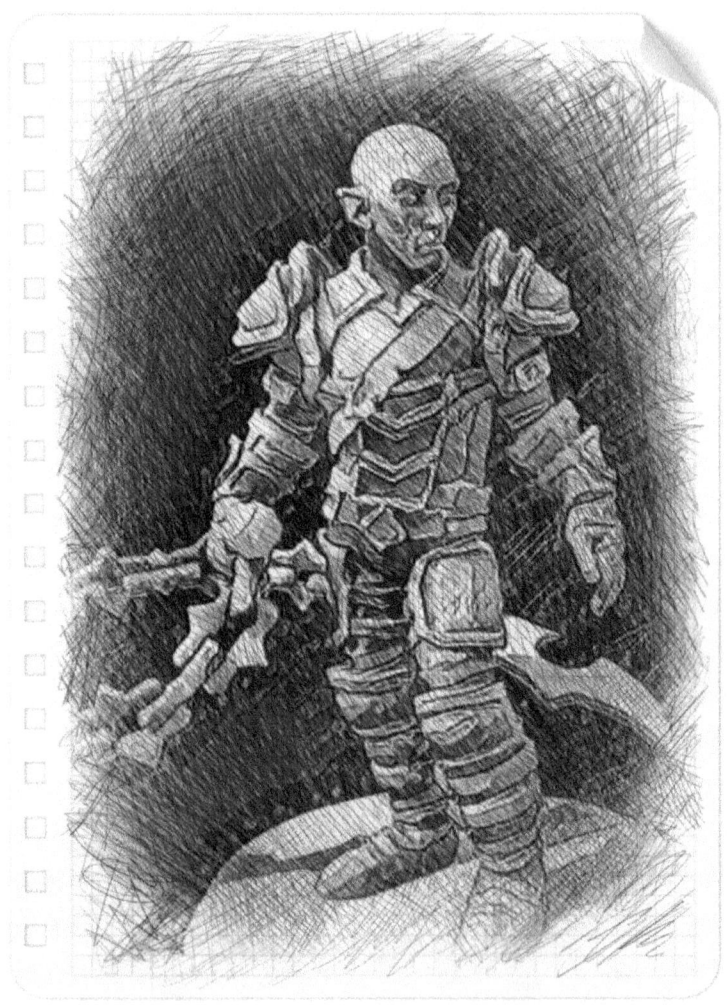

Skullgrin from the changeling kingdom of Rancorvale, and assassin of the Gloam.

**a.k.a. Vinhari.*

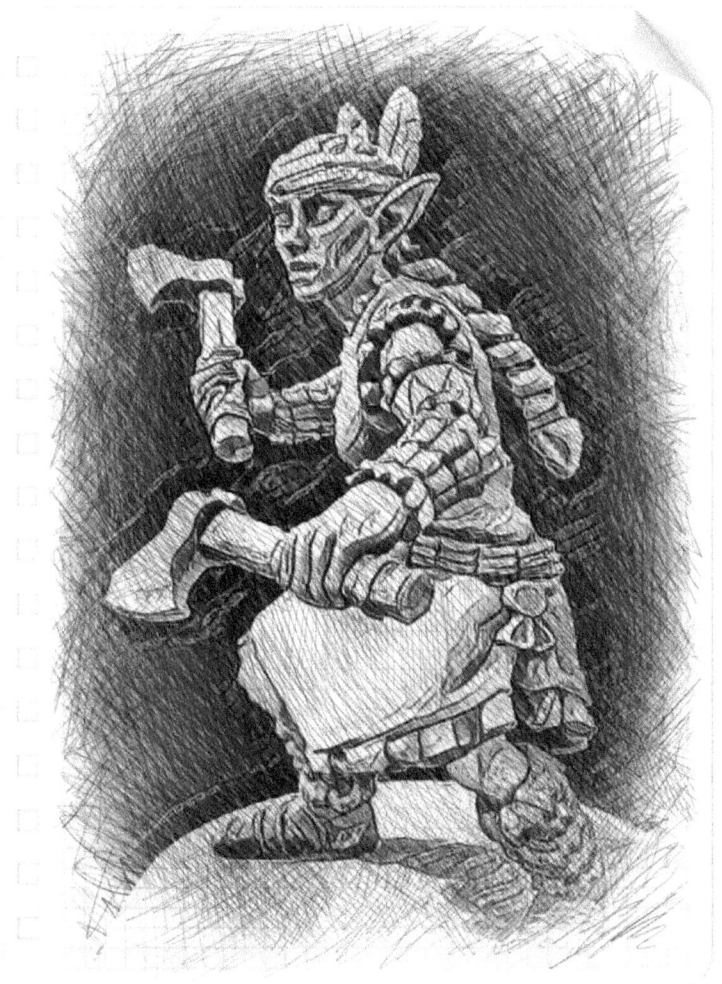

Summerose from the prarie elf (nunnehi) tribes of the Grande Solis desert.

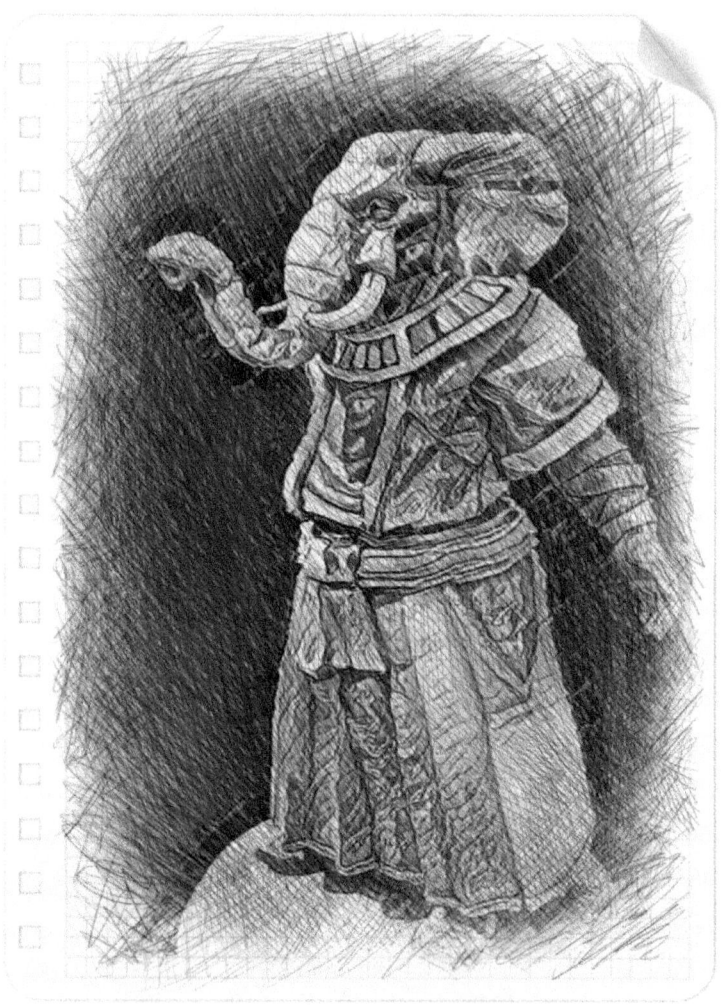

Surus, elephant nagloper and Beta of the Southern Protectorate.

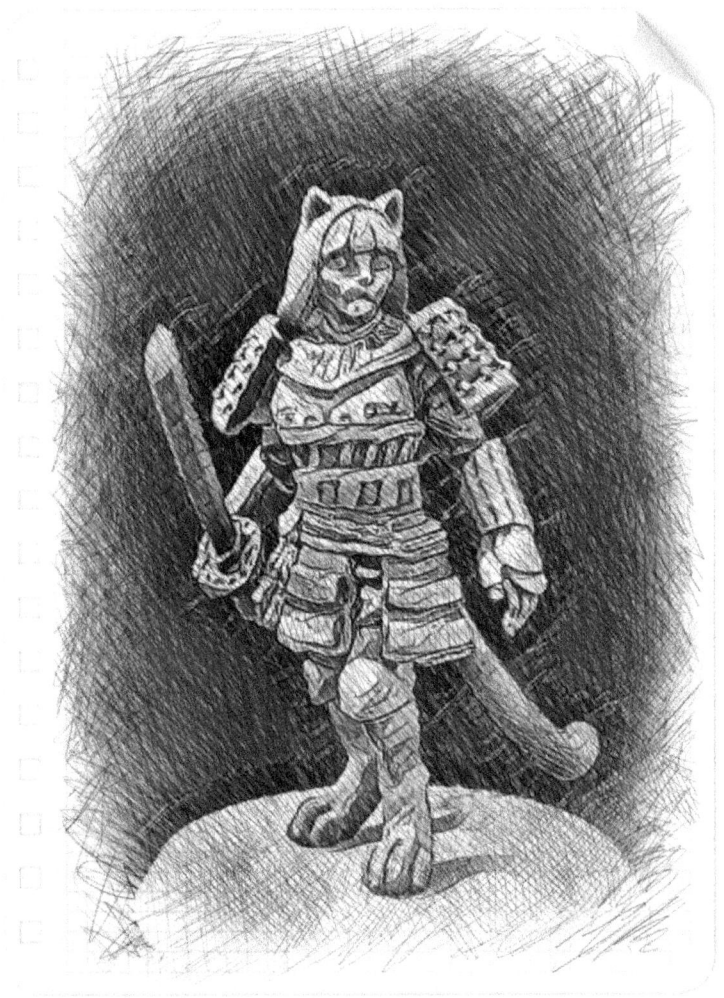

Tam from the Motuo Briar. Cat hengeyokai samurai of the Eastern Protectorate.

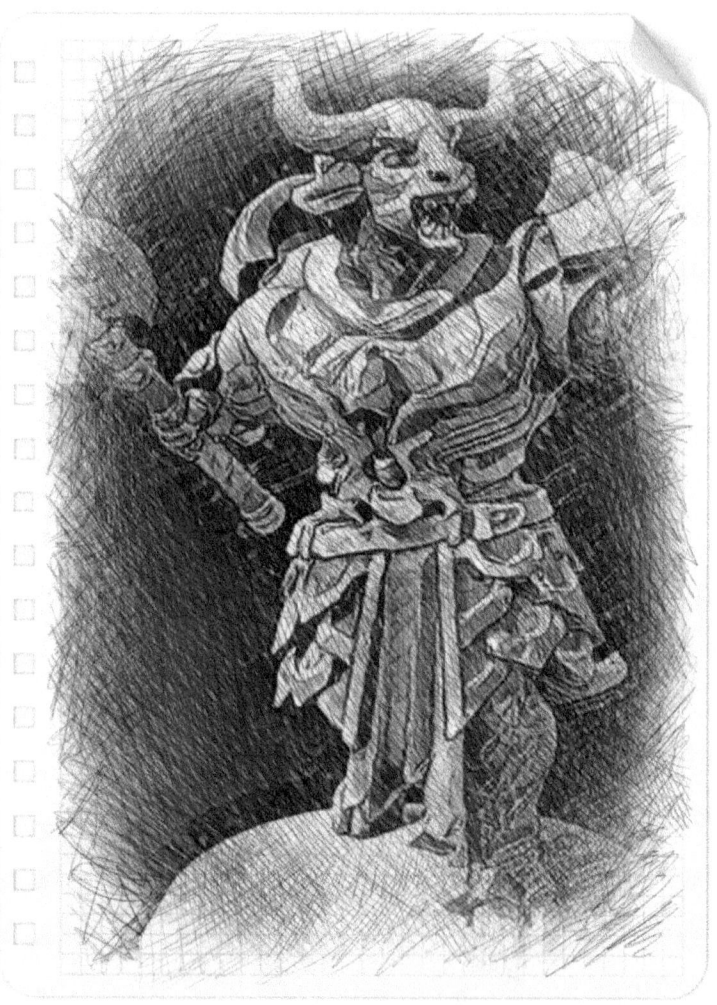

Taurox from the minotaur tribes of the Grande Solis desert. Former gladiator of the Imperial Arena.

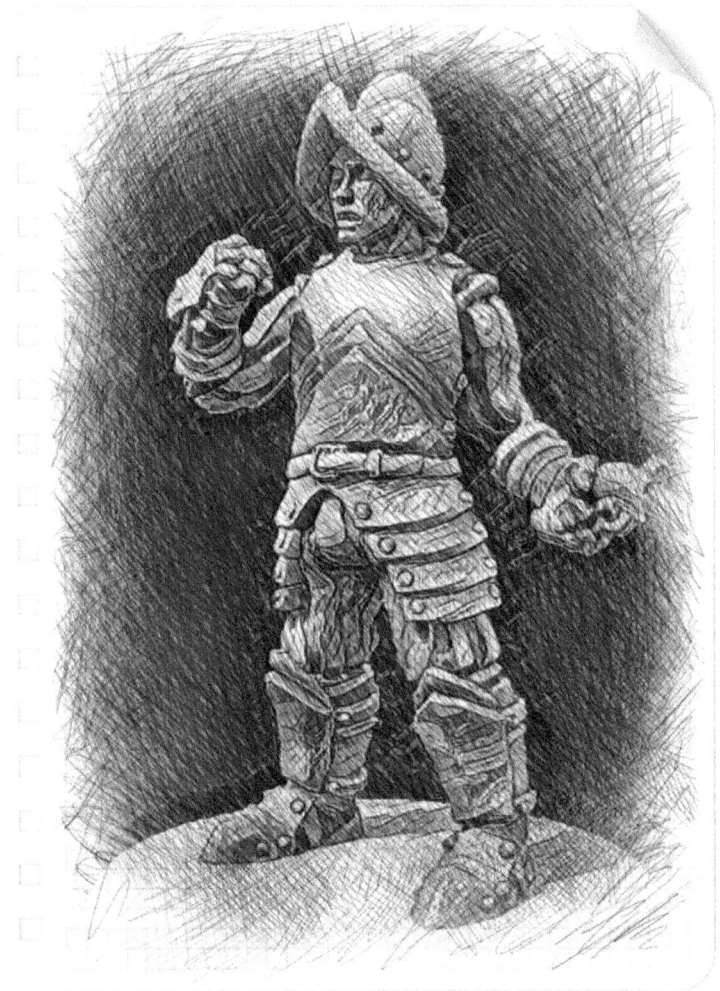

Don Tevy, member of the Compania el Couatl conquistadors.

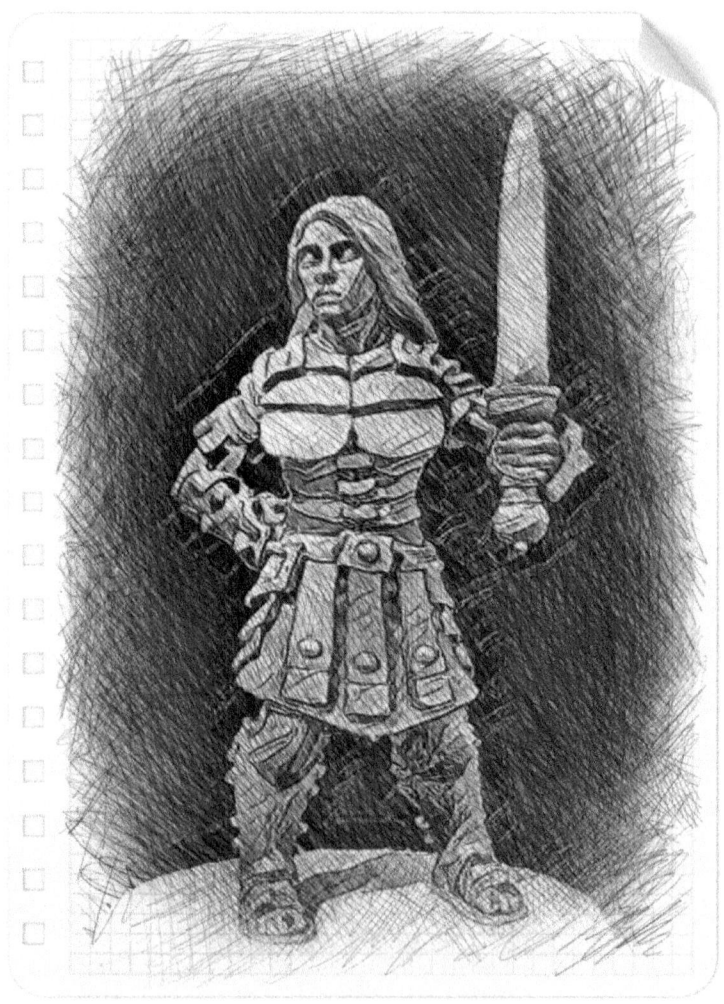

Sub-commander Themyscira Zopolus of the Praetorian Guard centurians.

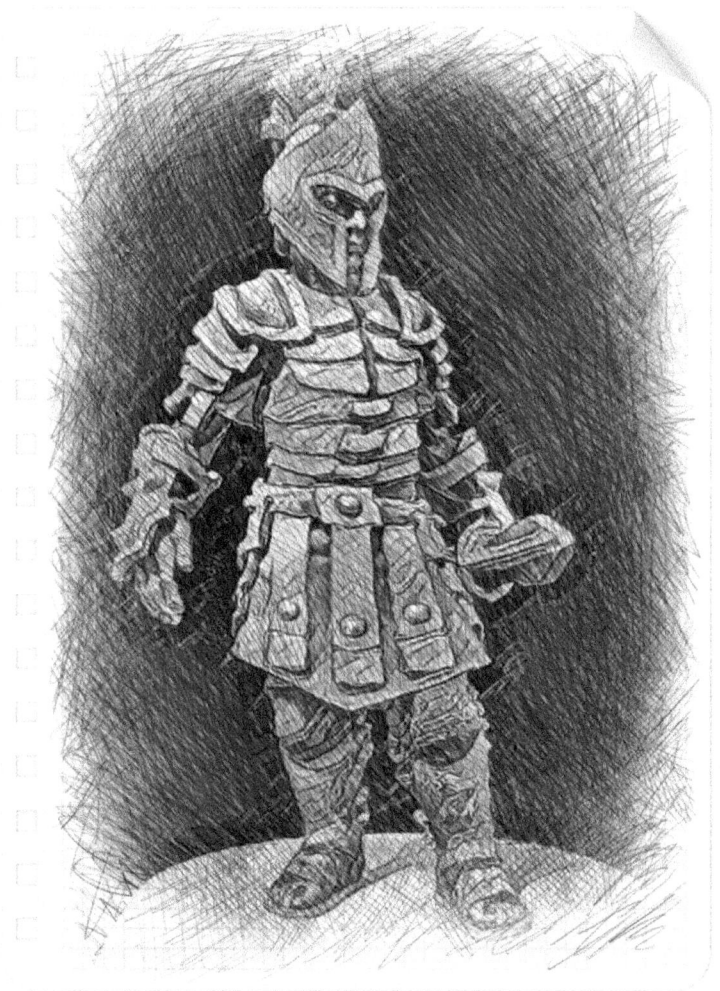

Commander Tiberius Barca of the Praetorian Guard centurians.

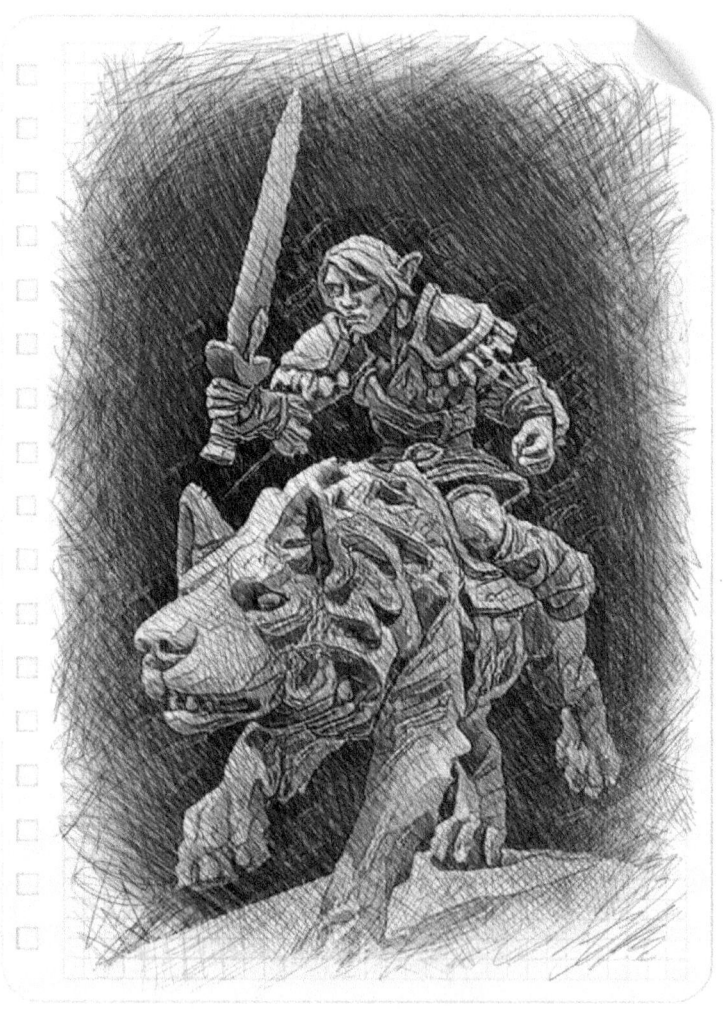

Jarl Timmorn Warfrost from the ice elf kingdom of Rimekith.

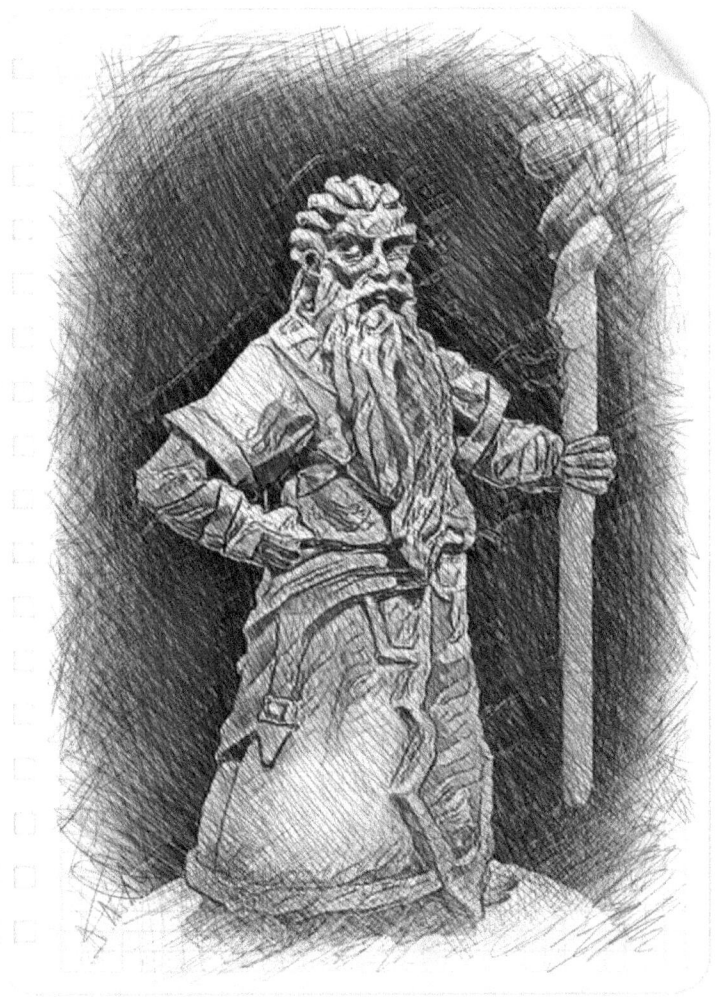

Grandmaster Titus Kyeema from Koori-Kuparri. Member of the Acolytes of Loa-Ra, and an Archon of the Quorum. FormerMabarn.

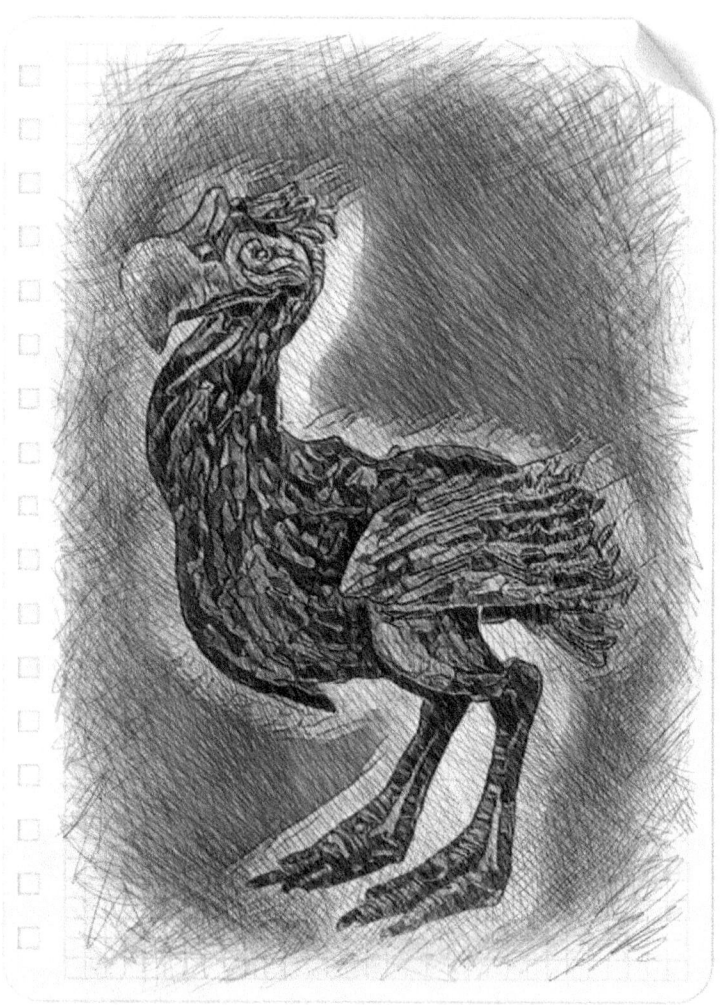

Twinkle, moa mount of Lorin.

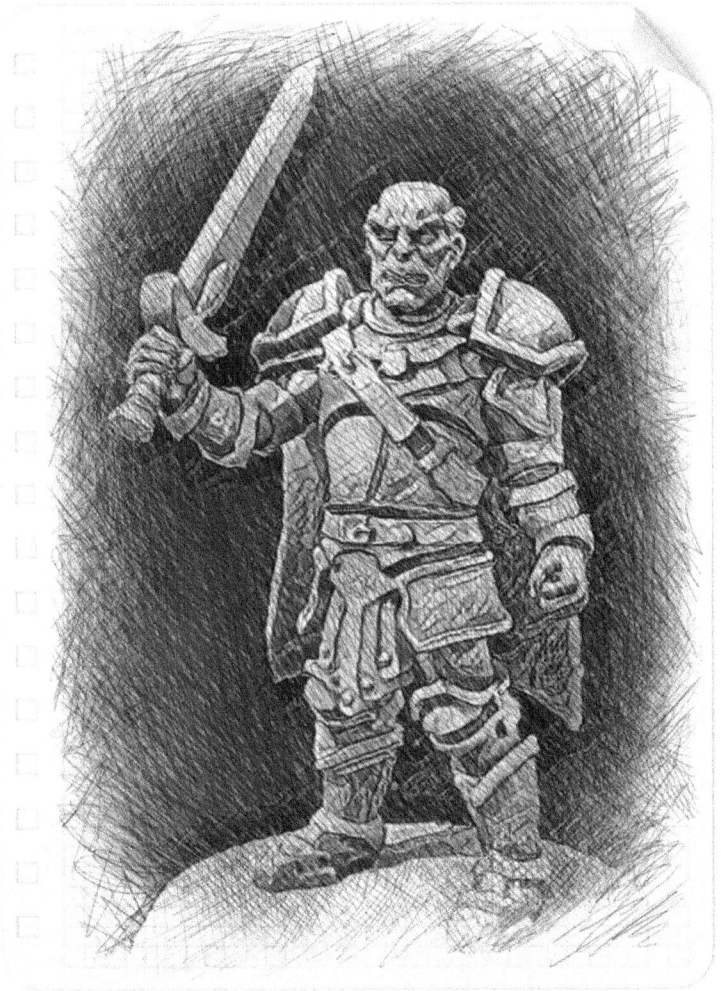

Capitán General Umberto Jaime Montenegro from Gran Caparra, and leader of the Compania el Couatl conquistadors.

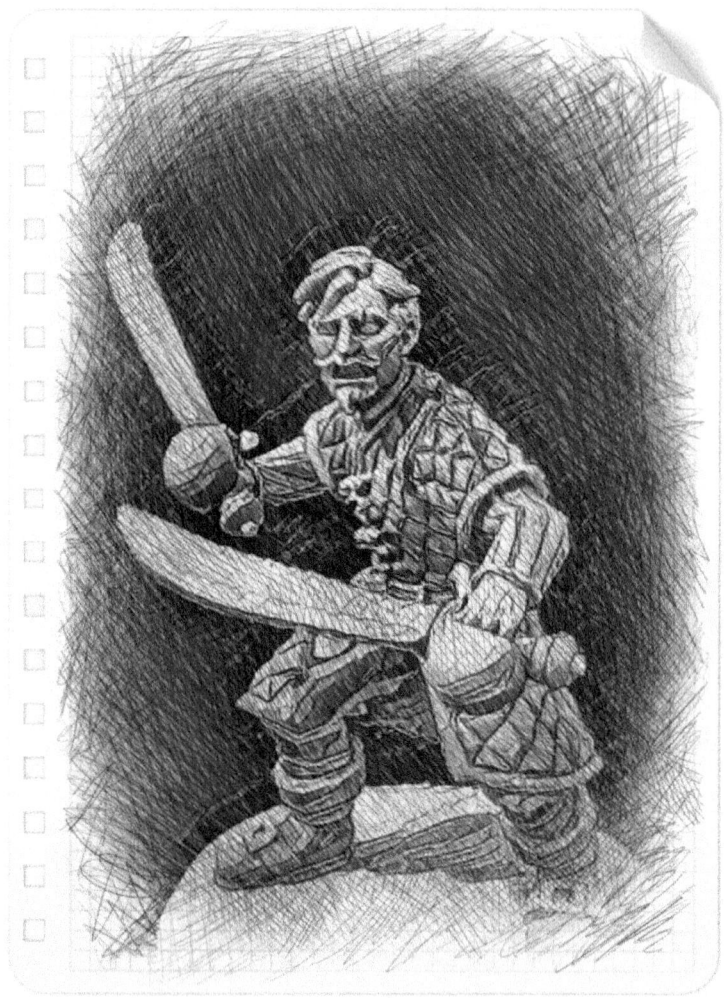

Easton Valence (Nth) from the Crossroads. 3/4 human/1/4 triton bounty hunter and former member of the Dust Men.

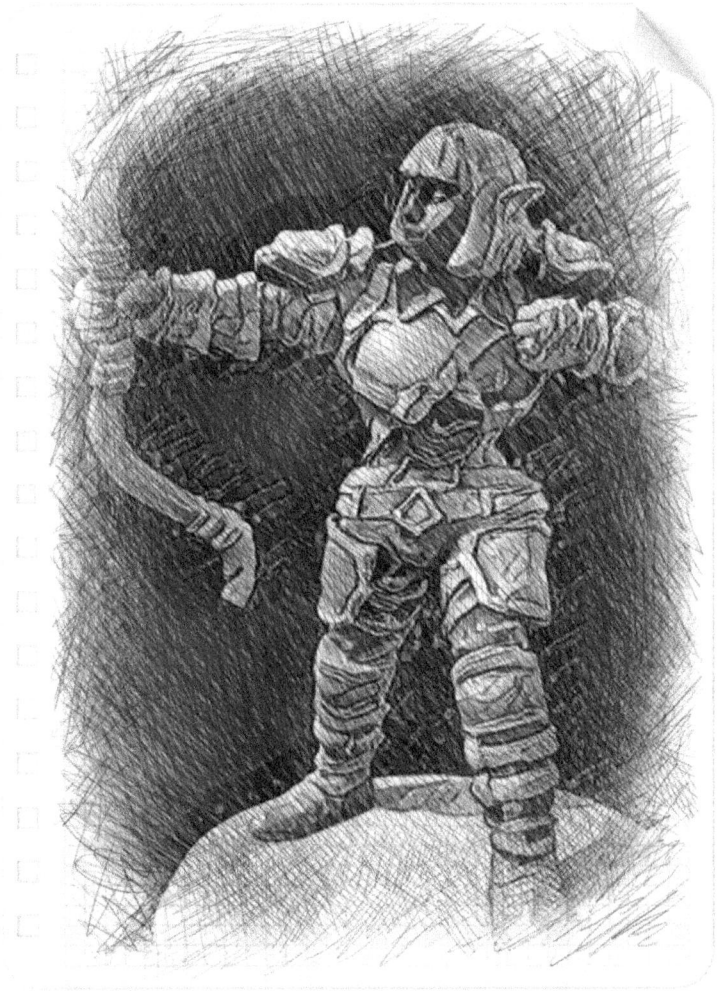

Valendra Woodlocke from the light elf kingdom of Sunkith of the Sidhe Court. Member of the Sagittarii archers.

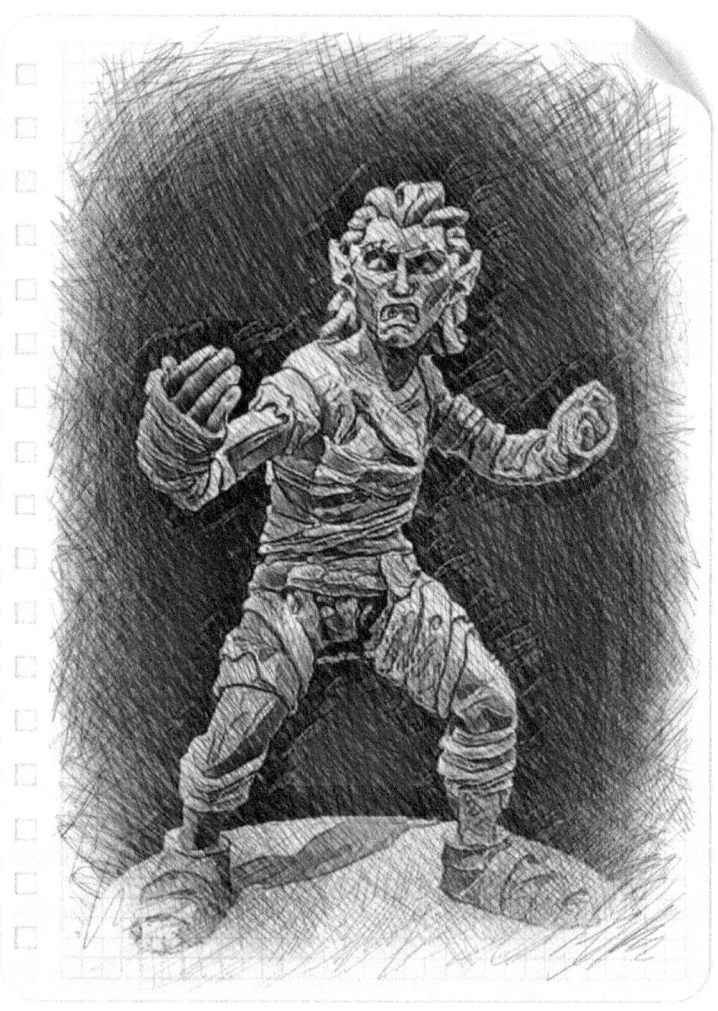

Venomyr from the sluagh kingdom of Svartlfar, and assassin of the Gloam.

** a.k.a. Master of Murder.*

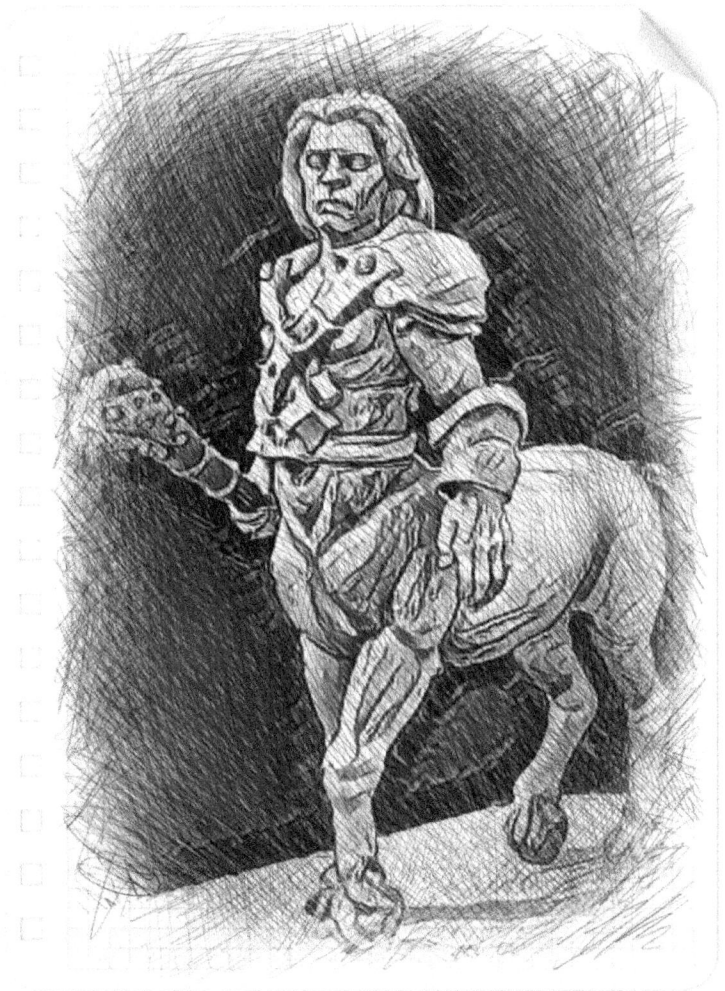

Walcue, centaur member of the Jolly Reapers.

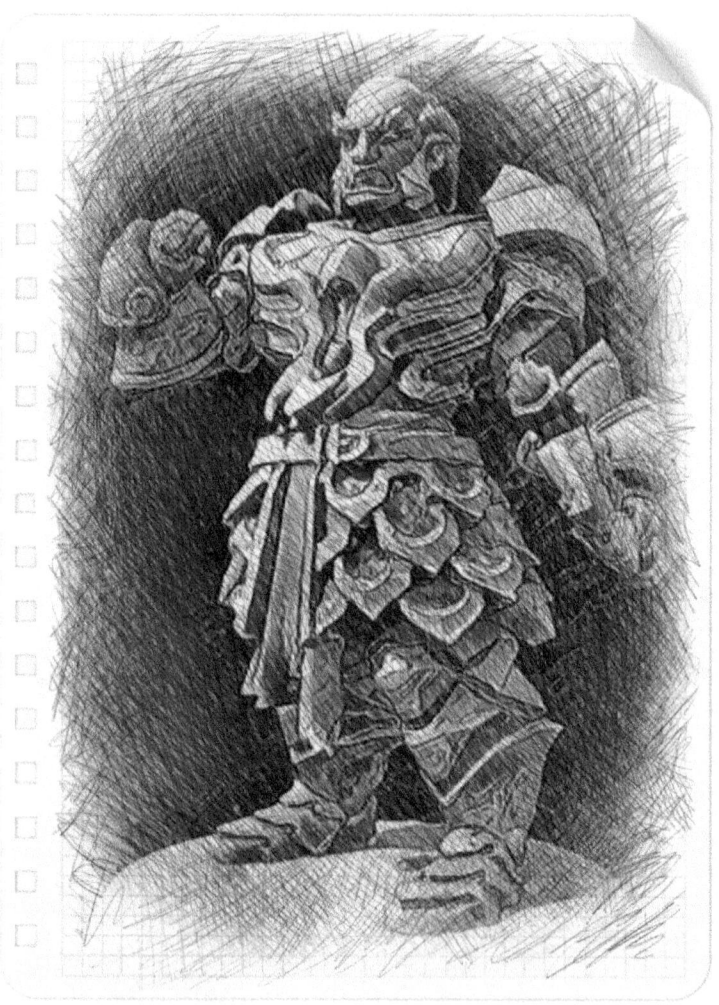

General Warjack, from Tejasli the Realm of Fire. Half human/half ogre member of the Hellmongers.

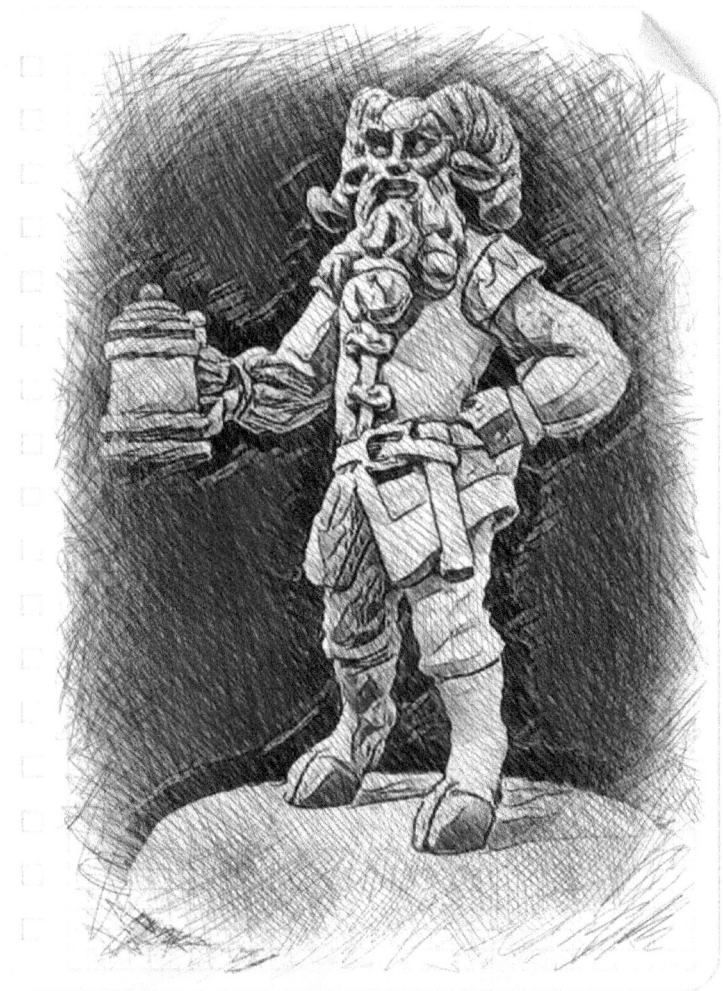

King Wartstaff ruler of the satyr kingdom of Korred Keep and former bard.

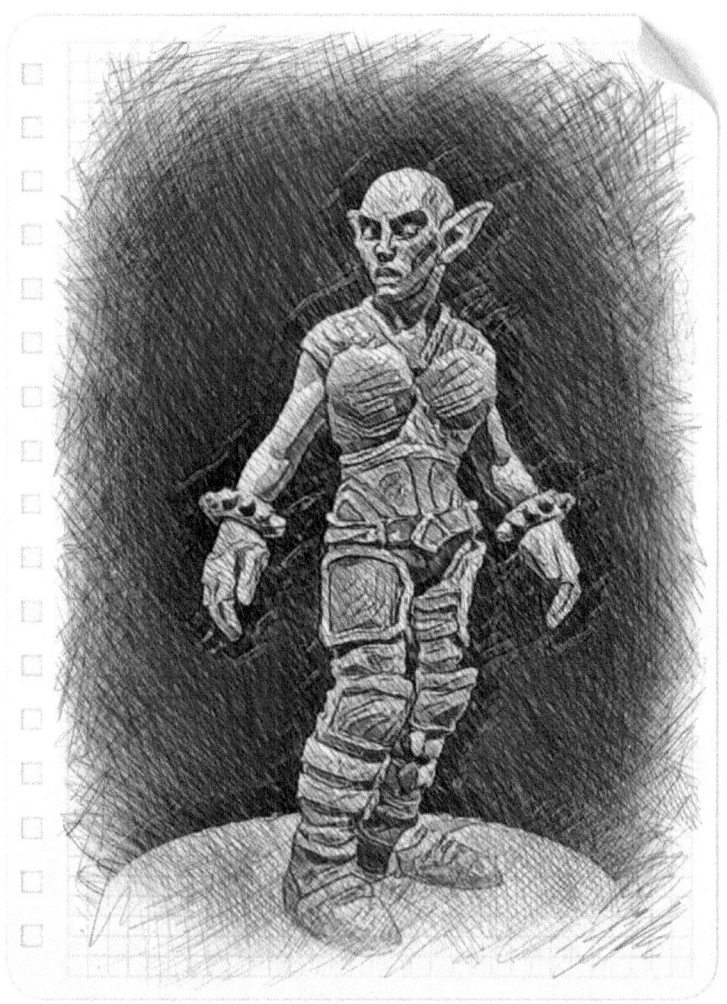

The White Widow from the changeling kingdom of Rancorvale, and assassin of the Gloam.

**a.k.a. Letilia.*

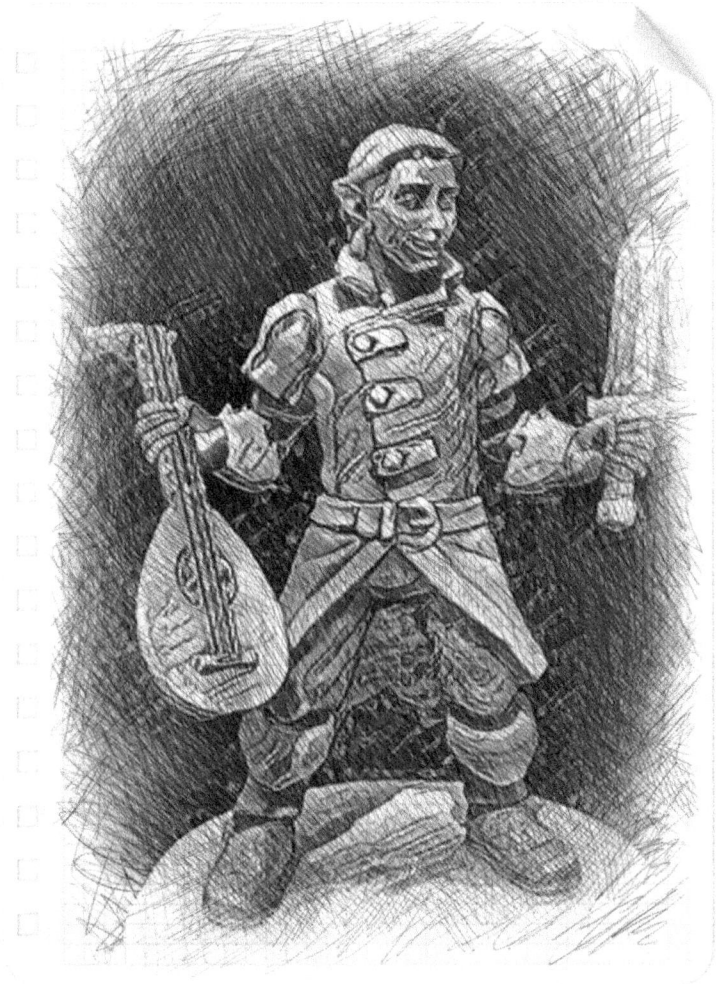

Whitefox (Wendlefyn) of the Nine Tails. Bard and quartermaster of the Dust Men.

**Fox pooka in half elf guise.*

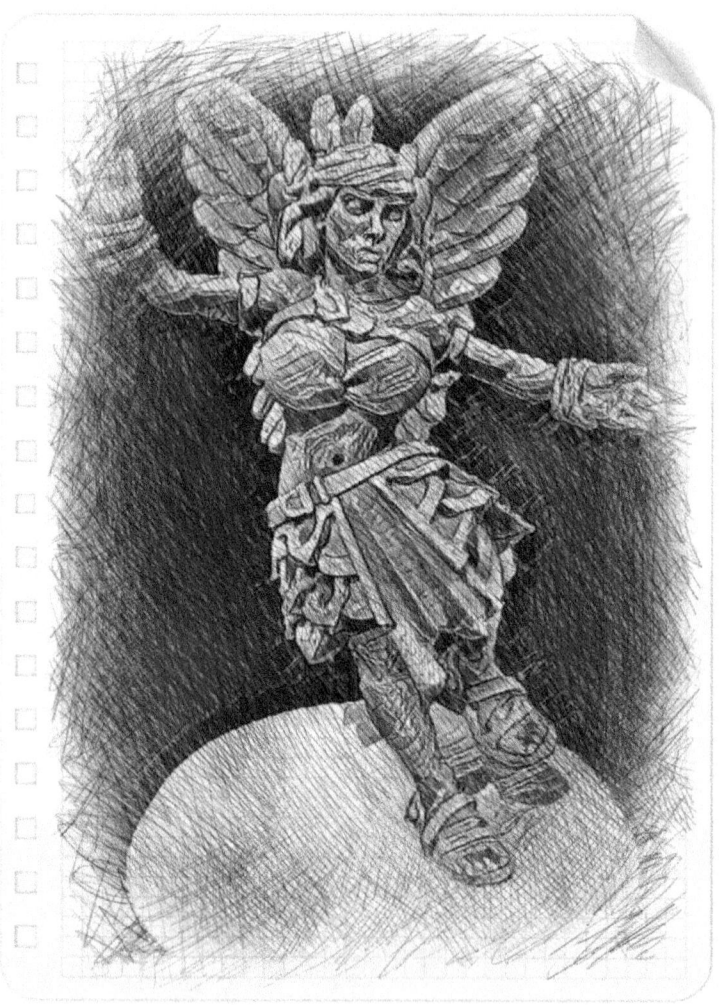

Xhal of San Pindorama, and member of the aguila (eagle warriors).

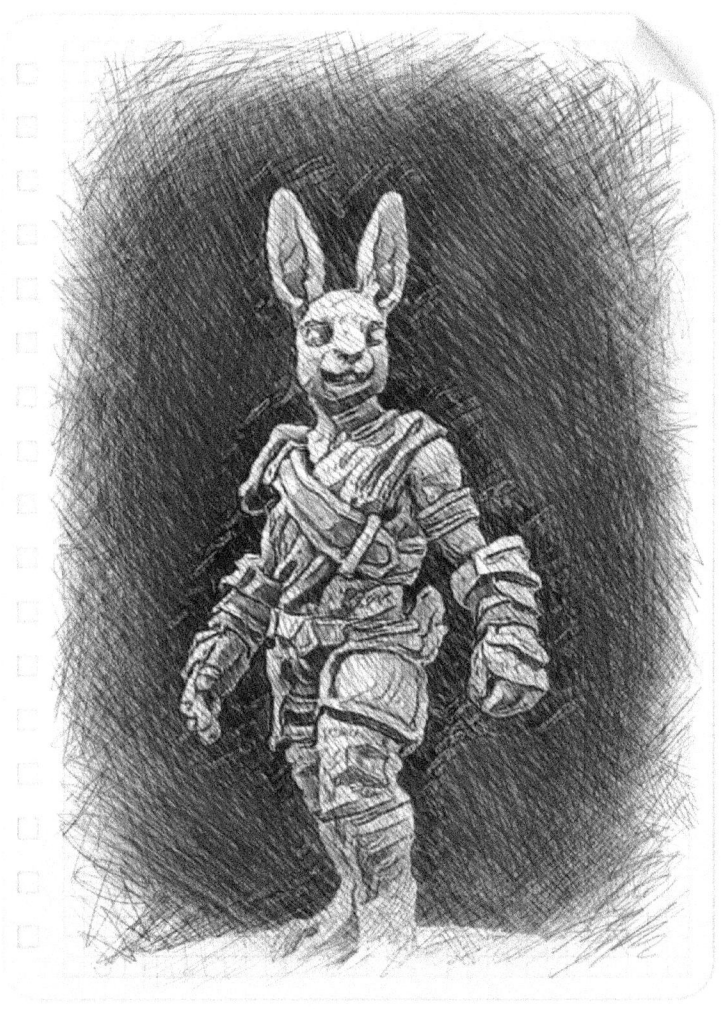

Yiro, hare hengeyokai, and chief engineer of the Fordham.

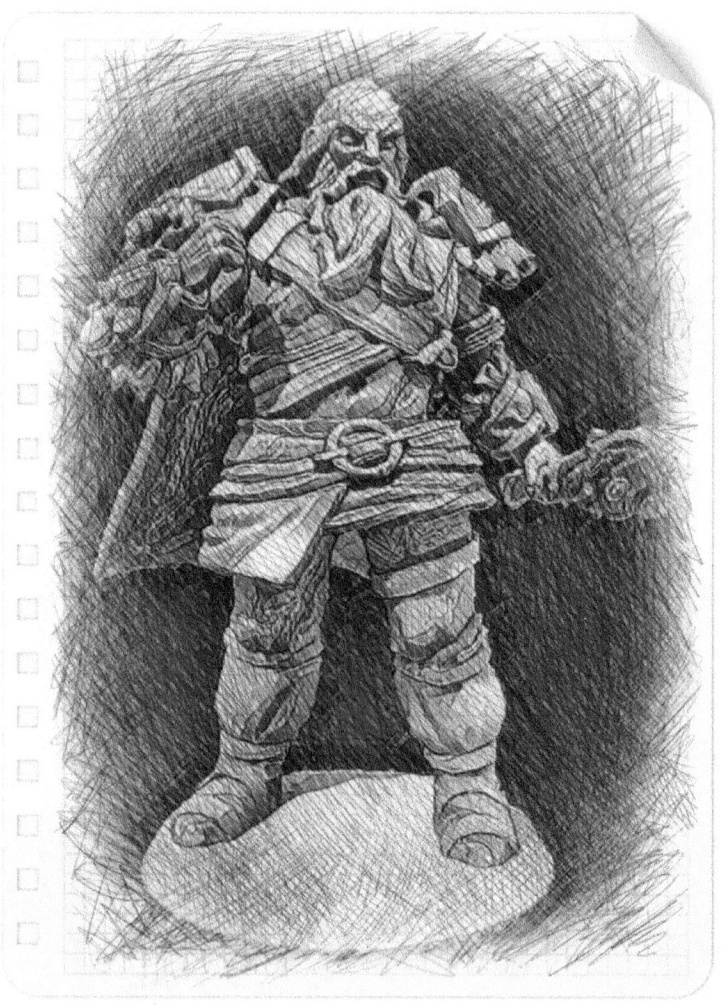

Jarl Ymolaf from Iron Icevale and ruler of the frost giant clan.

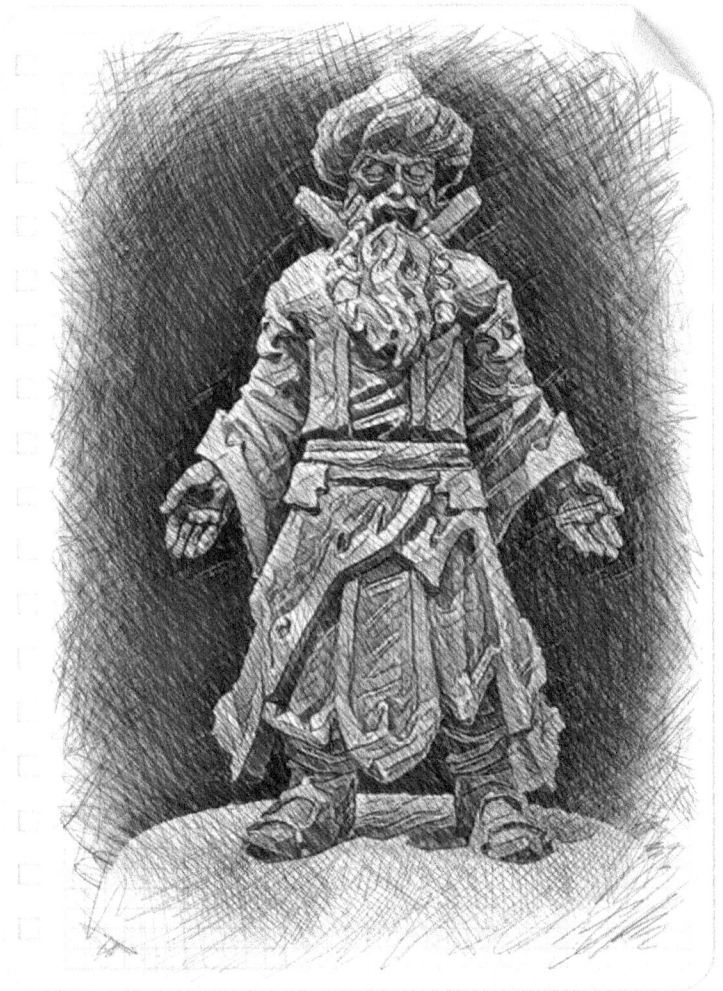

King Zolomon, ruler of Shomvale and leader of the Kabala Mystic abirs.

Steph (Short for Stephen and pronounced Stefen) is a director, producer, illustrator, and writer in addition to being the author of several novels, including the Aegis Odyssey anthology and the children's series for interracial kids, The Amalaganimals.

Steph is a native New Yorker who loathes silly author bio's, but appreciates irony.

www.ingramcontent.com/pod-product-compliance
Lightning Source LLC
Chambersburg PA
CBHW070233180526
45158CB00001BA/460

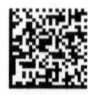